SLOW ROADS AMERICA

PHOTOGRAPHS AND TALES FROM THE NATION'S BACK ROADS

JERRY PARK

Slow Roads America: Photographs and Tales From The Nation's Back Roads

©2021 by Jerry Park

Published by Clovercroft Publishing, Franklin, Tennessee

Cover and Interior Design by Mark Cowden

Printed in China

978-1-954437-02-9

Front cover: The Open Road, near Wolcot, Colorado

Also by

JERRY PARK

A Tennessee Portrait
978-1-9484-8409-1

Slow Roads Tennessee
978-1-9425-5733-3

Author's Note

When I was in college and full of energy and foolishness, some buddies of mine and I drove round the clock in a 1953 Plymouth from North Carolina to Washington state to pick peas for the Jolly Green Giant. Within two weeks, a drought had hit, the peas dried up, and they laid us off. We went our separate ways and my way was back home, so I wrote "North Carolina" on a piece of cardboard I tore off a grocery store box, stepped out onto the highway and pointed my thumb eastward. Four and a half days later, I was home. What happened in between changed me forever and stoked a love for travel and particularly wandering around our own country that burns red hot to this day.

Around the turn of the century, I acted on my lifelong love of photography, bought a camera and set out to see if I could take a good picture or two as I continued to scratch my roaming itch. I joined a couple of clubs, watched a few "how to" videos, and tried to shoot alongside people who were better than me. Things progressed along at a start-and-stop pace until I retired in 2007 and could devote much of my time to improving my skills.

In 2012, a friend introduced me to the Holga, a $30 plastic toy film camera that is a little unpredictable but gives a soft, timeless look that I fell in love with. Loving the countryside like I do, I headed out to the Tennessee back roads and two years later published my first book, Slow Roads Tennessee. Folks seemed to like it and I came back three years later with A Tennessee Portrait, although I had broken up with Ms. Holga by this time and had used my big boy camera on the new book. That about did it for me for covering my beloved home state, at least for a while, and it was time to take the deep plunge - all 50 states. So, in early 2018, off I went in all directions, down winding country roads, through villages and county seats, and along streams and valleys. Three years, more round trip flights and rental cars than I care to add up, myriad motel nights, and 2 sets of tires on my own car, I'm done. While looking at some of the photographs, as in the first two books, I was inspired to write a handful of short stories to accompany the image. One of them, by the way, is the full story of that hitch-hiking experience of 1964.

There are photographs from every state in the union here. Whichever state you hail from, I hope you enjoy what I've included of your home turf. And I hope you get a kick out of meandering around the rest of our land, too. Who knows, maybe you'll be inspired to get out there yourself. I hope so. But, if you do, don't use your thumb.

Jerry can be contacted through his website jerryparkphotography.com
or directly at jerryppark@comcast.net.

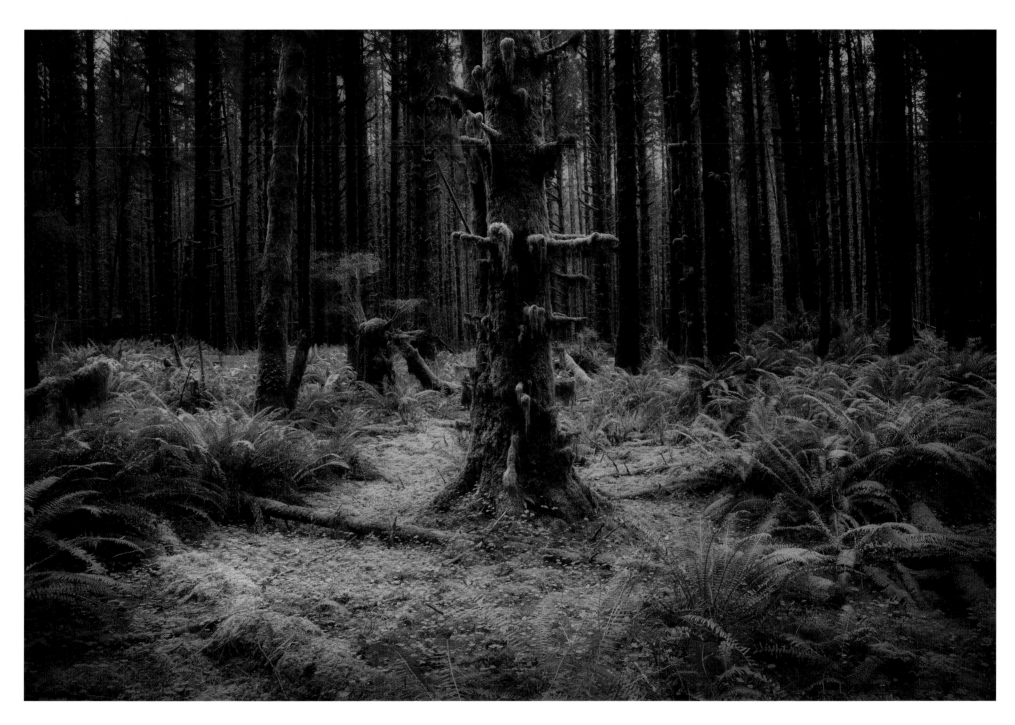

In The Hoh Rainforest, Washington

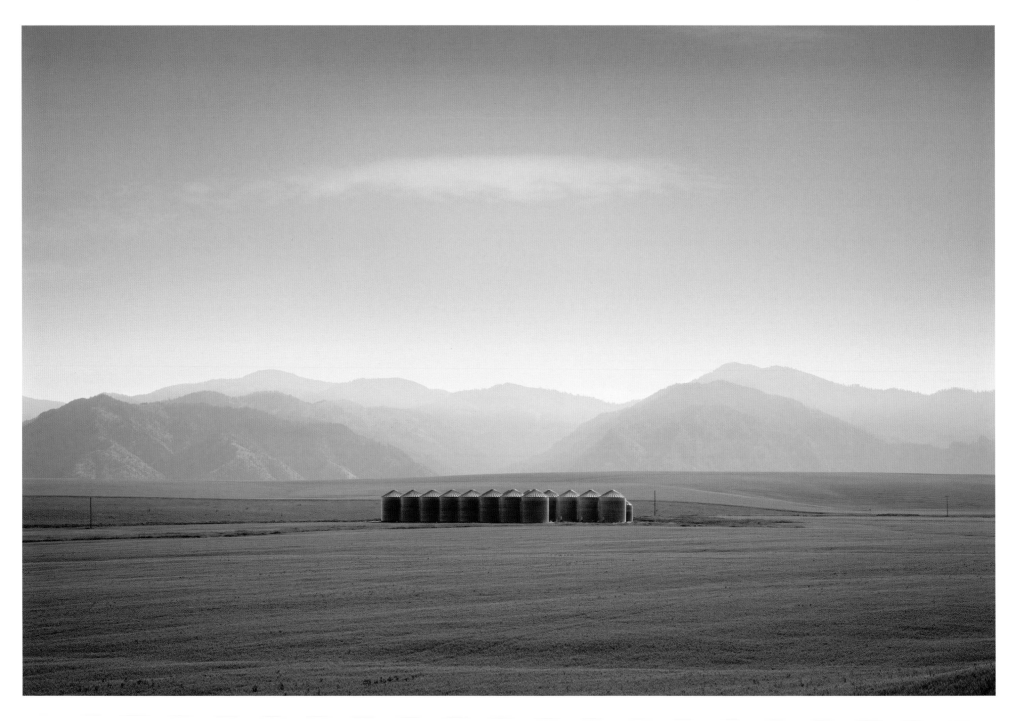

Silos, near Swan Valley, Idaho

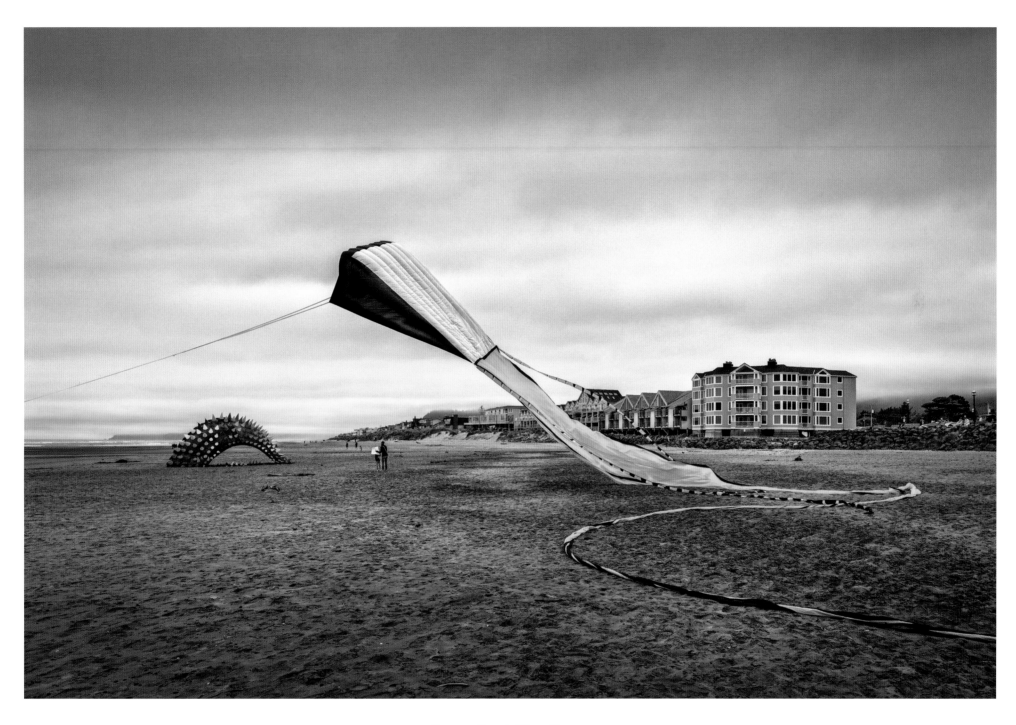

Cannon Beach Kites, Oregon

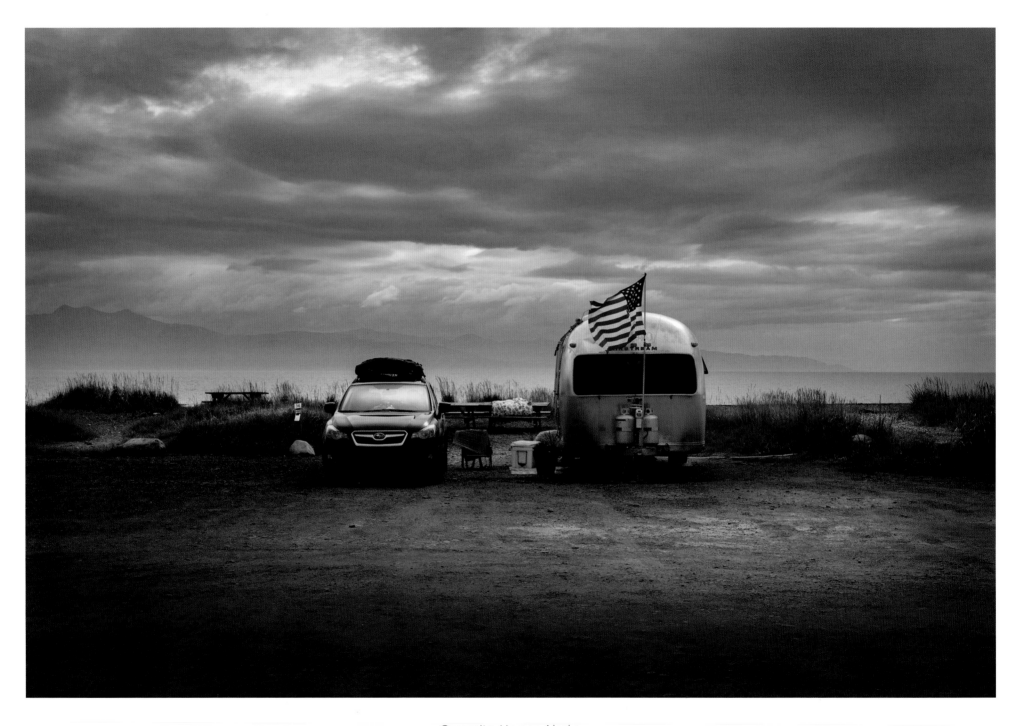

Campsite, Homer, Alaska

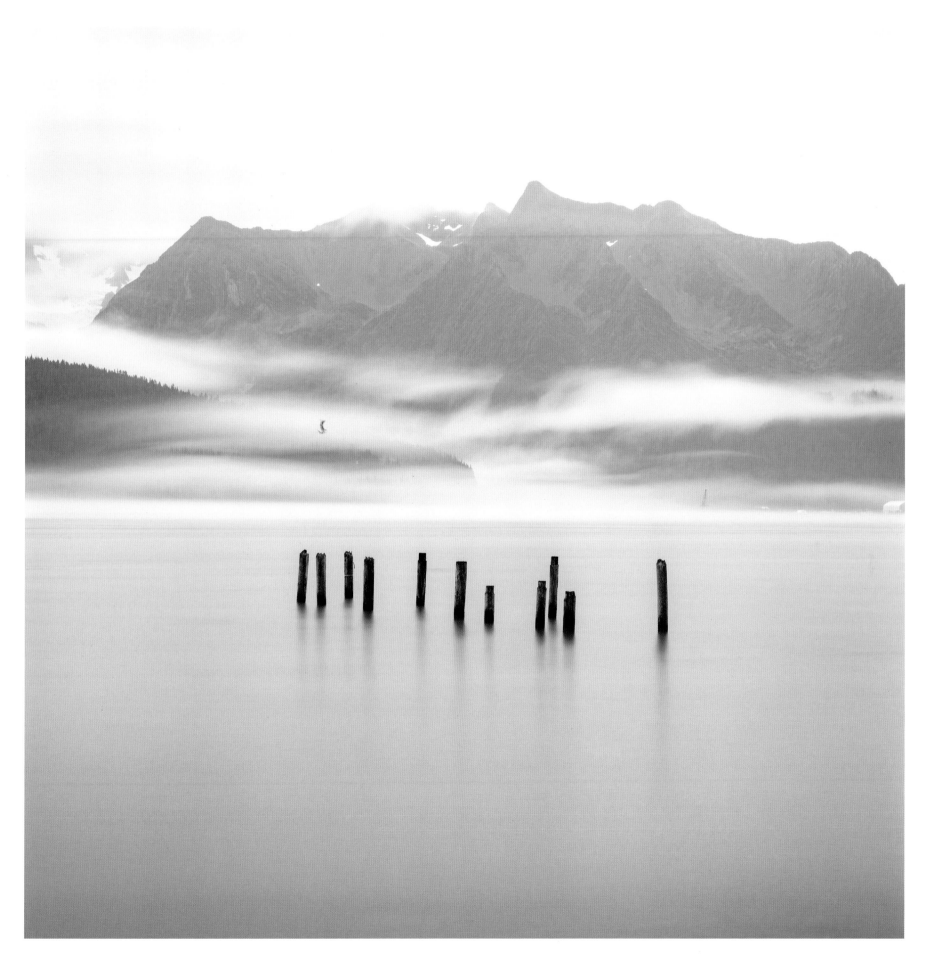

Harbor Morning, Seward, Alaska

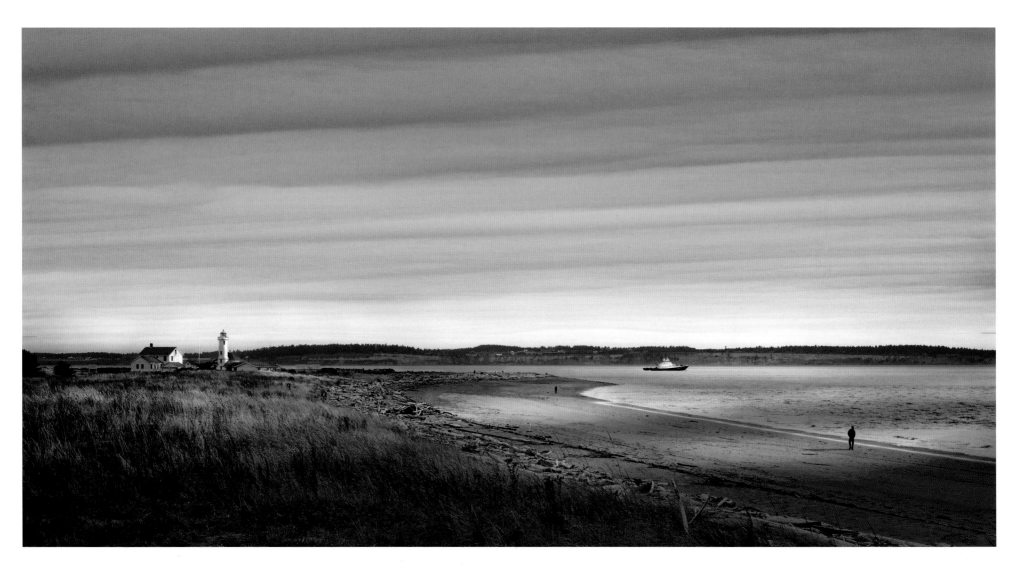

Point Wilson Lighthouse, Washington

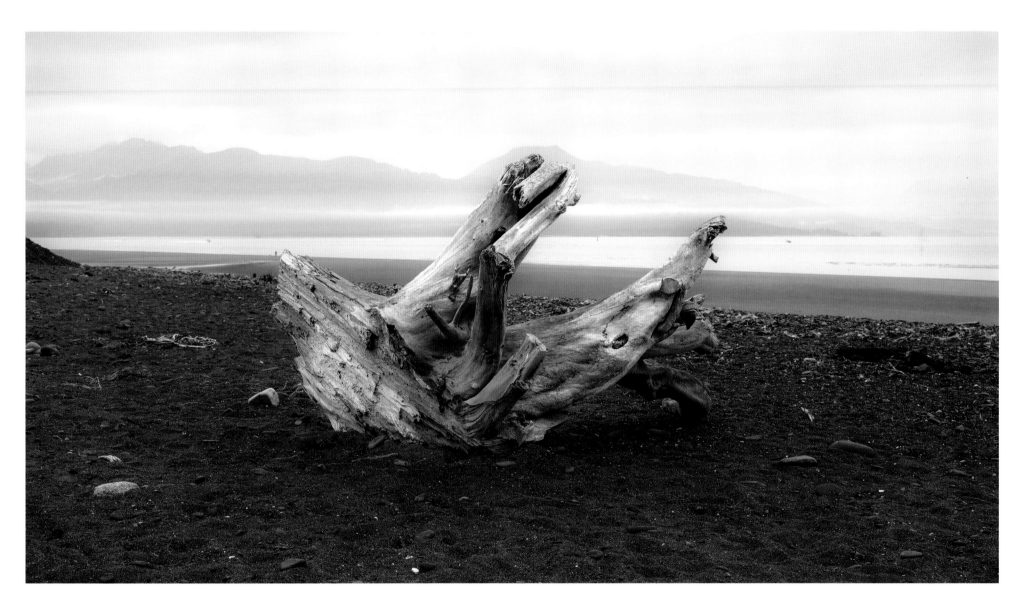

Driftwood, Homer, Alaska

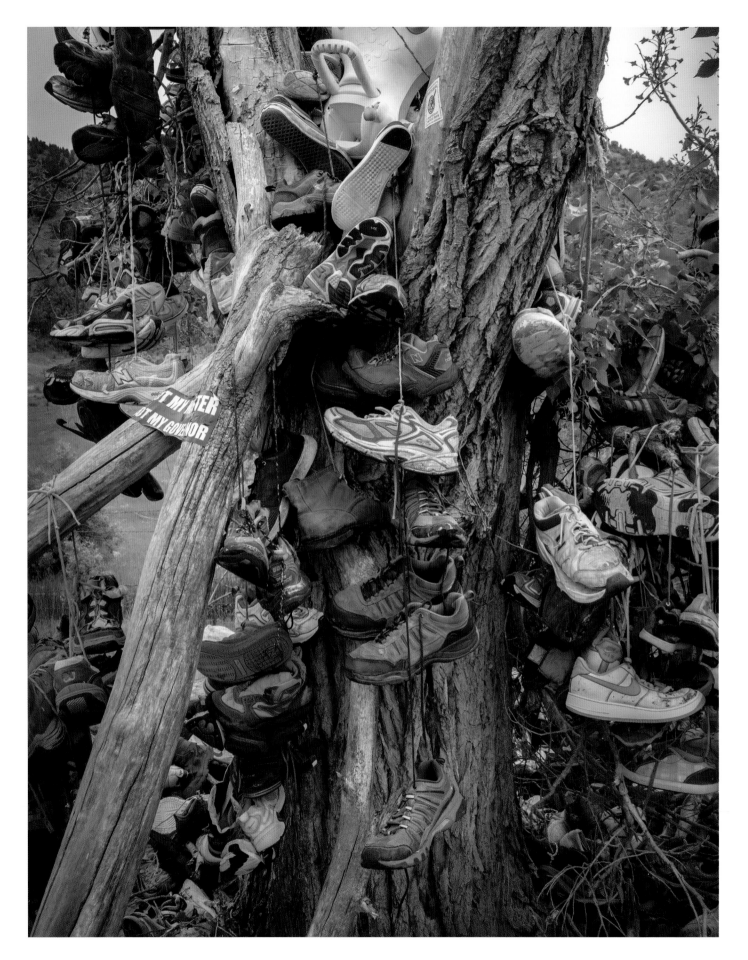

Shoe Tree, near Mitchell, Oregon

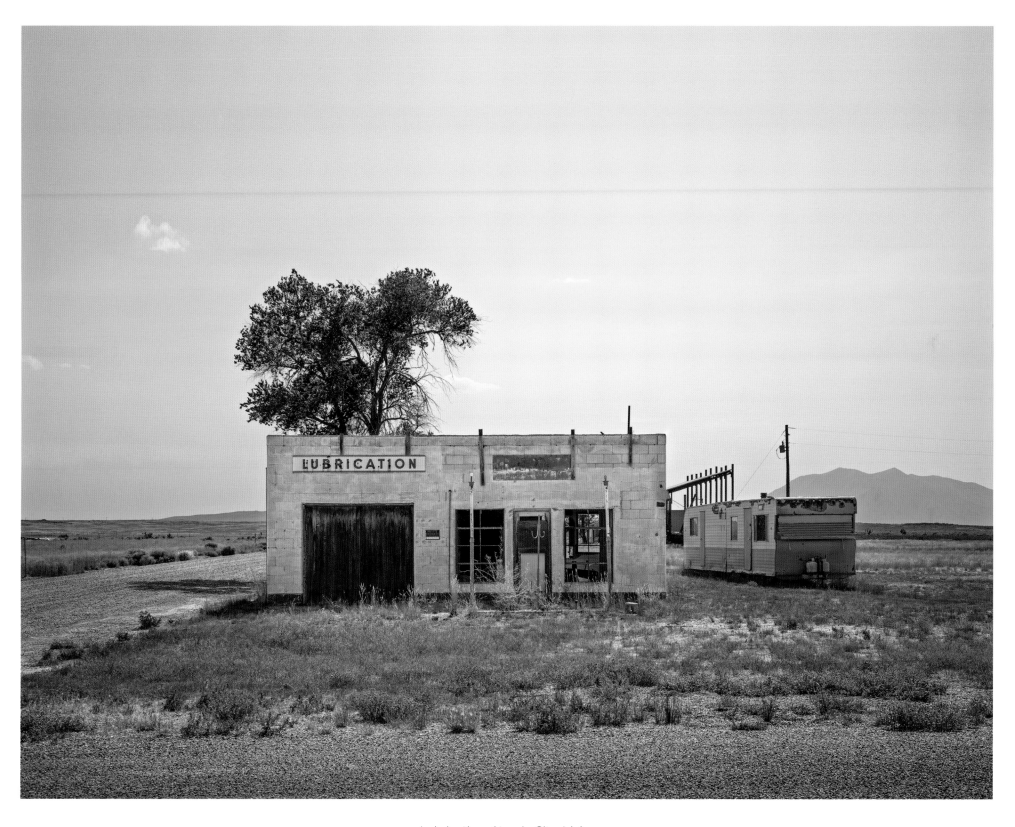

Lubrication, Atomic City, Idaho

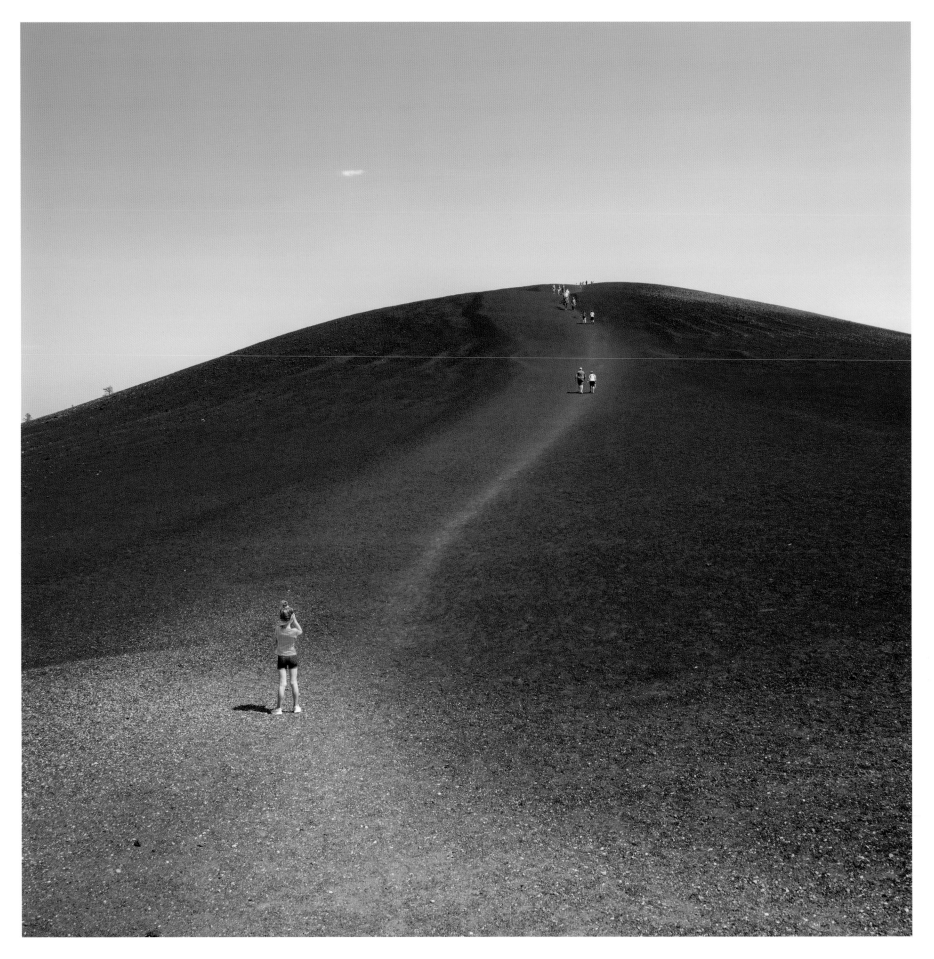

Inferno Cone, Craters of the Moon National Monument, Idaho

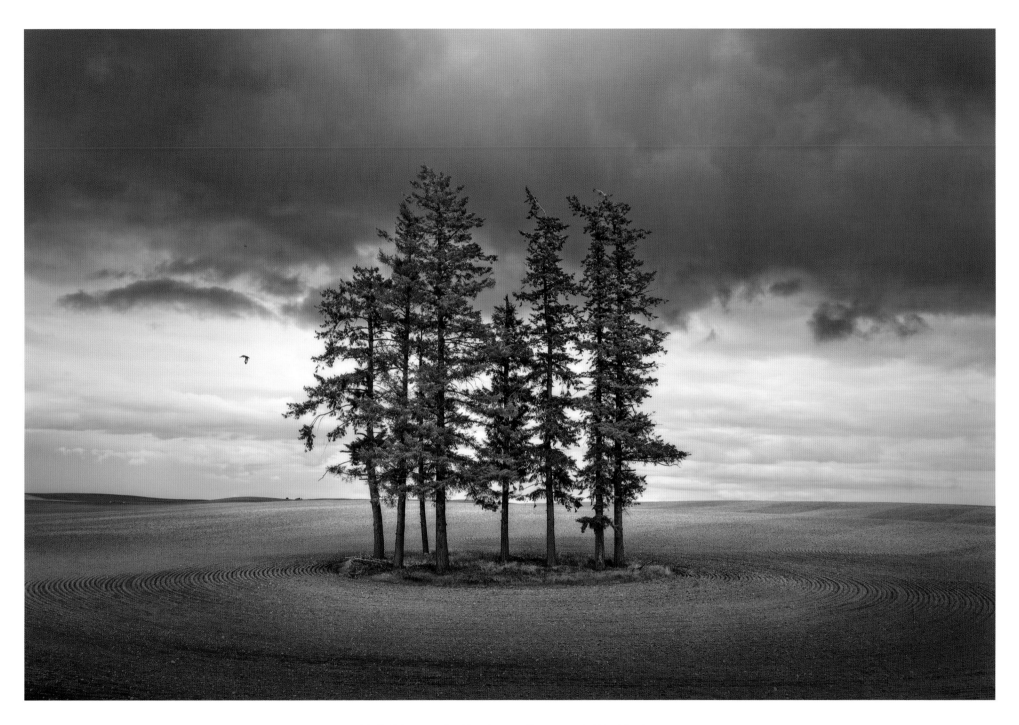

Eight Trees and a Hawk, near Davenport, Washington

A Totem's Lament

May 2, 2015

Hunters chased,
our women danced,
children hid and sought each other
where first I stood.

I reached out
wider and wider
to offer shade and shelter and
a place for a good dream.

Earth held me
and every thing I knew
in her maternal,
eternal hand.

Forefathers whispered to me
unshakable creeds,
fertile still with the promise
of forever.

Proud to be chosen,
I gave myself up
to be laid down,
to be shaped with message.

My brothers, straight and tall
like me, shared my joy
and bid me well,
to go and tell the story.

The trip was brief, the distance short,
and mine would be a place of honor!
Stood up again, my back now to the wood,
my view a ground for burying.

A comfort to the mourning,
my face and body reminders
of our sure continuum
and our certain reunion.

But that was long ago.
So many moons of dying ago.
Dying of dreams and hopes,
of pride and bravery.

We were not strong enough,
and the Great Spirit chose the others.
We are tattered now and weak,
and we are shadows.

We are our shadows,
wisps of the Before.
Even the wood behind is gone,
and I stand here bare and spent.

My inks have faded,
my message dimmed and dull.
Few even gaze my way.
I am less totem than token.

Oh, that I could bend my wooden knee
and close my wings about these remnants,
and straighten these crosses which bear
such sorrow and no names.

I would tell them again
of our mighty tribe,
of our love for each other
and for the Earth.

Of feats of great strength,
of victories and marches!
Of leaping fish and dashing elk,
heroic bear, and dauntless beaver.

Of days of play and hunting,
ceremony and dance.
Of a time when dreams were good,
we dared much, and tomorrow was a promise.

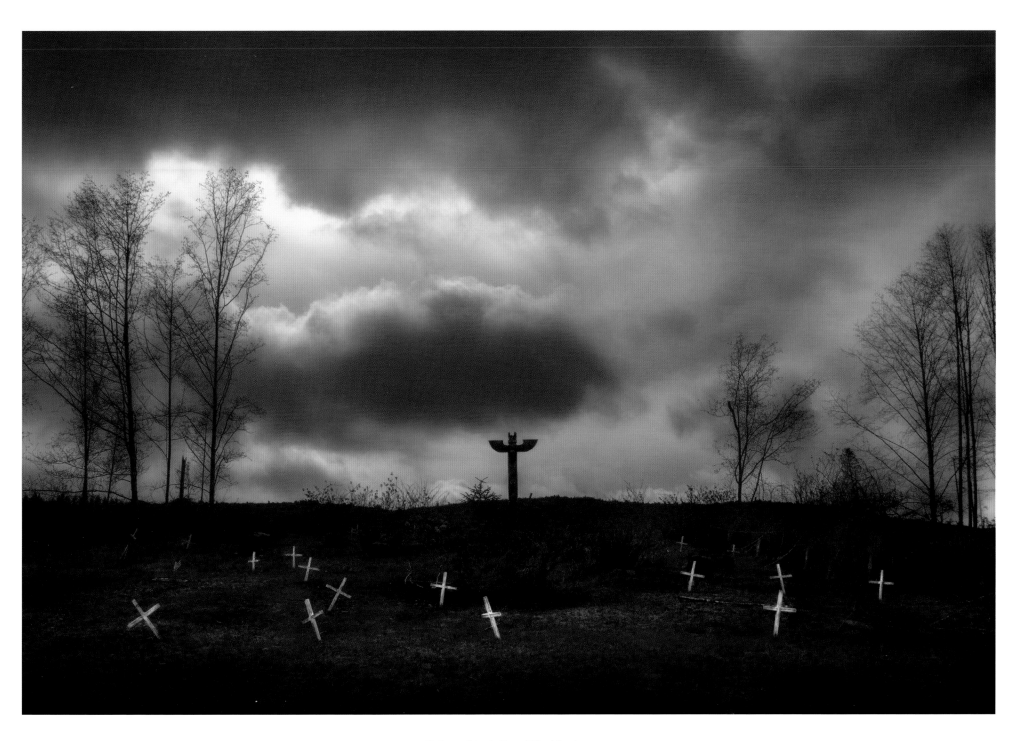

Totem, Neah Bay, Washington

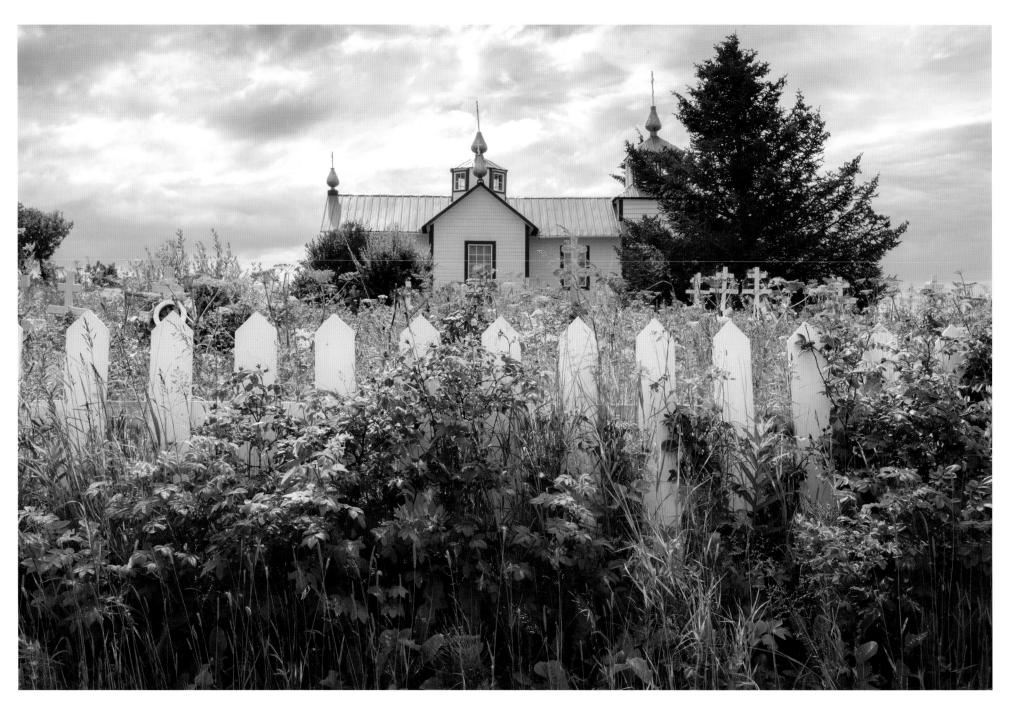

Russian Orthodox Church, Ninilchik, Alaska

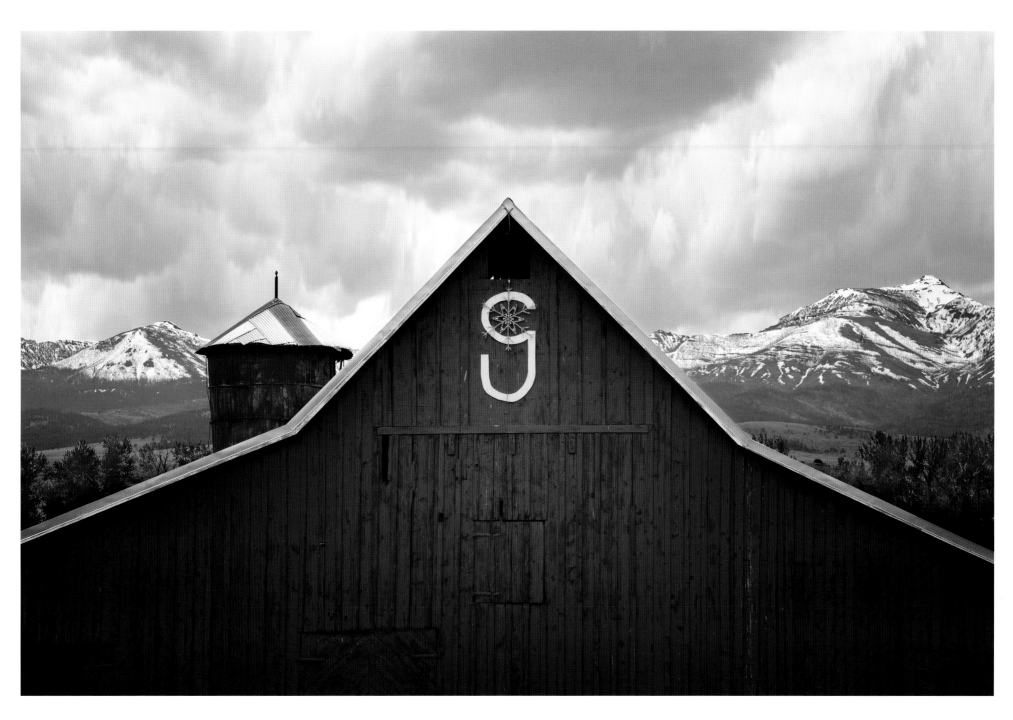

C G Ranch, near Prairie City, Oregon

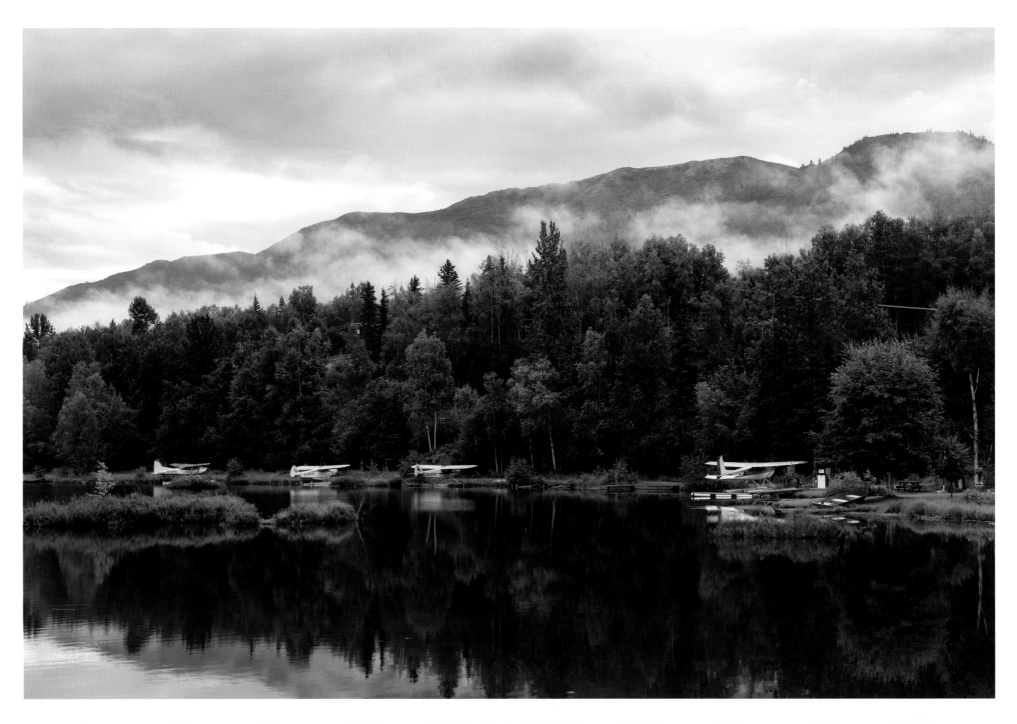

Alaska Parking Lot, Eagle River

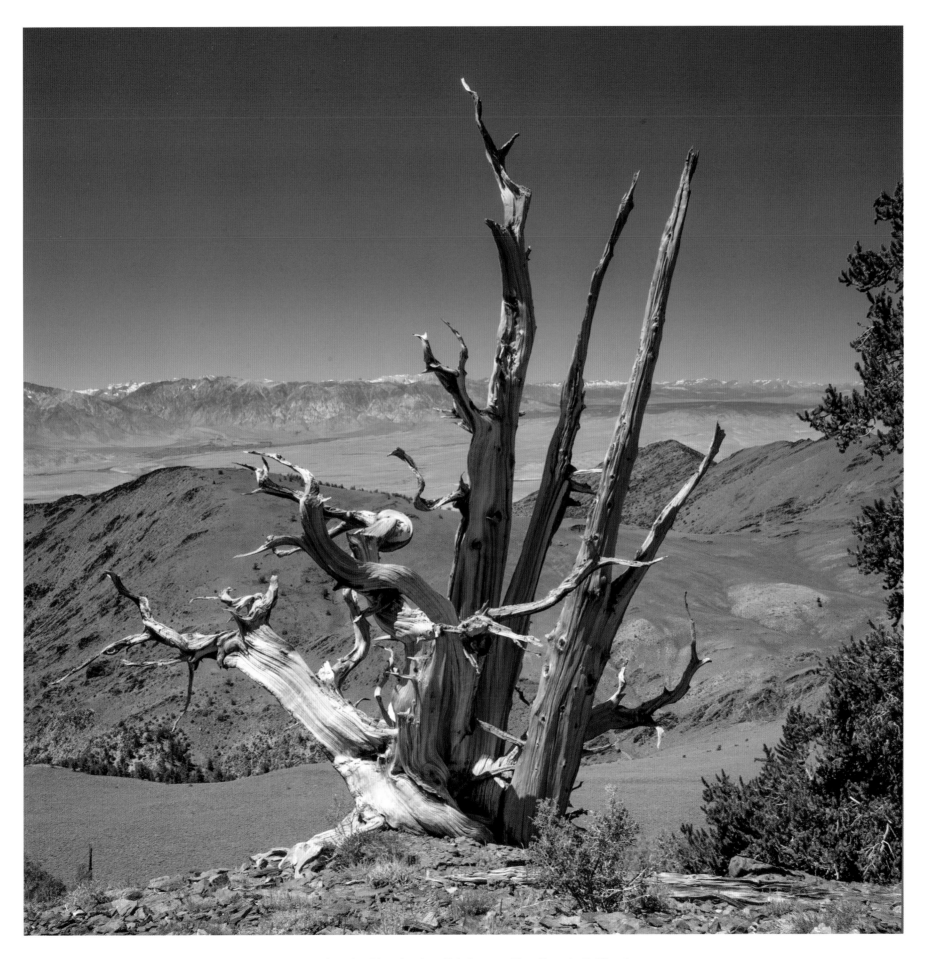

Hugging the Rim, Ancient Bristlecone Pine Forest, California

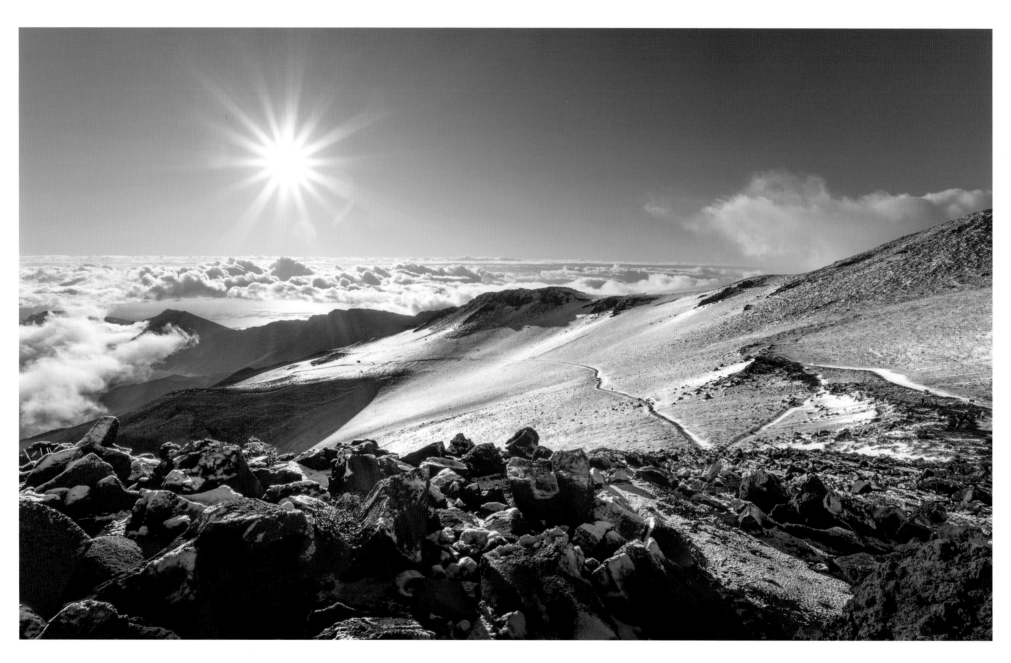

Morning at 10,000 feet, Mt. Haleakala, Hawaii

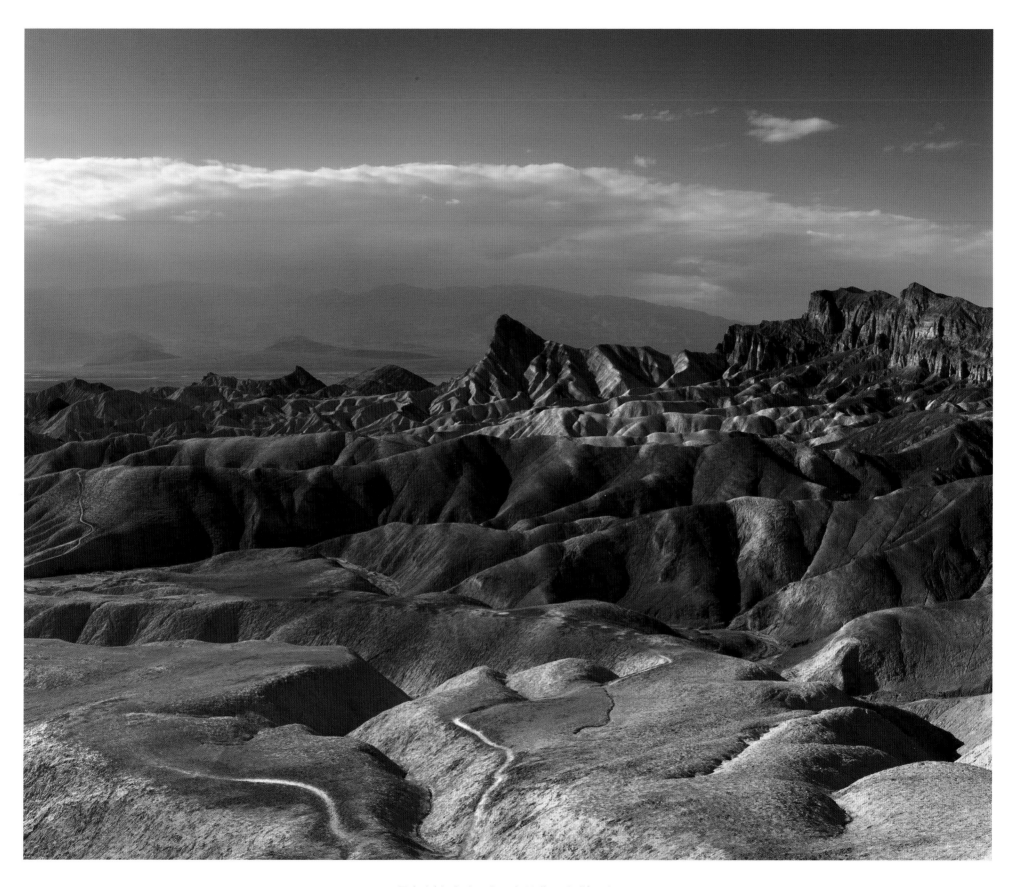

Zabriskie Point, Death Valley, California

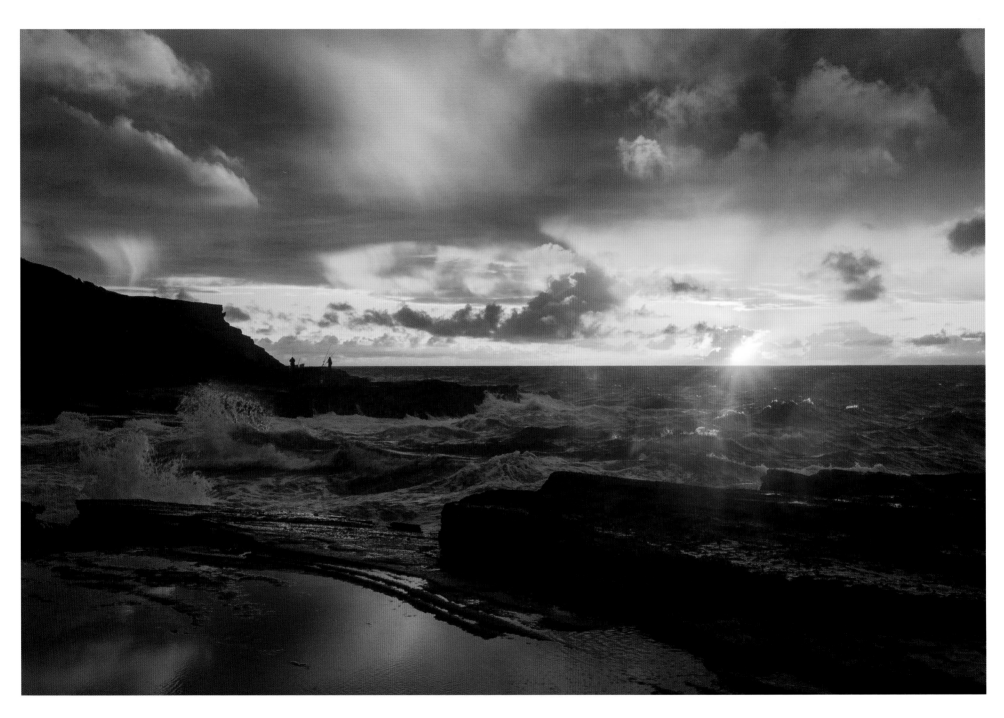

Sunrise Casters, near Hawaii Kai, Oahu, Hawaii

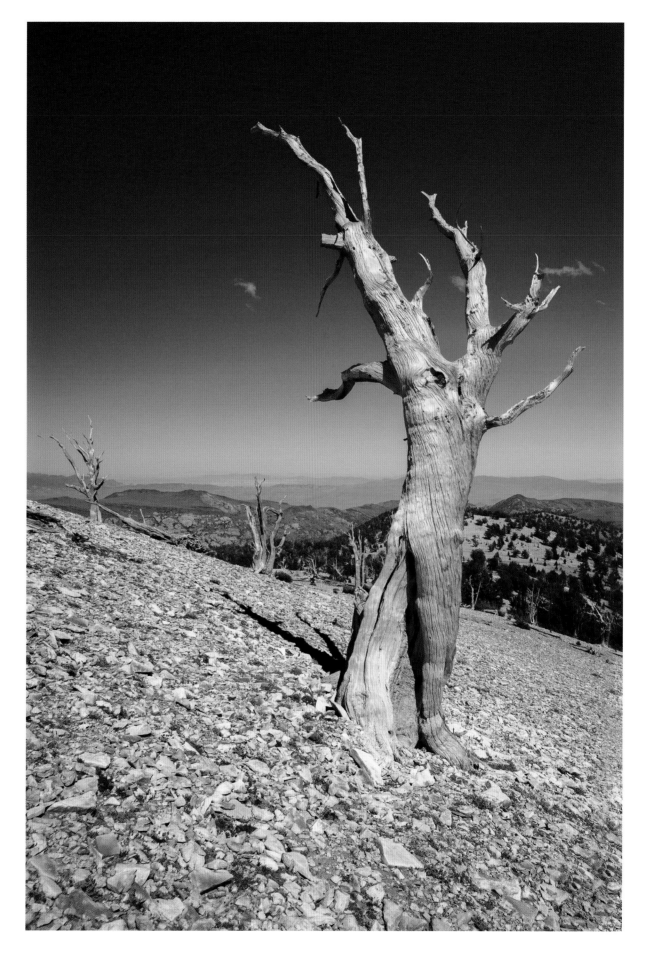

At the Treeline, Ancient Bristlecone Pine Forest, California

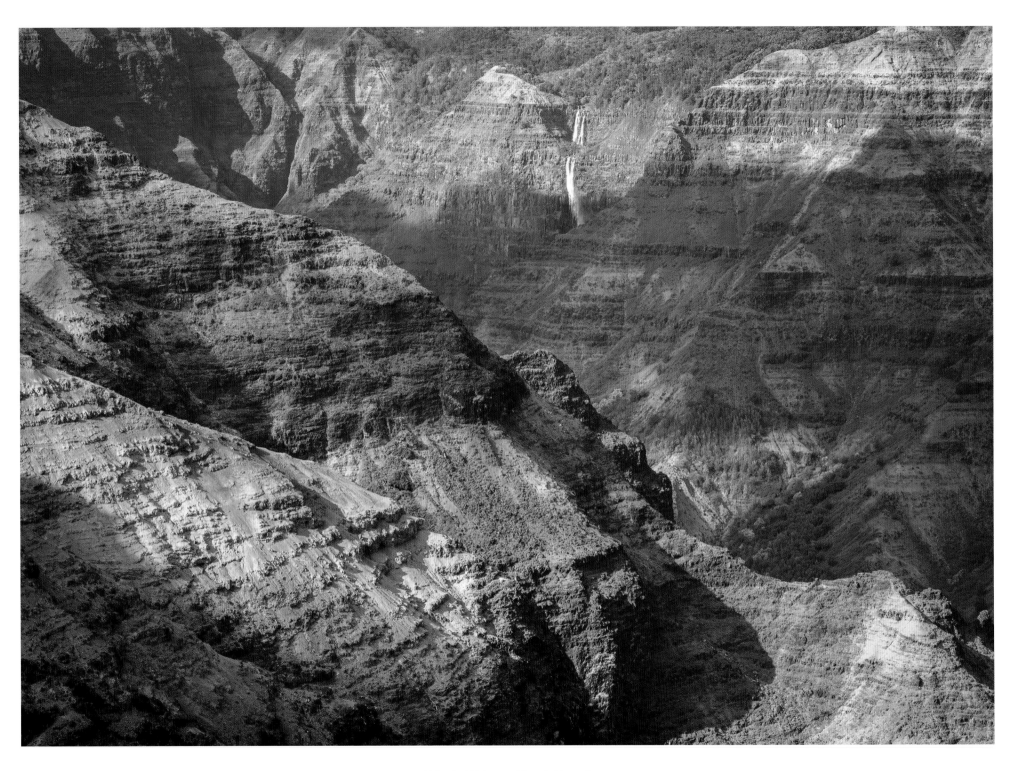

Windy Waimea, Kauai, Hawaii

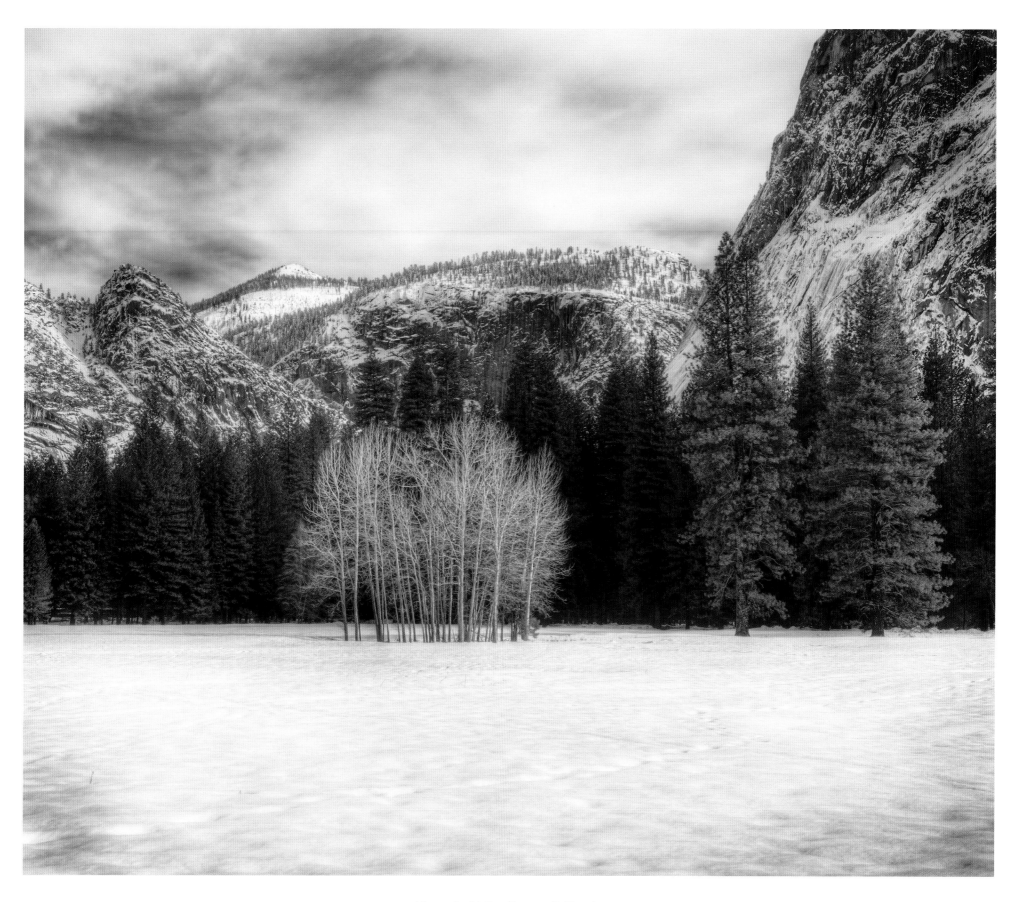

Yosemite Valley Copse, California

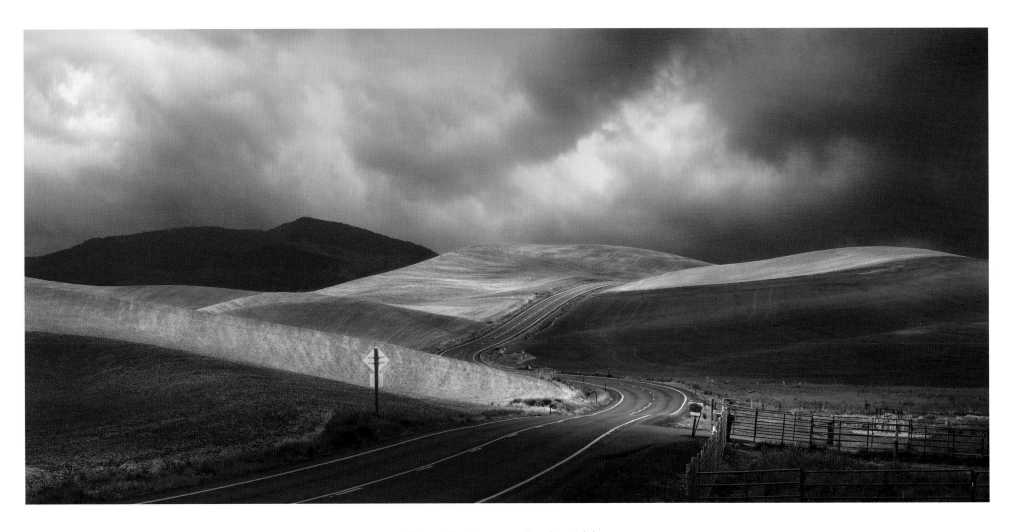

Storm Coming, near Sanders, Idaho

PEAS

June 15, 2019

As I pulled into Dayton, I thought to myself, what if I could find it? There on the right side of Main Street was the Visitors' Center. Worth a shot. I told the young lady who seemed to be running the place about my journey to this part of Washington in 1964 to pick peas for the Jolly Green Giant and did that still exist and if it did, where was it? She said that it did but it had sold twice since then and was called something else. She wasn't too busy, so I told her the whole story. With a smile on her face, she said I was the second guy who'd come through there in the last couple of weeks with the same tale and maybe the first guy was one of my compatriots. She couldn't remember his name but it wouldn't have made any difference, 'cause I've long since forgotten who 2 of my 3 sojourners were.

Anyway, she pointed me in the general direction and off I went, doubtful really that I would recognize anything after 55 years, but I'll be danged if I didn't find our old barracks, lined up like you'd see on a WWII Army post. Long since, I found out, given to the County for storage, which seems a more humane mission than the un-air conditioned one foisted upon me and the boys that scorching June back when global warming wasn't supposed to be a thing. Standing there in the shade of the towering oaks that weren't there to provide any relief in my not-brief-enough residency, the movie of that summer began its rerun in my mind as it has countless times over the decades....

Every 2 or 3 minutes, I'd look out the side window of my mother's kitchen to see if they had showed up. All I knew is that it would be a 1953 Plymouth and I, like all boys back then - I was to turn 21 on this trip - knew what one of those looked like. Same could be said for any car - they were all made in America at the time and there weren't that many of them and at that age cars are second in your heart only to your girl and not that far behind her. Finally, there it was, early on a cool morning at the beginning of a summer I'd never forget. Introduced to the two strangers by my best buddy, Worth, who'd lined this thing up, I threw my bag and sport coat (what? sport coat? But - it came in handy later as you will see) in the trunk and off we went, leaving Charlotte and heading northwest through Asheville, over the Appalachians, and into the heart of the country. Excited? Yeah, you could say that. We were like little kids, but, at the same time, trying to act cool about the whole thing. But, this was adventure of the highest magnitude, no doubt about it.

The driver had lined up a job in the wheat fields north of Dayton, and we hadn't lined up anything because you didn't need to if you were going to work for the Giant. They hired whoever showed up which certainly added to the unpredictability of life among the Pickers, as we would find out. Worth and I were tight and could be found, when we weren't working at summer jobs, on the lake water skiing, biking, even painting his grandmama's house one year. Picking peas was sort of the lark of the moment back then and we got caught up in the imagining of it. We'd finished our junior years in college and now was the time to go for it. Not knowing much more about the venture than the name of the town to head for only made the whole exploit more tantalizing.

We were young and housed in pliable, spirited bodies, and anxious to get on with it, so taking 100 mile shifts driving and going round the clock, rotating positions clockwise as we did sounded like a brave and fitting strategy to set us off on a judicious course. We'd make it in 4 days that way. Well, that got old pretty dang quick. Even with all that extra room in the back seat (oh, I miss the good old days of the land barges), all sleeping positions involved sitting, not lying. I believe I could prove, if there were such medical technology available, that my now chronic, All-America back problems began on that ride. By Madison, Wisconsin, we had to have some relief, so, in the middle of the afternoon, we found a city park and collapsed on the bank of a lake for a few hours. Minimally revived, we piled back into the now disesteemed Plymouth and aimed due west.

It was about 2:30 on a Sunday afternoon when we finally rolled into Dayton and were dropped off at the Green Giant employment office by our wheat field-bound compatriot. We bid good luck to him and waved a happy goodby to the demon automobile. I believe Stephen King knew about this car when he penned Carrie. I was ready to stand up for a few days, even if it meant going to work. And that's right where they put us - to work. I had counted on getting a good night's rest, lying flat on something, then hitting the fields with an intensity that would leave 'em all talking for summers to come about those boys from Carolina, but that wasn't how it worked. We were told where to store our gear and to show up for our first shift in a couple of hours. We had been assigned the 6 at night 'til 6 in the morning slot. I began to wonder.

We did as directed, and they loaded us all on open bed trucks with wobbly plywood sides - standing, no benches - and 45 minutes later deposited us atop a hill in the middle of an ocean of green peas and in front of 4 wooden machines called viners, each about 30 feet long and 20 feet wide, that literally came over on the boat from Holland. Here's how the work flowed: harvesters scraped the fields bare and conveyer-belted vines, pods, and peas into the back of a dump truck creeping along beside. The truck brought the load back to where we were and dumped the contents in front of our machines. Our job was to guide the swing arm of the viner over the pile, lower the tongs and grab all we could. A button on the left handle raised the swing arm at which point we'd push it over above the conveyer and, with a backward twist of the right handle, discharge our load and let the conveyor transport it all into the belly of the beast. Churning and straining, the old boogers would strip pods from the vines, then pop the peas out of the pods and into a row of wooden boxes on either side, the useless vines and pods disgorging out the back end like sausage from a grinder.

That first evening, as it is with most new things, it was kinda fun. A couple hours into it the day's heat was pushed off the hill by a cool breeze and that felt pretty good and replenished our energy supplies. We were boys with new toys and worked those tongs like video game toggles, except there wasn't any such thing at the time. The viners were lined up side by side, so contests of speed ensued almost immediately. By about 11 o'clock or midnight, the nice cool temps had dropped into the shiver area, muscles had begun to cry uncle and we weren't having fun anymore. A 15 minute break every 3 hours wasn't cutting it. Well, during the contests, we had discovered that shoving those vines into the machine faster and faster eventually proved more than the old girls could handle and down to a halt they'd grind. While the mechanic was on his way to unclog the mess, we'd run around to the rear and burrow up under the pile. Killed two birds - knocked the wind off and grabbed some shuteye.

At 6 am the sun broke the horizon and the shift was finally over. We could barely summon up the strength to climb into the truck bed for the ride back to base camp, but we did and jostled back and forth along the field ruts, packed so tight we kept each other from falling. Breakfast, a group shower to get the grey-brown microdust out of every pore and crevice, and to the barracks we went. I could hardly contain my glee as I neared Building F. A bed. A bed. And all day to lie in it. Sweet relief. I should have saved my enthusiasm. Noise, heat, a lumpy mattress on the top half of a double bunk bed, and wondering what sort of folk might be included in my new community made sleep a mostly sleepless dream. At 5:15 that evening, we loaded up and did it all over again. Same thing the next day. And the next.

Now I was no longer wondering if this was one of those things that "seemed to be a good idea at the time". I knew the answer. But, I had made my bed and was determined to sleep in it (a wistful irony).

And then, a miracle happened. A drought caused the peas to dry up. We were no longer needed! Twelve days after we had arrived, we were let go. To the migrant workers, this was not good. Not what they wanted. They were used to horrible conditions, unfortunately, and had little choice but to endure them. Now they must move on to places that still needed their help. For us, the boys of adventure - totally different. Worth went to work as a janitor at a country club. There were still some peas to can, so my other car mate got on in the cannery, at least temporarily. After making Worth swear he wouldn't tell his mother what I was about to do - she knew my momma well and would call her right away - I borrowed a Magic Marker, wrote "North Carolina" on a piece of cardboard and stepped out on the highway early the next morning, my sport coat on, $50 in my pocket, and my thumb pointed eastward. I was too relieved to be scared. And back then, if you were dressed nice with a recent haircut and face scrubbed, you usually could nab a lift in a few minutes. Like video games, we hadn't yet been blessed with the advent of serial killers.

My last ride of that first day was with a young, vibrant, ruddy-cheeked dude from Texas who was on loan to the local fire teams for the peak forest fire season. His recitation of a forest firefighter's work conditions and risks was all it took to affirm the decision I had made in the past few days to stick to the original plan - finish college, go to graduate school, and get a nice white collar job in an air-conditioned building somewhere in the South. I didn't know at the time that there'd be a 3-year pause in the order of events just after grad school to serve in the U.S. Army. Viet Nam was a spear poised to pierce the life of every American boy my age. We pulled into Shoshone, Idaho, at dusk, and I asked to be let out in front of the cheapest looking hotel I saw along the railroad tracks - remember, $50 was it. Well, after I paid for the room which featured a window that faced a brick wall about 18" away, I had $48.50 left. That's right, a buck fifty. After spending a night there, it seemed to me to be fairly priced.

I turned 21 that next day. Not much celebrating to be had, standing in the middle of a Utah canyon, long, quiet lulls in between passing cars which I could hear coming several minutes before they suddenly emerged from behind the canyon wall and, just as quickly, disappeared around the curve to the east, the sound fading along with my hopes for a lift. The stream that had formed the ravine ran alongside the road. In between the two was one set of train tracks, as silent and even less traveled than the highway. A lone railway worker walked the tracks, gripping some sort of long, metal handle. I waved. He waved back. "Where you headed?" he shouted. I turned my sign toward him. "North Carolina." He shook his head, "Well, good luck, then!" put his head down and kept walking. He was long gone by the time I landed a ride. Turned out to be the longest wait of the trip - about an hour and a half. Happy Birthday.

That night, I forked out another $1.50 for a room in Grand Junction, Colorado, which might be better described as "storage" than "lodging". Fashioned out of an old elevator shaft, no longer needed for the long-defunct elevator, it contained no windows and featured about 12" of room on three sides of the bed. The headboard was pushed up against the fourth wall. This put a different slant on the phrase "falling into bed". I'd made about 900 miles in two days. At that rate, I'd have to keep finding $1.50 rooms - I had to eat, too - or I'd run out of money somewhere in Arkansas. As it happened, I wouldn't be looking for a motel again until Nashville, Tennessee, 1500 miles away. And in between here and there would be some moments to remember and not because you'd want to...

My first and second rides on that third day combined to form a story in itself. I handed in my key at the front desk, turned right on the sidewalk, and walked to the corner where US 6 sliced through town. In no time, I was picked up by a family in a station wagon bursting with kids and enthusiasm who were able to get me to the city limits before veering north. As they pulled to the curb to let me out, they asked to pray for me. Mom and Dad had graduated from Bob Jones University and felt led to cover me up with protection from above. Being a praying man myself and knowing full well that I was a little vulnerable out there in the middle of nowhere with nobody knowing where I was, I was grateful for the intervention. No sooner had they said "Amen" and rumbled on away than a rough-rode '52 Ford sped past me. The brake lights went on, it screeched to a stop and back it roared toward me. When I looked in the window, that little warning light flashed on but it was too late. Shotgun Rider popped out of the car and with a big smile on a dirty face and straw-stiff hair sticking out from under an old baseball cap, he said they were heading across the state, he and his driver buddy, and would love some company. I'd have to sit between them in the front seat because the whole back half of the car was filled with dirty clothes. I threw my suitcase and coat on top of the pile and squeezed in. Within a half hour or so, miles from any settlement, the temperature gauge signaled trouble and the pucker factor climbed another notch.

After another little while we came to a small, a very small town in the middle of the Colorado dessert with one visible place to eat. We were all hungry and I coveted having a little space on either side of me for a few minutes. The two comrades finished breakfast before I did, left the cafe and went back across the street to the still ticking car. I downed the last bit of my bacon, paid, and headed across myself. They were sitting up against the wall of a store and said, "Sit down. Car's too hot to go now. We're gonna wait here 'til dark." Ding, ding, ding! My warning light had acquired a bell. I sat. And sat. Long enough to hatch the best plan I could come up with. I had noticed that under the store sign hung a shingle that said "Bus Stop". I was the closest to the front door. I waited until they were glancing the other way, and jumped up. "I'm gonna check out the store, long as we're hanging around for awhile", I blurted as I hurried toward the door. The inside was a bit dark, filled with wooden display fixtures, old merchandise and a bit musty. But I didn't care about any of that. I told the man behind the counter - he was by himself - what was going on and what I was afraid these guys were up to and gave him my wallet and my mother's number to call if this didn't work out.

I inched to the edge of the front door and peeked out. I'd watched enough Gunsmoke and Have Gun, Will Travel to know that the element of surprise often meant the difference between disaster and living to fight another day. When again something attracted their attention in the opposite direction, I bolted from the door, reached into the car window, grabbed my suitcase and sport coat, wheeled around, garbled out, "I'm gonna get the next bus! Thanks for the ride!", and raced back into the safety of the store, all in one motion. Matt Dillon would have been proud. And wouldn't you know it, miraculously, the car must have found some inner source of coolness, 'cause less than two minutes later, Butch and Sundance got back in the car and took off. They had given up on whatever plan they'd hatched for my undoing. I guess I was just too fast for them, being a Carolina boy, after all.

Not smart enough, however, to leave well enough alone, I got right back out on the highway with my thumb extended, giving no consideration to the possibility that they might circle right back around. But, shortly, a gleaming red and white '56 Ford Fairlane hardtop, windows down all around, second only in covetability during that halcyon period of Detroit design to the '57 Chevy Bel Air, glided to a stop by me and a smiling, trustable face welcomed me in for a ride to Denver. Nothing in the back seat but shiny, rolled and pleated naughahyde. After I'd settled in and settled down from the events of the morning, it hit me that all that praying could not stop the bad guys from trying something evil, but it could, perhaps, get me out of it.

We had miles to go in desert heat. Afterwards, even this well-loved, pampered limo struggled to pull itself up the mountains leading into the Mile-High city. We stopped several times on the way up to tote water from a roadside stream to a steaming, thirsty radiator, but eventually we made it. My good samaritan dropped me off on the far side of Denver and said he'd enjoyed the company. It was toward night and I was tired, but, my courage renewed and confidence reestablished, I thought, what the heck, let's give it a few minutes and see what happens before we pack it in for the evening. Stretch that $50, right? Almost immediately, an unadorned, featureless sedan of indistinct hue, the antithesis of my most recent chariot, pulled to the curb. The offer came, "if you're willing to share the driving, we'll go all night. I'm heading to Kansas City." Well, dang right, I was! Money, get back in my pocket! I didn't know exactly where KC was, but I knew this was probably a day-saver.

We grabbed supper and my new friend took the first shift. I rode up front as we swapped stories, but from then on, when I wasn't driving, I was stretched out in the back seat sawing logs. Sunup found us slipping into KC just ahead of the morning rush. He dropped me off on the Missouri side outskirts as I faced another "what the heck" decision point. But not much of one as I profusely thanked my long haul brother, grabbed my stuff and pointed my thumb and myself toward home, as he set forth on his day. The sun was out, the waits between rides short, and I was on a roll. The day went fast and ended with me in Nashville sharing a cheap motel room with my final ride of the day. Still conserving my dwindling cash, I recalled fondly what Jesus did with the loaves and fishes and assumed he had a hand in my getting this far with folding money still in my pocket.

Nashville, I thought the next morning as I took up my familiar position beside the asphalt, I'm in Nashville. The way this is going, I'll make it to Charlotte in time for Momma's supper tonight! Won't she be surprised! Oh, the ebullient certainty of youth! You know those disclaimers on mutual funds prospectuses - "Past performance is no guarantee of future performance"? Well, my one and only ride that excruciating day was with a couple of good ol' boys that had recently decided to open up an auto junk yard and they needed to learn all about how to run one, so we stopped at every - and I do mean every - junkyard on US 70 between Music City and Knoxville - 190 miles worth - which is where I was let out of the car as dark and the Appalachian Mountains put an end to my dream of fried chicken and tea at Momma's. That brought me squarely face to face with the fact that I was done. I had had enough. It was time to get off the road. I found the Greyhound Bus Station and bought a ticket for the 11:15 pm to Asheville. That would get me over the mountain and to my Grandmama Ingle's where I could bed down before hitching that last 115 miles down to Charlotte and home. I had a few hours to kill 'til the bus came, so I stowed my suitcase in a locker, grabbed some chow at the diner next door and walked around downtown Knoxville in the dark. For the first and only time in my life, I was propositioned by a lady of the night. I don't remember what I mumbled to her in my shock and innocence, but what she said back to me wasn't very nice.

By the time Ralph Cramden pulled into Lane 4 at the downtown Asheville station, it was 2:30 am and raining. I was basically out of money after the bus ticket, so I walked the three and a half miles to Grandmama's and knocked on their door at around 4 in the morning, soaking wet, and with no warning. I'll never forget the sight of them peeking out of their bedroom door. I could see down the hall from the front door window. Faces all alarmed, mouths agape, Grandmama clutching her bathrobe to her chest. Good thing the porch light was on, I guess. I didn't think they kept a gun in the house, but...

A short explanation of what the heck I was doing there, a warm bath, and off to the guest bedroom for a few hours. Mid-morning, I rolled out of bed to a breakfast that would challenge a logger in peak harvest. Filled to bursting, I was more than ready to get on with it and stand roadside one last time, but my Grandmama was having none of it. Not on her watch was her grandson going to be exposed to the awful dangers of the open highway. Never mind that I had just done it for 5 days and 2500

miles. So, the great climax of this audacious adventure, the heralded arrival of this returning hero of the common man was me pulling into the Charlotte Greyhound station courtesy of a ticket paid for by you know who. The women in our family have always been pretty strong.

My mom was there to pick me up, Grandmama having phoned to let her know I was on the way. She gave me a hug that felt born of agony and relief, then backed up a step, put her hands on her hips and let me know that Worth's mother had called her a day into my trip and she'd been worried sick all that time. I swore to myself silently that I'd kill that doublecrossin' sonofabuck the next time I saw him. Mama got over it pretty quickly though, and we were both really happy that I was home.

A lot of life had been packed into what wound up being only about 3 weeks. And a lot of story. Back in Charlotte, all the good summer jobs were already gone, of course, and, needing spending money to take back to Wofford College for my senior year, I got on at Shoney's as a curb hop. Not the most glamorous job, but no roller skates, thank goodness. The tips were good, I ate free strawberry pie, and slept in my own bed the rest of the summer. The week before I went back to school, I capped off that summer of summers parked at the end of the runway at the Charlotte airport, smooching a fellow curb hop named Snake. Said she was an Indian, she did. I just knew she was pretty.

Well, that's the "The End" of my movie, at least this episode, and you can roll the credits. I won't kid you, it was probably foolhardy, but I'm awfully glad I did it. Maybe we all ought to take more chances, calculated perhaps, but risk a day or two here and there doing something in the arena of the unknown, suiting up for an endeavor where the end is not guaranteed, where you don't know what the rules are ahead of time. I can tell you this - I've told this story a hundred times over the years and I'm pretty sure I wouldn't have ever spun a tale about the summer of '64 if I'd spent it sorting packages in the warehouse of the Sears and Roebuck Company.

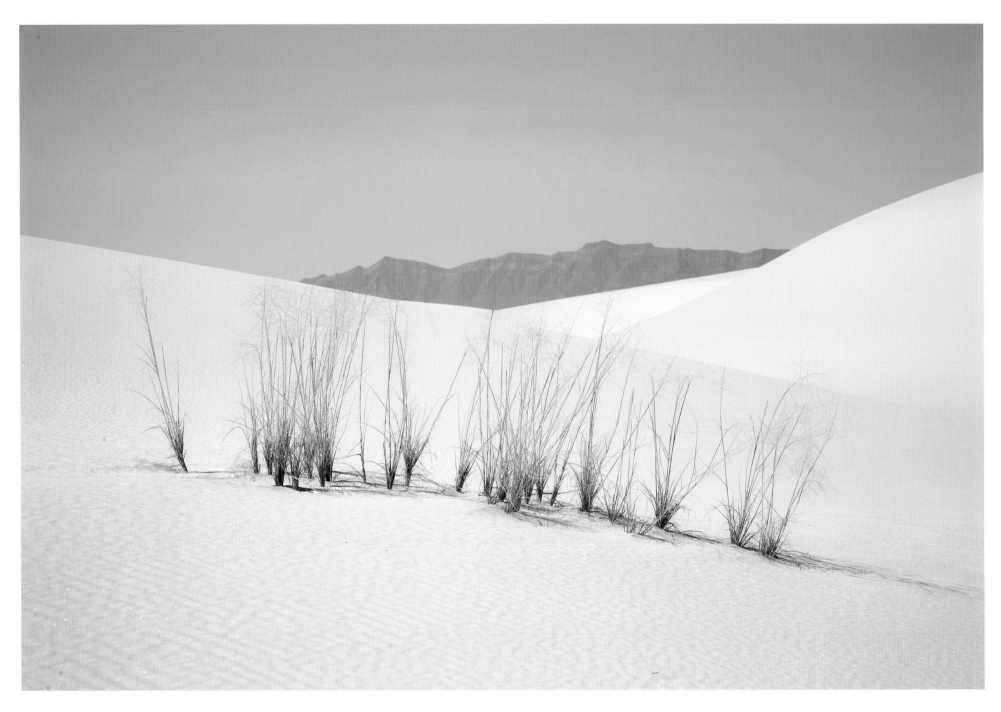

Line in the Sand, White Sands National Monument, New Mexico

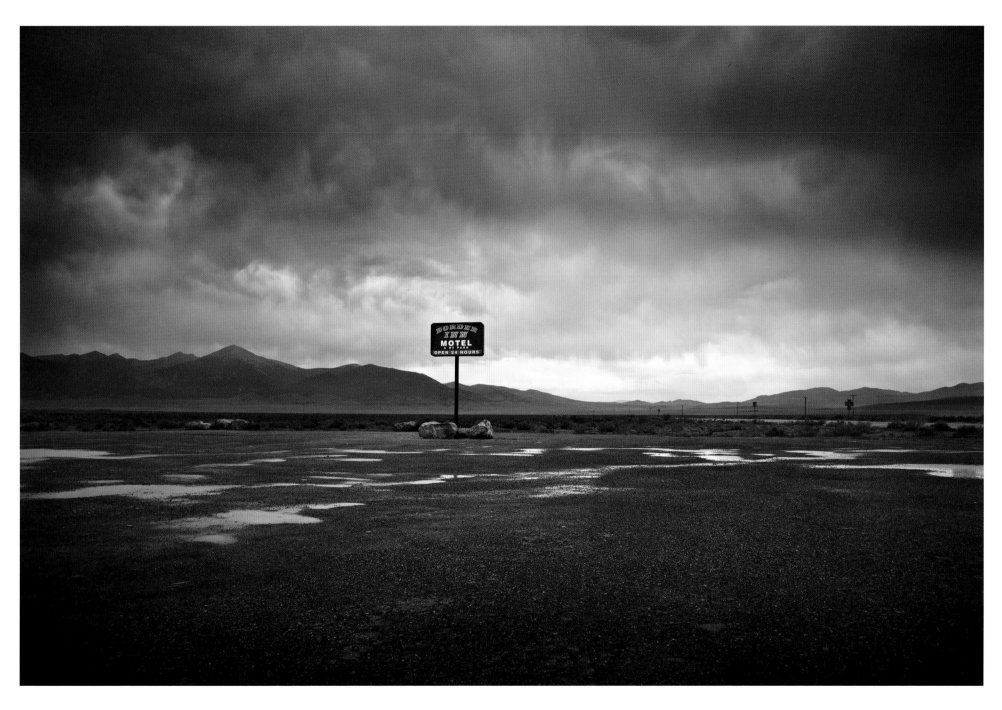

Border Inn Motel, Baker, Nevada

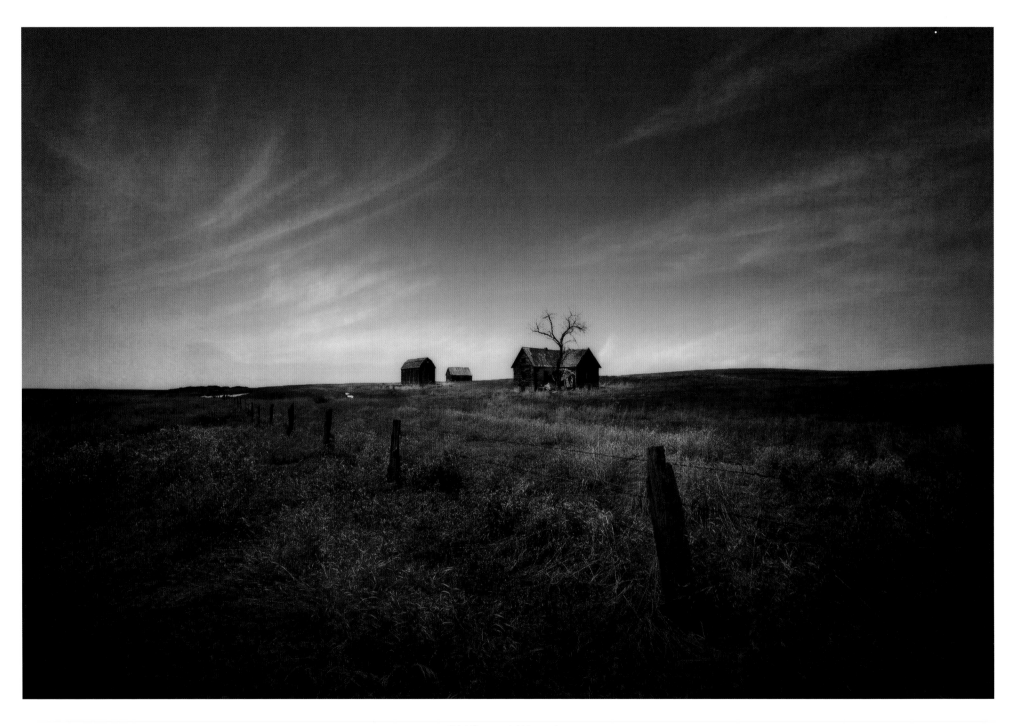

Old Spread, Wyoming

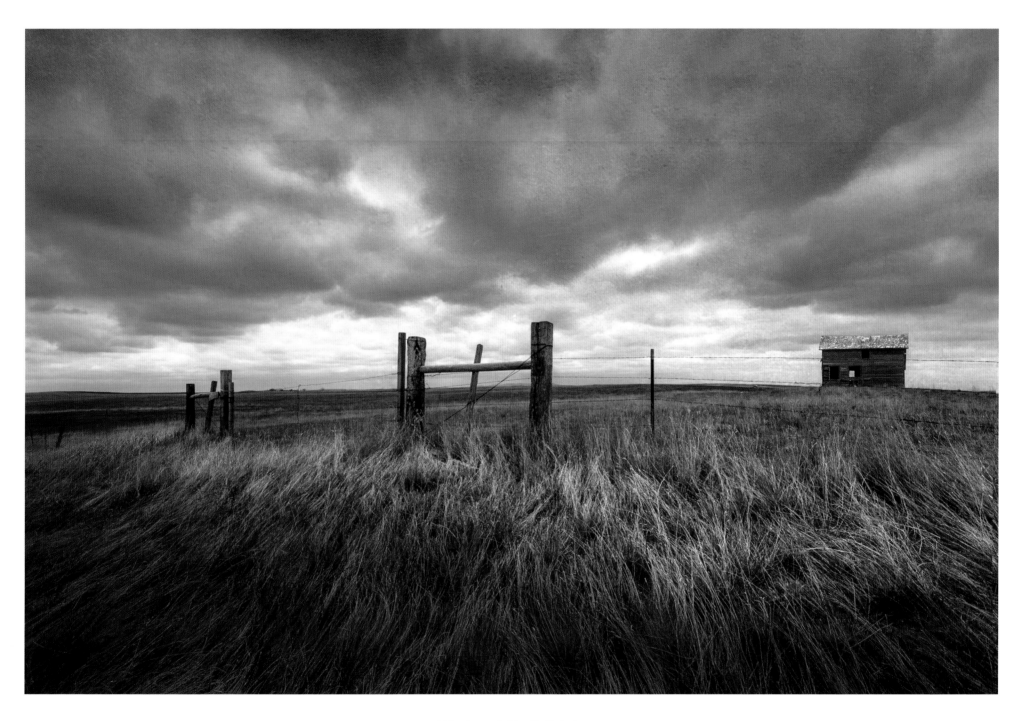

Windswept, North Dakota

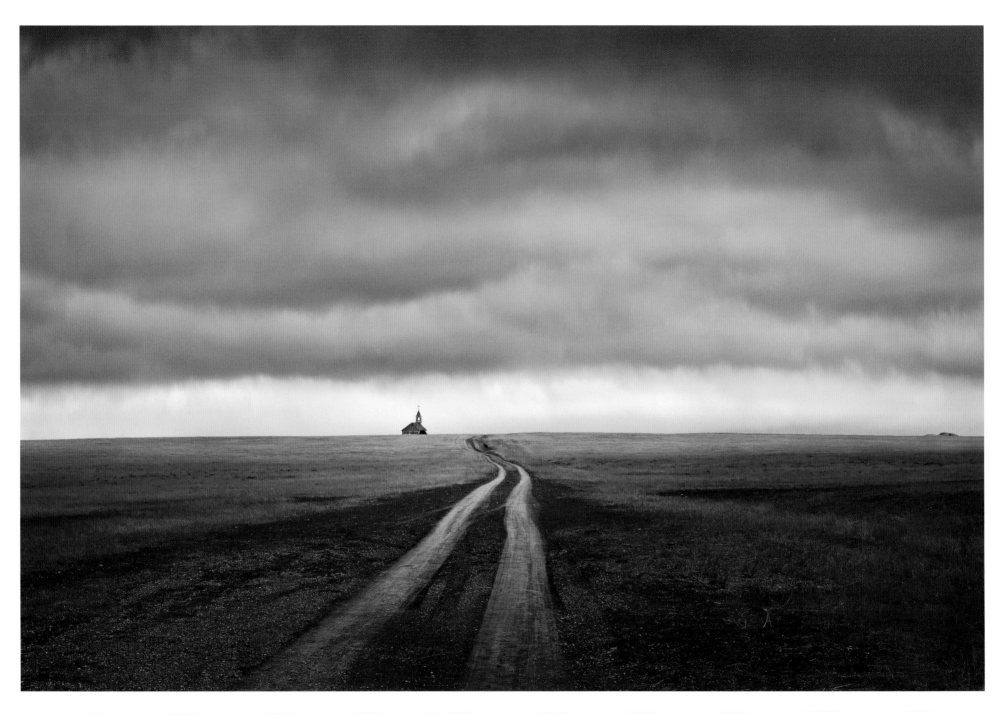

Church on the Plain, Wyoming

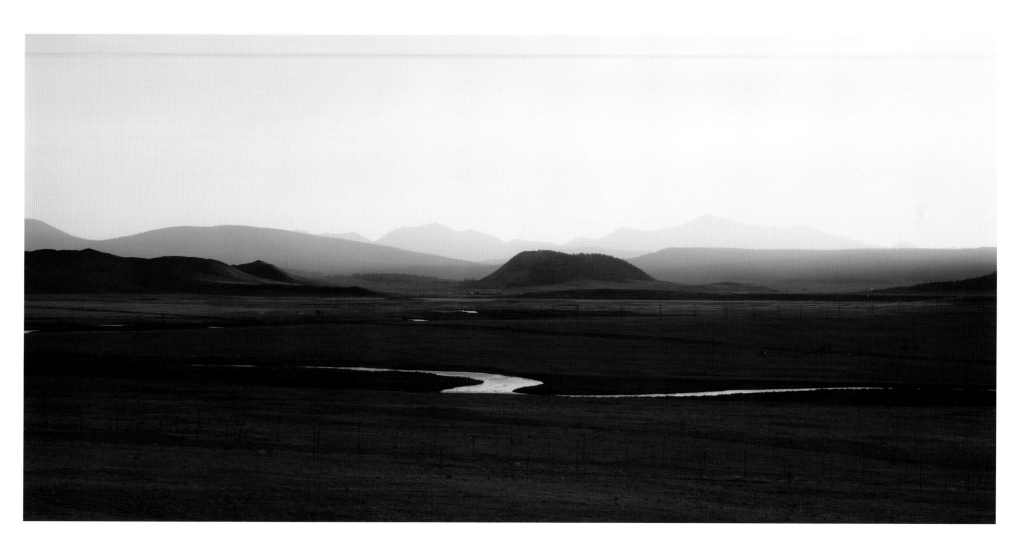

Dusk, near Fairplay, Colorado

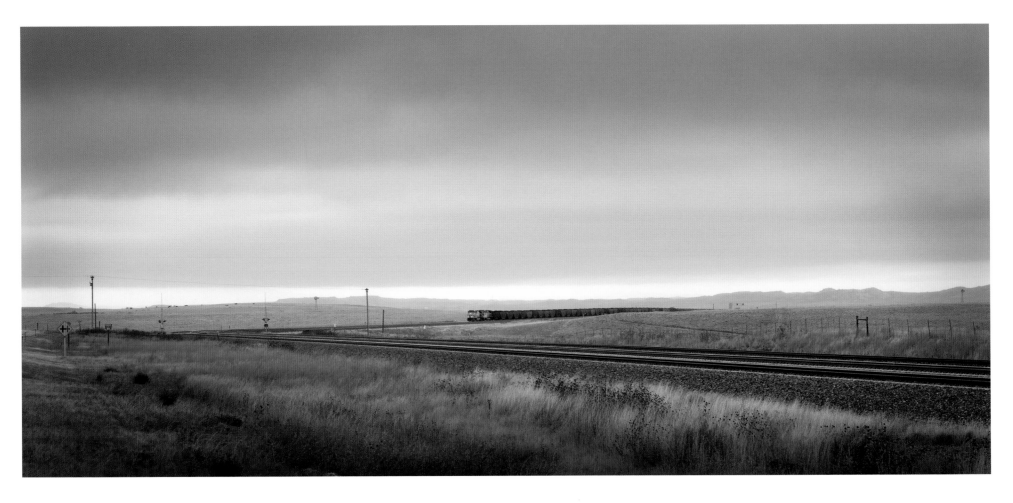

Long Train Running, near Lusk, Wyoming

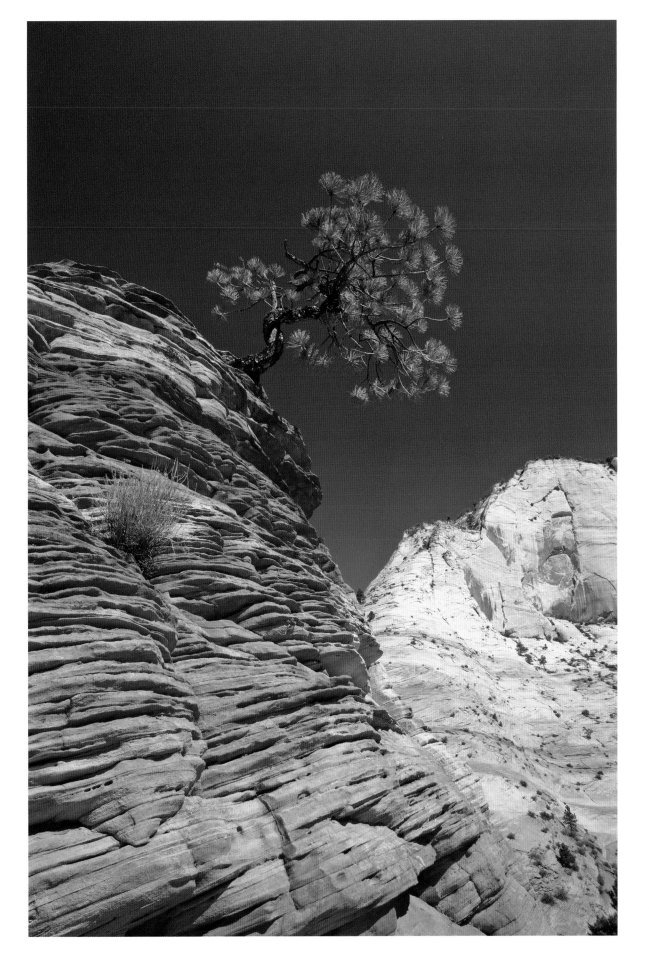

Indominable, Zion National Park, Utah

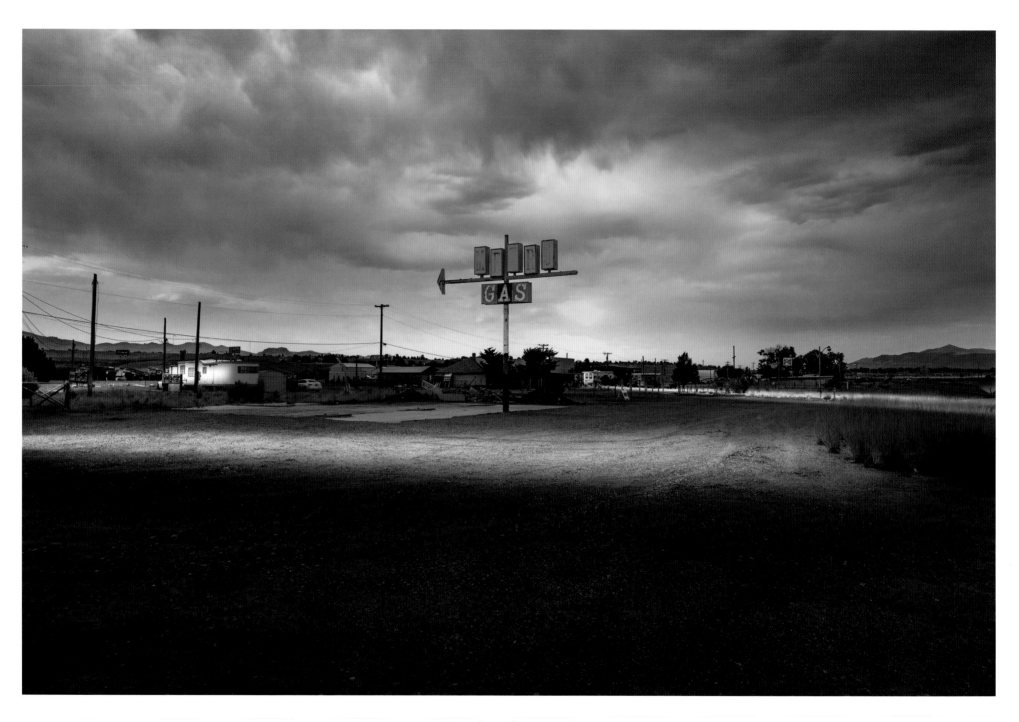

Metro Gas, Elko, Nevada

Helpmate
July 18, 2019

The air was stale and the lamplight dim where she waited. Bits of dreams tormented her. Dreams of what she'd never have now. She had turned 15 this morning when she woke up and any pretense of being normal, becoming a woman slowly and on her own terms died with the dark. It was quiet back here. A cow someone forgot to get back in the barn before dark lowed. At some point soon, the door would open and one of the Elders would motion for her to stand, straighten the wrinkles in the white dress she'd been given, and come into the gathering. The gathering, where all 72 members of The Creed would be primed for the ceremony. Helpmate Crossing, the ritual that signified that a teenage girl was now ready to leave behind childish play and selfish dreaming to provide comfort and children for the Elders. The Elders bore the arduous responsibility for the welfare and protection of the Creed squarely on their shoulders and it was only right that they be given any relief that might ease their burden. It was the way and had been since Brother Canaan got his vision in 1946.

Rebecca finished washing Hannah's face and putting her hair up into the bun that would crown her head from now on. Rebecca was the wife of the Overseer, and, as such, steered questioning little girls back to the center until they reached Crossing and it was too late.

Rebecca stood back, clasped her hands across her apron, and admired her work. Voices on the other side of the wall muffled through the first part of the ceremony. A dog yelped in the night like it had been whipped. "There, Hannah, look at you. So beautiful. We are so blessed to have you.

I know you're nervous, Honey, I was too," as she patted Hannah's hand. "But this is your big day! You're going to be so good." She sighed. "Well, this silly old bladder of mine! I'll be right back."

Hannah was not encouraged by Rebecca's words, not relieved at all. For the past few years, she'd been aware of what was coming, and a dread had built and built again upon itself to the point where she didn't think she could survive the ceremony. Later, when she would try to recall the events of this night, she couldn't remember even thinking about running, she just found herself racing across the room and bursting through the back door, tumbling down the two steps into the dark Nevada night. Scrambling to her feet, she sprinted with a speed she didn't know she had into the black, no idea which direction to head, where she might be safe.

She tripped and fell, got up, tripped again, pushed herself back up as she darted among the scattered refuse of the commune. Her mind was clearing and panic seized her at the realization of what she'd done. She had said no. A 15-year old girl, by declaration of The Creed a subservient being, expected to fall in line and do what she was told, had said no. She had dared defy the order of things. This could not be allowed. They would be coming for her.

She dove into the shadows behind a pile of firewood. She gulped breaths, fighting to stay quiet. The dress, intended to present her primed and ready in all her purity, now hung in shreds and threatened to trip her, catch on something, leave clues to where she was. Grabbing loose pieces

of dress and tearing them away, she peeked around the pile to see the back door of the meeting hall. She was struggling to pull herself together, to think! Think! Where could she go? The settlement was not fenced in, but it might as well be, because it was not on a highway, just county roads, and with no town anywhere near. Its isolation was its fence. Even if she weren't caught, how would she survive long enough to find her way out? Canyons and open range lay in all directions. Suddenly, men began pouring out of the back door, scanning the compound, hurrying to trucks to get flashlights, everyone shouting competing instructions to each other. She was not safe here. She must go! Now!

Holding onto the dress pieces and keeping low to stay in the shadows, she broke toward a tree, from there a pole, then a wagon. Flashlights were everywhere now. Every man in the Creed must be looking for her. Even as she knew seconds mattered, she tried to calm herself, think of her options. There were only three she could come up with. Run into the desert and risk dying out there, sneak out on the county road and try to make it to town 45 miles away, or turn herself in and hope for the best. She'd come too far to even think about that last one. She'd rather die trying to get free.

Voices grew louder and she took off again. Up ahead was the old wooden schoolhouse where she'd spent so many happy days with the other innocents. It had been built to rest on short posts. Flash floods were rare, but could be devastating when they came. They'd spent many recesses playing hide and seek underneath. If she could make it to the door on the other side, maybe she could find a closet or a corner or something inside where she could hide for awhile until the search party passed by. A beam of light swept across the schoolhouse wall toward her and she dove behind a bush just in time. The second it passed, she was up again and tearing around the corner, up the steps and through the back door.

She carefully closed the door, then fell exhausted to the floor. Several seconds later, of sucking in head-clearing air, she got to her hands and knees, crawled to the teacher's desk and shoved the dress tatters into a drawer. Then it came to her - the long lunch table they kept folded and leaning against the wall in the cloakroom! She half-crawled, half scrabbled to find it in its usual corner, dark and as good a place as she was likely to find. She squeezed herself behind the table as far as she could and reached back to grab the rest of her dress, tucking it behind her.

Her heartbeat and breath began to slow. She could think now of how she came to this moment, the snap decision to run. it was the Bible. Actually, part of the Bible. The New Testament part of the Bible. She'd grown up almost entirely unaware of it. Oh, the Creed used the Bible, all right. In fact, a few passages from the Old Testament were quoted and tacked up on walls and recited as justification for all sorts of things, over and over again. Things like punishment, and obedience, and an angry God, and men having authority, and, yes, having many women. Creed women weren't allowed to read the Bible. It was read to them. By the Elders. But, Hannah had found a copy of the Scriptures one Monday when it was her turn to sweep out the Meeting House after Sunday services. It had been left behind on a shelf under the podium. This was one time when she was glad for the full dresses with their deep pockets that all women of the Creed wore.

When she could sneak off and read, she began to see the Jesus that Luke and Mark and Paul talked about, the One who loved everyone the same - women and men, that didn't seem particularly angry. In fact, He was all about love. He loved so much, it hurt Him in the worst way. And all you had to do was be sorry for bad things you did and He put his arms around you and made you feel great. And loved you just like you were. This didn't sound like a God that wanted her or her sisters to be Helpmates. Sounded like He wanted girls to be a lot more than that, wanted them to do important things, just like men. She'd been stewing on this for a lot of months and here she was, choosing to believe it.

And then there was her mother. They'd never once talked about it, but she didn't have to hear her mother say it aloud to know what was bothering her. As this day had approached, her mother had turned into herself, grown thinner, looked deeper into Hannah's eyes and away from her father's. Maybe she was reliving her own ceremo— the door opened! A beam darted around the walls and ceiling like heat lightening over the canyon. A man's steps, going away at first, then turning back toward the cloakroom.

"Hannah? Are you in here?" Her father's voice stunned her. Of all people.... What a relief it would be to run into his arms but who was he tonight? Father or Elder? She pressed tighter into the shadows. "Hannah, are you here? Hannah?" Several long seconds with no sound passed and then the flashlight clicked off as Hiram turned to leave.

"Daddy!" She took her chances. "Daddy, I'm here", and she crawled out, stood and faced him.

"Oh, Hannah, daughter! What are you doing? What's happened to you? You have to stop this! You have to come back. This can't be, you know that!"

She had her answer. She grabbed his arms and pleaded, "what can't be, Daddy, is you doing this to me. Your own daughter."

That caught him up short for a moment, but then, "We're only following the Scriptures, Hannah." He reached for her. "Now, come on, I'm taking you back!"

"No, you're not, Hiram, you're not taking her anywhere!" Out of the dark, her mother's voice. When had she come in? Even in the black, Hannah could make out her father's rifle in her mother's grip. "No, Hiram, this ends right now, at least for our family. Hannah's doing what I didn't have the guts to do 20 years ago. No, I put up with it. Three years of it before they picked me to marry you. Passed around like a bottle of whiskey, everybody taking a little and passing it on. No, not for my Hannah. Hiram, I've learned to love you and I'm sticking with you, but you're going to have to be a real man right now, and here's what that means. You're going to go back to our house, take all the money out of that box you don't think I know about, get your truck and drive back over here with the lights off. If you bring anybody else with you, I'm going to shoot them and then shoot myself, and that blood'll be on your hands. Hiram, do you understand?" Three futures hung in the balance for long seconds as the battle for Hiram's soul raged within him. Then, without a word, he left and the night swallowed him up.

In the sudden quiet, standing in the cloakroom, Hannah became aware again of voices, some distant and some not so distant. She could hear more frustration and anger now, more urgency as men came to grips with what could happen to their world if they didn't find her. "Momma, do you think he'll come back?"

"Oh, yes, he'll come back," Rose said. "Your father is a good man, Hannah, down deep. He just doesn't always make the right decision. He's pulled this way and that and he gets confused and sometimes just has to be told what to do."

"Oh, momma, I don't want you to be hurt, I just wish..."

"Don't you worry about me, child. Don't you know that you're doing this for me, too?"

Hannah took her hand. "Momma, there's a Bible under my bed. Read the New Testament."

The door in the classroom opened again and someone stepped in. But they had heard no truck. This was not Hiram. Too late to hide, they froze where they were. A shaft of light caromed dimly around the next room. They heard a metallic slap as the searcher jolted the fading batteries back to life for a little longer. If he came through that passageway, it was over. For both of them. And that's where the light now pointed as he closed the gap.

"Amos, you in there?" A voice from outside.

"Yeah! Almost finished."

"Don't worry about that! I saw Hiram come out of there earlier. They want us all over at the corn fields. They think she's in there, so, c'mon, let's go!"

The light flicked off, the door closed, and it was quiet again. The wind was picking up outside and rattled a loose window behind them. Fall was winding down and winters could be mean out here. Two more agonizing minutes stretched out. They were afraid to speak. It could be a trap. Amos could still be in the classroom. Then, there it was, that precious sound. Hiram had always babied his truck and Hannah could barely hear it idling in the shadows. He put it in park and eased up the stairs and into the schoolhouse. Rose could see no one else in the truck. She hadn't expected there to be.

Hiram looked stricken, Rose defiant, and Hannah terrified but ready as the family, this little family faced each other on the precipice of an unscripted future that threatened as well as promised.

"Here's the money, Hannah. There's enough there to keep you going for a few months, if you're careful." A pause. "Look, Hannah, I...I never wanted anything to hurt you. I love you, I do. It's just that...we've always done it this -

Hannah's palm flew up to stop him. "Daddy, that's enough. Just...just don't say it. It's over now. If you want something to do, pray that God keeps me safe long enough to get out of here, and then you won't have to live with it." Hannah was growing up on the spot.

Time was short now as Rose took a firm grip on Hannah's shoulders. "Loop back to the right until you find the drive. Take it to the county road and turn left. Don't hit your brakes, don't turn on your headlights, and go slow until you make it around that first turn there - you know where it is. That road dead ends in about 15 miles. Turn right there and you're on US 50. Don't go left towards town - they'll look there. Don't stop, don't slow down for anybody 'til you get to Utah That's about 2 hours away. You got all that?"

Tears welled up as the moment waited just seconds away. "Yes, ma'am." Nothing she'd ever done, or learned, or watched, or read could have prepared her for the next 10 minutes of her life, the next hour, the next day. Her future swirled in the air like a kite that's snapped its string. Her mother pulled her tight to her breast, and Hannah held on for the last time. Rose said, "Don't look back", and nudged her toward the door. Her father couldn't look her in the eye, already limited to just memories of his oldest daughter.

The night was cooling, the voices more distant as she put the truck in gear, took one last, blurry look at Rose, then eased it around toward the county road. She forced herself to keep it slow, picking up a little speed when she hit the pavement. After a minute that seemed like ten, she rounded the first turn and turned on the lights. She was gone.

Rose handed the rifle to her husband, and, without a word, walked down the steps and toward home.

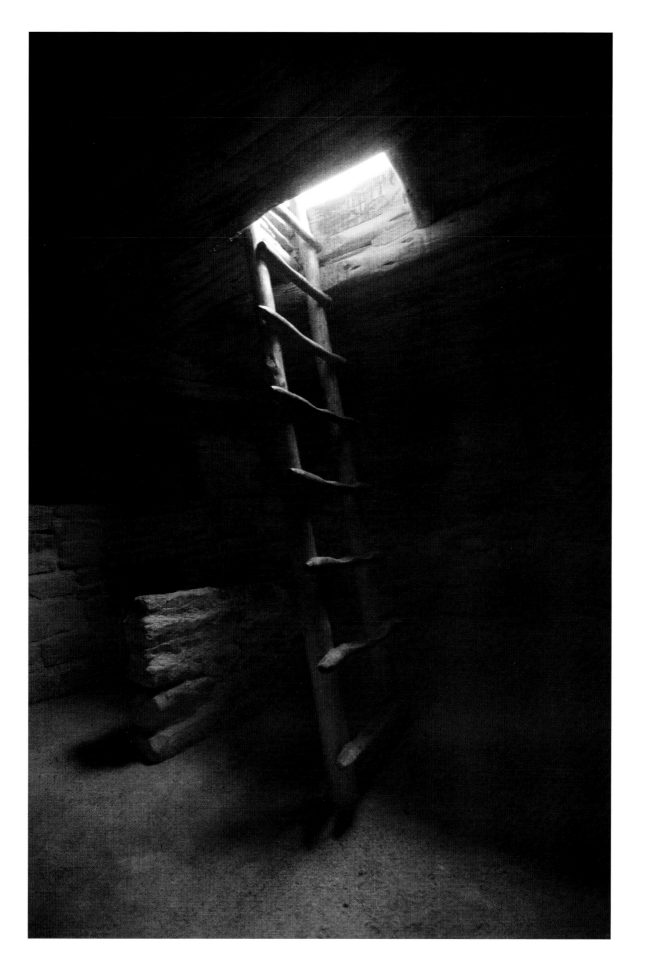

Mesa Verde Living Room, Colorado

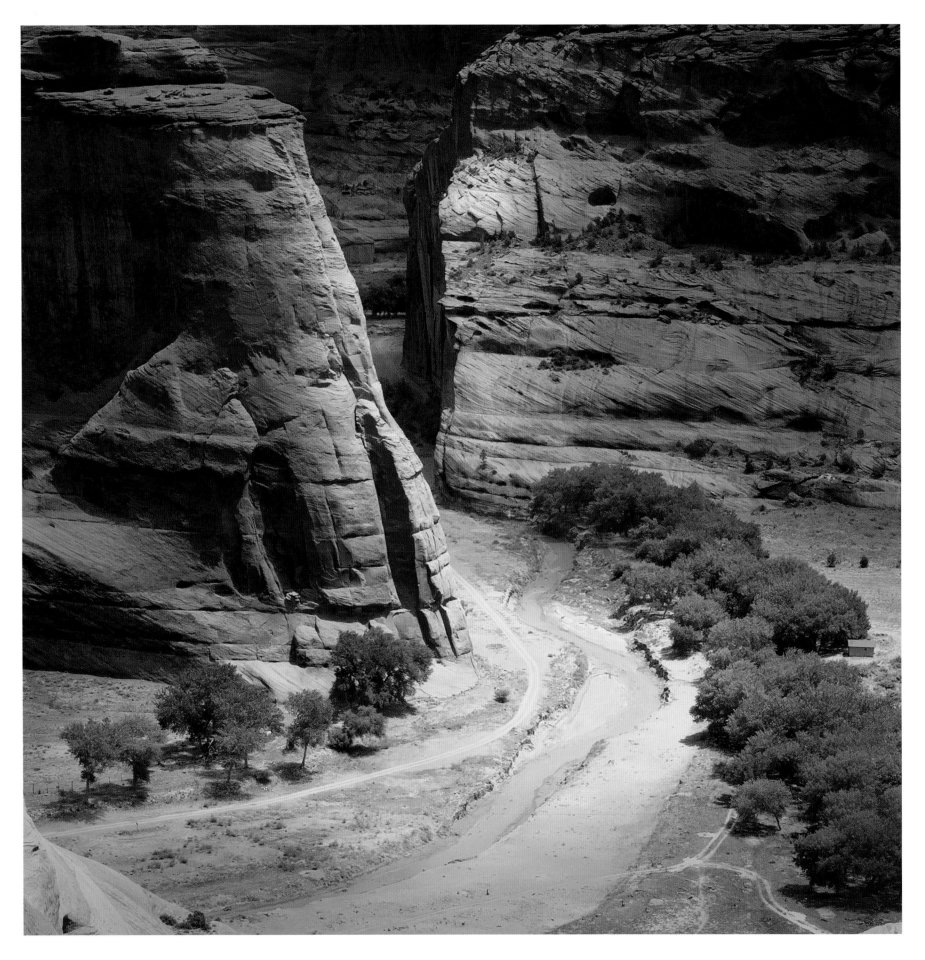

Canyon de Chelly Valley, Arizona

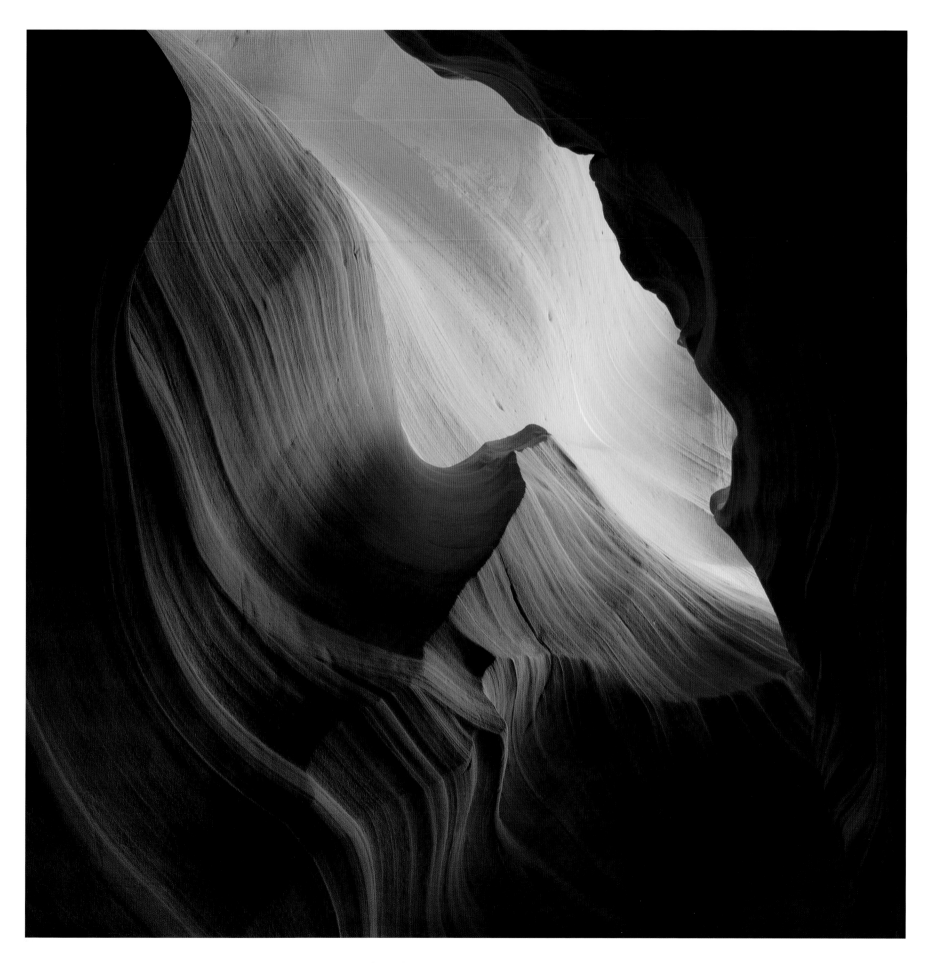

Antelope Canyon Wave, near Page, Arizona

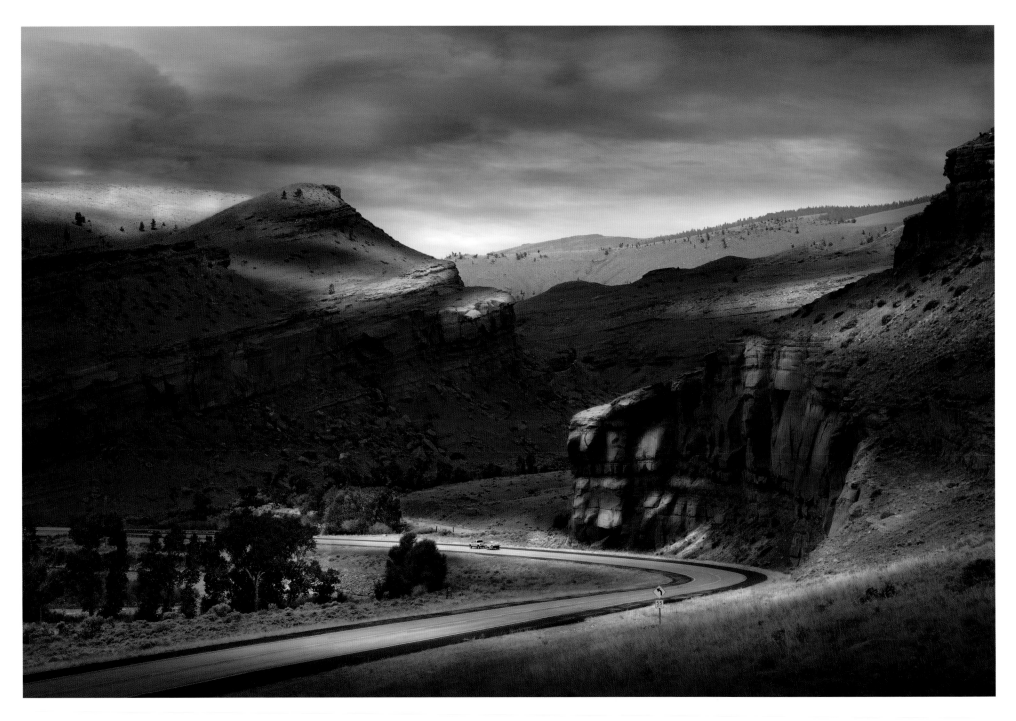

Curve, east of Dubois, Wyoming

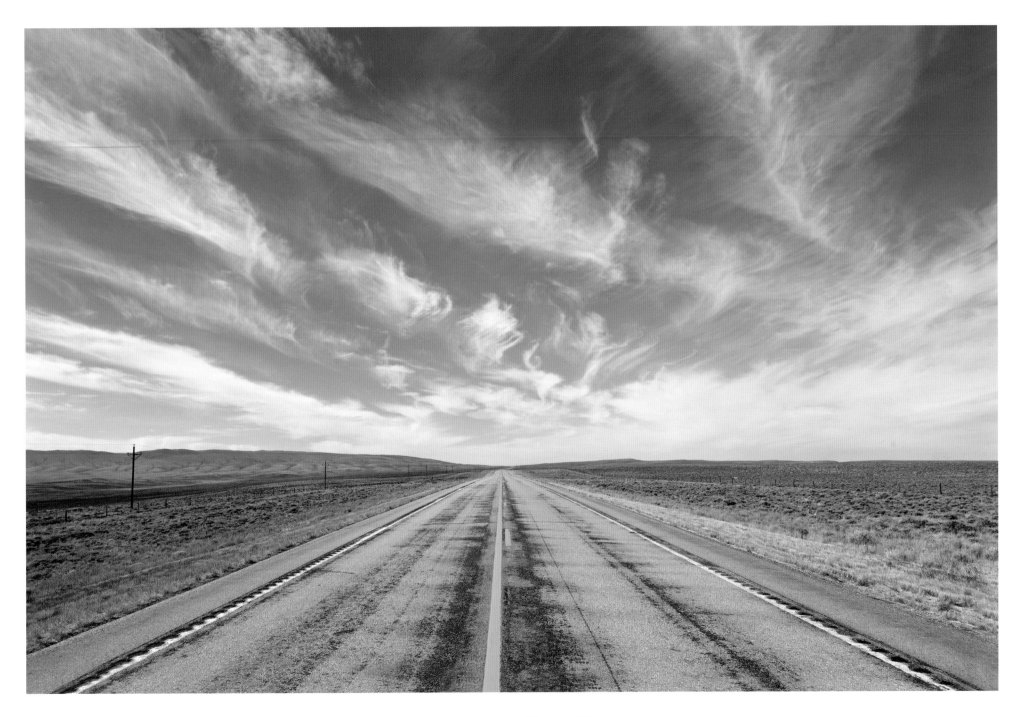

The Open Road, near Wolcot, Colorado

View, Dinosaur National Monument, Utah

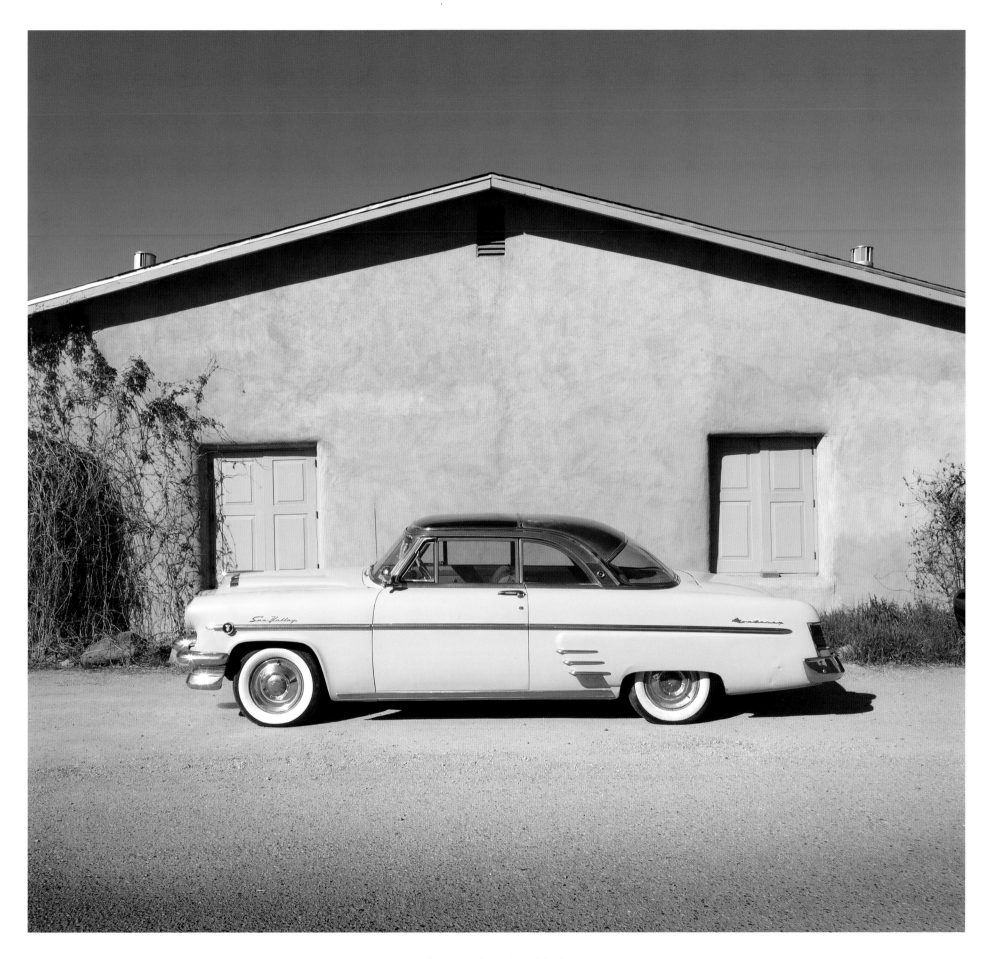

50's Merc, Taos, New Mexico

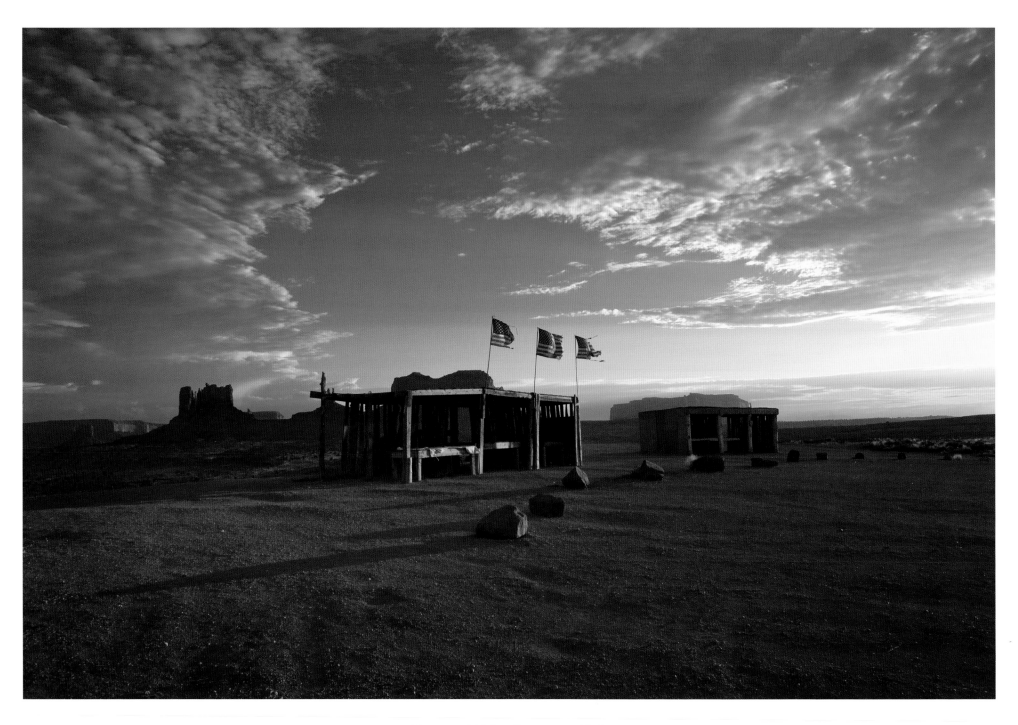

Monument Valley Commerce, Utah

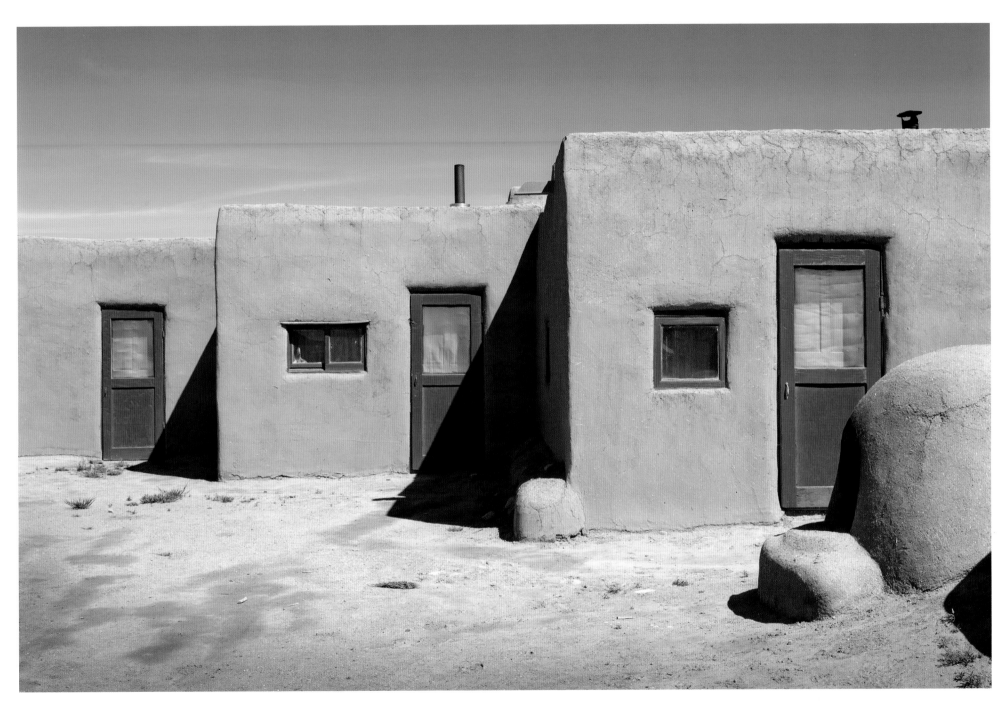

Three Doors, Taos Pueblo, New Mexico

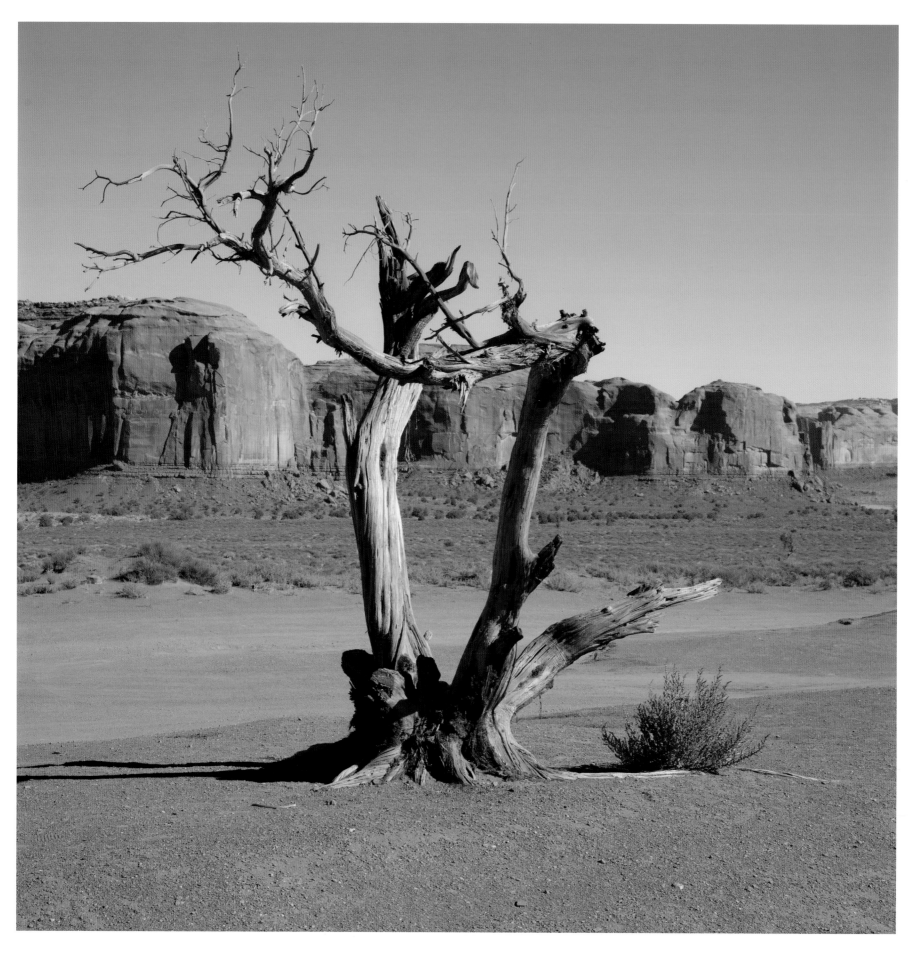

Juniper Skeleton, Monument Valley, Arizona

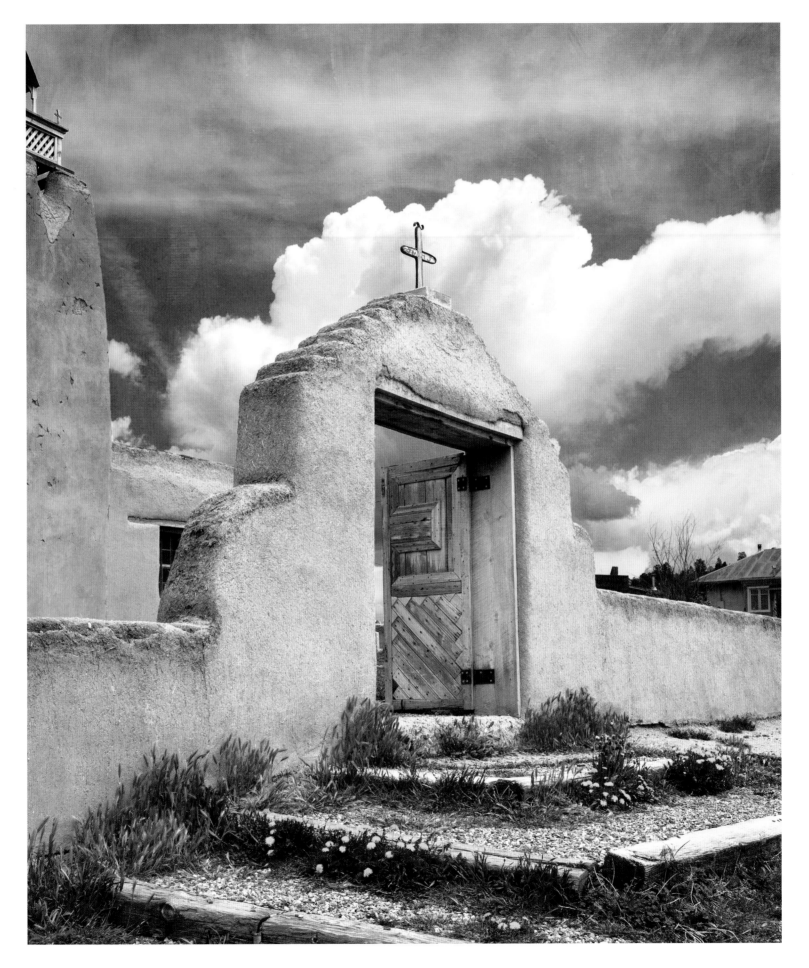

Church of Santo Tomas Del Rio de Las Trampas, New Mexico

Island In The Sand, near Hinkley, Utah

Cowboy Homage, near Marmarth, North Dakota

Road Through the Badlands, South Dakota

Big Sky Worship, near Chelsea, Montana

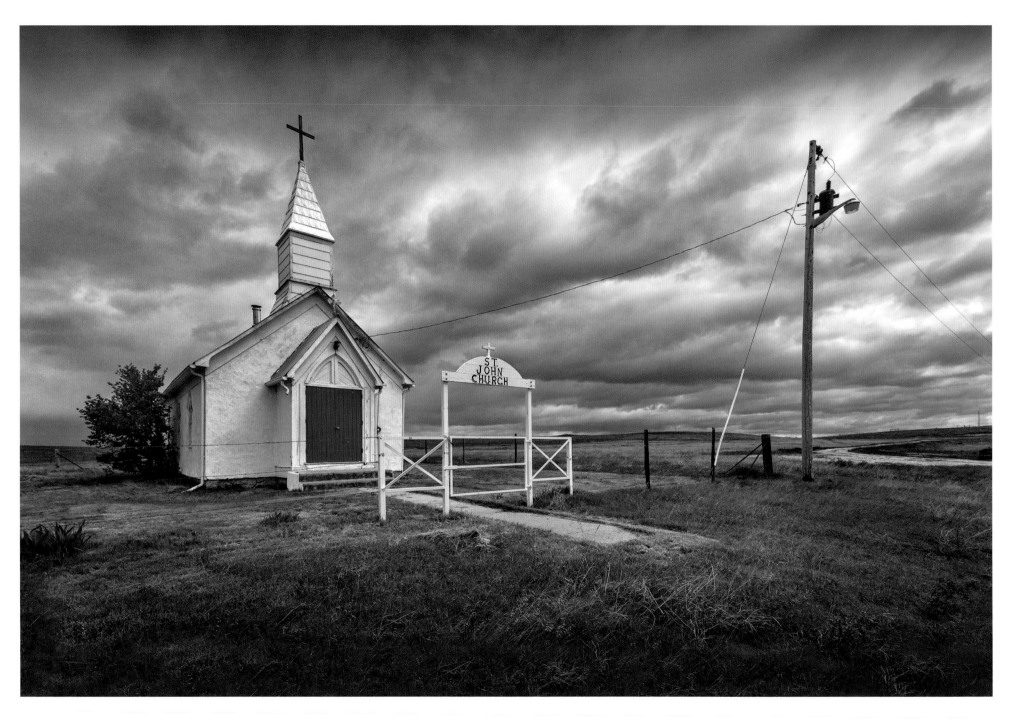

St. John's on the Reservation, North Dakota

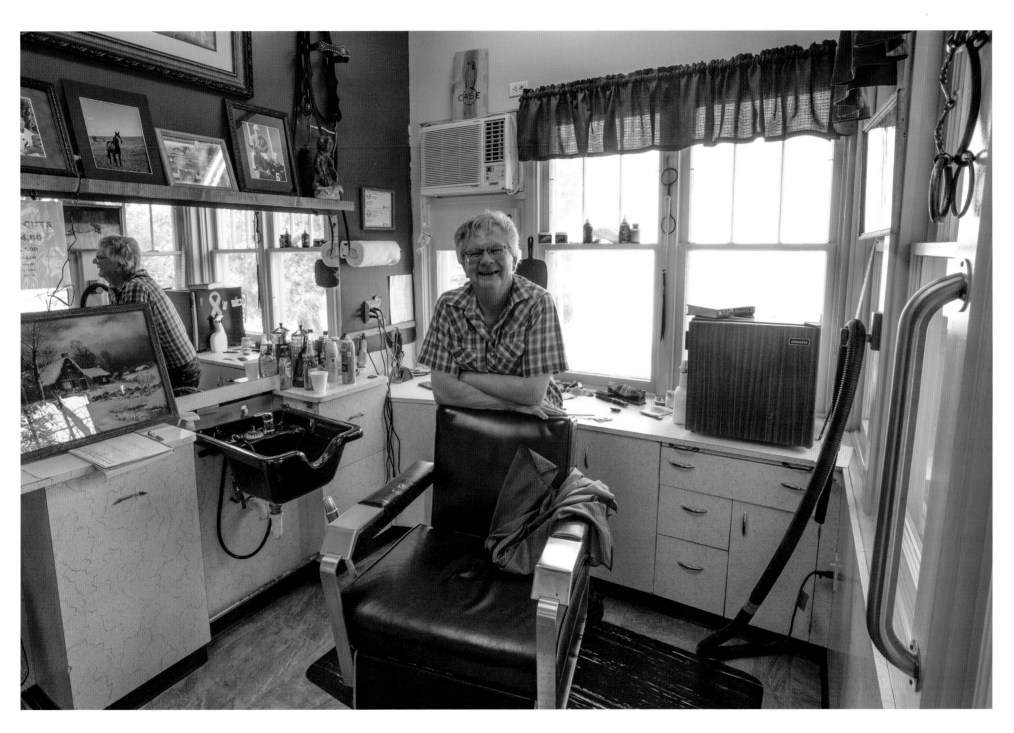

Jerry's One Chair Barbershop, Malta, Montana

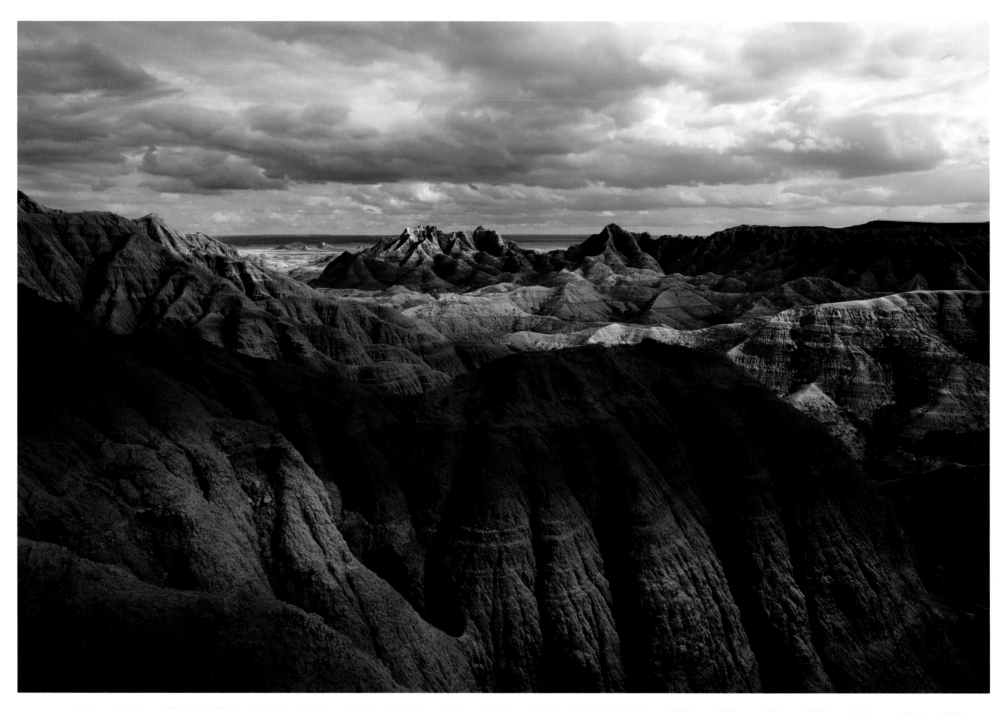

Badlands National Park, South Dakota

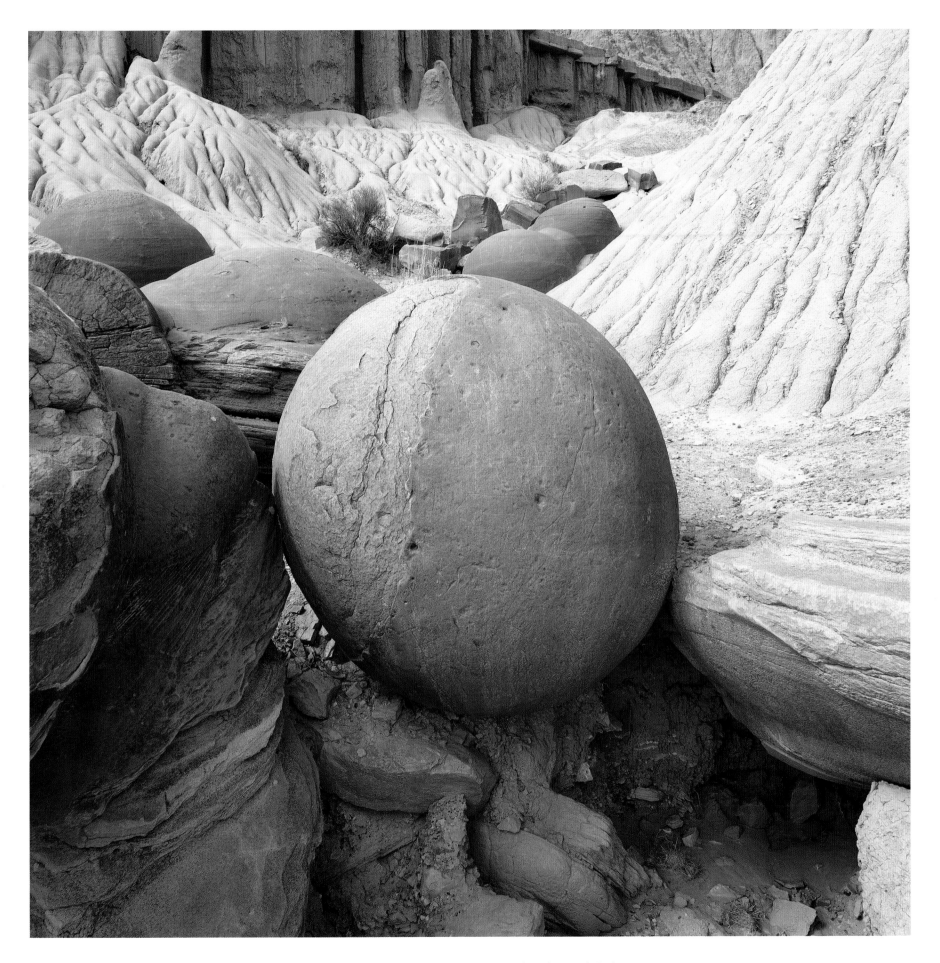

Millennia, Theodore Roosevelt National Park, North Dakota

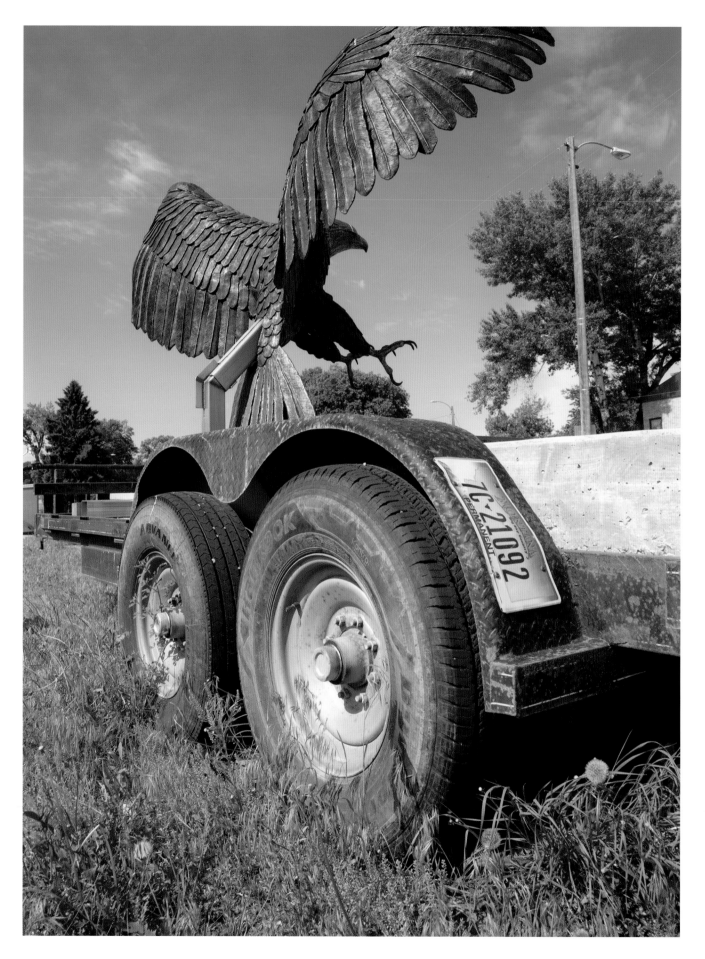

Eagle to Go, Fort Benton, Montana

Missing Link, near Plummer, Idaho

THE LAKE

October 31, 2019
edited February 2, 2020

He told the agent he wanted something isolated and right on a lake. He was lucky, and he knew it, that they had a place just like that available, since he had no reservations. He didn't give a rip about the cost. Yes, he said, he understood the map he was given.

"Here's the key, Mr. Owens. Don't hesitate to call us if you need anything at all. Our number's on the back. We'll see you back here next Saturday."

"Will do, Nick, thanks."

25 minutes later, he pulled up in front of the cabin, parked under hemlocks 100 feet high. He could see the lake from the car. Tied up at the dock was the small fishing boat and motor that came along with the rental. Given the suddenness of the whole thing, this was turning out pretty good. The interior was not as exciting. It needed airing out, the bed sagged, the towels were thin as an old dish rag, and a couple of broken windows were taped over with plastic. But it did have a scattering of fishing rods and lures leaning up in a corner. Kevin dropped his small bag on the bed and the groceries on the table, grabbed a rod and headed to the lake. The motor cranked on the fifth pull and off he went. With no wind, the surface was like glass. October leaves mirrored themselves at the far shore. The lake was not large and he covered it in short order. He noticed only two other cabins, both in a cove at the opposite end of the lake, and there didn't look to be any activity at either one. So he basically had the place to himself, which was just fine with him, the way he felt.

He found an old dead tree fallen over in the water and tied off the boat. He started casting. It got quiet in a hurry and he could at last relax and catch his breath. He and Megan had finally had the big one. It had been building for a long time. The first 6 or 7 years were what everyone would hope a marriage would be, but then she started noticing little things that she hadn't before that irritated her. Small stuff that didn't seem to matter earlier. And he gave it right back. Moments of tenderness were fewer and fewer. Neither one of them were in the mood much. They'd have a few spats, then guilt or fear would grab one or the other and apologies would be made. For a while, things would be better, the loving would get fired back up, and maybe they'd solved it. But before long, something would set one of them off and here they'd go again. It had been a long time since the last good time and the tension had never been thicker. And then this morning as he was getting ready for a round of golf, the lid came off. For the first time, Megan accused him of having an affair. He lit up like a roman candle and screamed back. How could she possibly think he would do something like that! Didn't she trust him? If she wanted this to work, she wouldn't say things like that! He stormed out of the kitchen and back to the bedroom, threw a few things in a bag and came back. "I've gotta get away. I can't take this." "Where are you going?" "I don't know!" He slammed the door. She opened it back up as he reached the car, "when are you coming back?" "I don't know!" Tires squealed as he backed out of the driveway and tore down his quiet neighborhood street. He didn't want her to know where he was going. He was offended, and she didn't have the right to know. He wanted her to hurt, to worry.

For an hour, he just drove. Somewhere around then, he landed on the lake idea, and headed north toward Ely. That would put him a couple of hours from home, but remote enough to seem like a world away. It was all lakes and wildlife and pine needle covered dirt roads up there.

Something hit his line. He jerked but too late. He re-cast and slid back into his thoughts. He had stayed furious all morning. But sitting by himself now in a spot where sound was a stranger, he found it hard to hold onto his indignation. All that earlier noise and emotion and movement had made it easy to hide within it, but the purity and power of this silence stripped away his armor. Now he had to deal with what he was really feeling deep down. Guilt. His wife had nailed it. He had

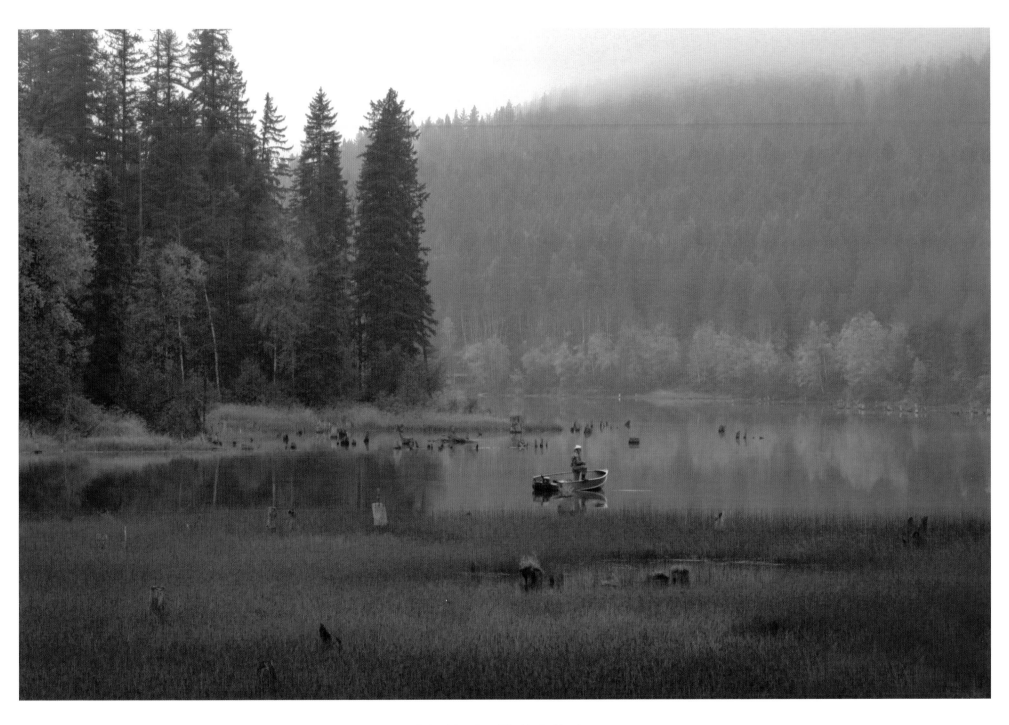

Quiet Morning, Big Fork, Montana

in fact been unfaithful. The first time was after one of their bitter fights when he found himself sitting at a bar. The woman talked to him like he was somebody special, like he was attractive and appealing and a real man, assurances he hadn't heard in a long time. He told himself afterwards that he had been taken advantage of, that he was vulnerable and wouldn't normally do anything like that, that that wasn't the real him who'd cheated. The second and third times, his post-game pep talk to himself wasn't quite as convincing, and after that, he quit telling himself much of anything, draped in shame and guilt with no energy to figure out how to stop.

The potato chips served two purposes: crumbled, they coated the lake trout he'd bagged and pan fried up pretty nicely; taken by themselves, a less than perfect side dish, but convenient - he really was not in the mood to spend a lot of time cooking. He'd worry about greens and roughage another day. He finished the trout and the bottle of white about the same time. He barely made it to the bed. Bad as it was, after the day he'd had, it felt like heaven. He was gone in seconds.

Somewhere in the deepest part of the night, he dreamed. He was sitting at the end of a long table. Gathered around both sides were people he knew best - family and close friends. His father, brother and sister, both of his daughters, his pastor, next door neighbor, golf buddy, his boss. At the other end was Megan, dead eyes locked on his. They were all holding hands, just not his. Someone began to pull his chair back. He stood up to keep from falling and the chair was taken out of the room. Now they all looked at him, no expression on their faces. In slow, choreographed unity, they raised their fists and pointed their thumbs down. A hood dropped fast over his face and someone grabbed him from behind. He jerked awake screaming!

The next couple of days were an emotional see-saw, back and forth between self-righteousness and self-condemnation, justification and remorse, grace and guilt. He fished a lot, catching a bunch but keeping just one or two a day to feed himself. He found a trail up into the mountain he'd passed on the way in. He tried to read a paperback someone had left behind, but one of the couples in the plot hit too close to home. Too much of what happened between them mirrored his own situation. At dusk, after dinner, he sat in an old, rusted glider on the screen porch,

listening to the haunting wails of a loon calling for the night to come alive, the smell of pine trees and a late afternoon rain primordial and intense.

As time will do, the passage of it eroded his self-righteousness and certainty and forced him to think about other alternatives. When he'd stormed out of his house last Saturday, he didn't know whether he'd ever come back. Now, he wasn't nearly so sure. He woke up Wednesday morning just after dawn, pulled a pair of jeans over his pajamas, slipped a flannel shirt and his untied boots on and walked down to the shore. Tendrils of fog seemed stuck to the water, the air unstirred by even a whisper of a breeze. A dozen different kinds of birds contested frogs of every type for sound space. Light was gathering through the pines across the lake, mist and sun defining beams that split the forest.

That did it. This was a new beginning, this day, this fresh morning, and its creatures were in celebration because of what it heralded - another chance at life. And that's what he wanted, another chance. He'd go home. it'd be no fun, coming clean. Confessing all that he'd done. Would she even listen? Just then, a mother mallard and 7 chicks swam out from behind a log to his left. The shore grasses were thick and coarse and blocked his view. This interaction would be a proper send-off, he felt, something pure and good, so he stepped into the bush toward the ducks. He hoped they'd hang there until - CLANG! Searing pain surged up from his leg through his brain and back again! Down he went, grabbing for his right ankle. His screams shattered the wilderness morning. All creatures hushed and froze in place as they tried to figure out what this was. He twisted to his side and saw with horror that he had stepped into a bear trap, the old jagged tooth metal kind designed to stop and hold 700 pounds of rage and brute force. Any movement, he quickly found out, made it worse, as he tried to grab at the trap. He managed to sit half upright and got a hand on either side of the jaws. Pulling with all his might managed to do nothing but make him scream louder. He collapsed on his back, ragged breaths staccato-like. Instinctively, he knew he needed to calm down. Deep breaths, no moving, try to get his mind around what had happened and what his situation was. And then he passed out.

The sun was directly overhead when he came to. The pain was not quite as bad, or it at least felt like that, probably his body doing its job, rushing

chemicals to war in the brain and at the wound. This was definitely not the way he wanted to re-enter his wife's life, but he needed her now more than he ever had. He reached for his phone in his left front pocket. It wasn't there. With a cold, paralyzing feeling, he remembered that he hadn't taken it off the charging cord this morning. It was safe and sound, fully charged and ready for use some 50 yards away. It might as well be 50 miles. How stupid could you be! His mouth felt like it was full of dirty gym socks. Maybe he could drag himself to the edge of the lake not a dozen feet away. But when he rolled to his side, he felt the tug and he looked down and saw that the trap had a chain whose other end disappeared into the ground. Of course. It had to be bear proof. He wasn't going anywhere. ARRRGGGHHHHH!!!!! Total frustration!

Flat on his back again, he tried to take stock. Bleeding, but that could be worse. The teeth had missed the large vein that curled over his ankle. Pain like crazy. No water. No food. Can't move. No phone. Nobody around. No one knows where he is. Panic threatened to take control. He began to shiver. He could feel ants and beetles crawling all over him. His back itched like he was in a bed of poison ivy. His pulse pounded in his ears. Tears blurred his vision. He was going into shock.

He slipped in and out of consciousness the rest of the day and night. Asleep or awake, his mind was besieged by rambling thoughts and visions. Some were cogent, but most made no sense, an LSD-like voyage through fantastical worlds with outlandish, awful monsters his companions.

A grinding, mechanical roar clamored somewhere at the periphery. He blinked his eyes open. It was daytime again. And hazy. Or was it just his own private haze? What was that noise? Then it hit him. He clawed himself up on one elbow and tried to shout but not much came out. He tried to get his arm up to wave but fell back. The sound of the motor receded. The boat was gone and he was still pinned to his prison. Tears ran down his temples. It was the only other boat he'd heard since he'd been here. That was probably his best chance and he'd missed it. The irony of it all brought a wry smile to his sunburned face. Now that he'd come to his senses and knew that he wanted another chance to be the man he should have been all along for Megan, he was going to be denied that redemption. And she was never going to know how his heart had changed. He had not been a regular with God these past few years, but

he talked to Him now. "God, I'm not asking You to work a miracle here. I probably deserve this. But, please make it easy on Megan and let her find someone who'll treat her like she deserves. Please."

A peace seeped into Kevin's mind as he began the gradual acceptance of the fact that this was probably it. The bleeding couldn't go on forever. He'd last had water Tuesday night. He wasn't really hungry, but he was getting weaker all the time. He was cold, he was wet, and he hurt like hell. Unconsciousness mercifully took him again.

"Michael, did Mr. Owens ever show up today? It's almost dark."

"No, not on my watch. Didn't call either. He needs to bring us that key of pay for another week. Want me to run up there?"

"Nah, I'll do it. You go on home and enjoy the rest of the weekend. Tell Missy I said hello." Nick was glad to see Kevin's SUV still at the cabin, but his next thought was how strange that was. If he was still here, why wouldn't he have called? Was he ok? He opened the screen door and crossed to the main door to the cabin. It was slightly ajar. Pushing it further open, "Mr. Owens?" No response. He stepped into the house and called again. "Kevin?" A quick search of the cabin turned up nothing. Except one very odd thing. A cell phone was plugged into the wall. Why would Kevin go off without his phone?

Back outside he called again, "Mr. Owens? Mr. Owens? Kevin?" He made a loop around the cabin, shouting in every direction. No response. He walked down to the lake. There was the boat, so he wasn't out there on the lake. But he shouted again, just to make sure. Maybe he was on the other side of the lake. There was an old path that went all the way around the shoreline. "Kevin! Kevin Owens!"

Afloat in a no-man's land of dreams and phantasm filled with strangers and family and cacophony, Kevin seemed no more than an observer now, a submissive witness to someone else's bizarre journey toward the end of things. But now he was being screamed at and screamed for from all directions, pulling him back into the story. Slowly, the scene transposed itself from a fire-punctuated dark Hollywood setting full of grotesque creatures to a day lit view of the underside of hemlock branches.

The voices drew nearer. "Mr. Owens? Mr. Owens? Kevin?" Someone was here! He was still alive! He opened his mouth to shout, but less than a whisper came out. "Kevin! Kevin Owens!" Whoever it was hadn't heard him.

Nick stepped back off the dock and headed for his car. The situation was very odd, Kevin's SUV still here, the cabin open, his phone there, but he'd done about all he could for now. It was almost dark and there was no telling where Kevin was. He'd call it in to the sheriff and leave the next steps up to him.

Kevin had to will himself to do something. He knew he couldn't hold on much longer. He frantically scoured the ground with both hands and found a rock about the size of a golf ball. Could he make the 10 feet over the scrub and into the lake? He had to. He took one huge breath and, pushing up with his left arm, mustered all he had left to heave with his right. Pain exploded through his body and he fell back unconscious.

Nick stopped about 20 feet from the dock and turned around. Was that a splash? No sound now but a light wind soughing through the tree tops. He stepped forward in the direction of the splash.

Sometime late Sunday afternoon, Kevin woke again, this time with tubes running into both arms, his leg swaddled from the knee down, and feeling little pain. Everything was white, including what the two men on either side of his bed were wearing. He had survived. The doctors shared with him how Nick had found him and called 911. How the volunteer fire department guys had the equipment to free him from the bear trap and rush him to the Ely Regional Clinic, infusing several units on blood on the way. How eaten up he was with bites of all sorts, how he had lost 15 pounds and come close to dying from the combination of exposure, loss of blood, pain and dehydration. They told him he probably wouldn't have survived another night. It was too good to be true but it was true. "Where's my wife? Has anyone called Megan?"

A pause as each doctor looked to the other. "Well, yes, she's been contacted, but...."

"Is she here? I want to see her?" What were they not telling him? He needed to get it over with, to lay out the truth and hope she still held some feeling for him. "Where is she? Megan! Megan! Megaaaaannnnnn!!!!"

"Wake up, Kevin, wake up! You're dreaming! Wake up!" The voice belonged to Megan and she was shaking him awake. They were in bed. Their bed. In their home, their town. It had all been a dream. There'd been no climactic big fight. No storming out of the house, no flight to the woods. No bear trap. It was all just a dream. Not real. No accusation of infidelity! Relief flooded over him like an adrenaline cocktail laced with caffeine, but it disappeared just as suddenly with Megan's next words, her eyes welling with tears, "You've been talking in your sleep".

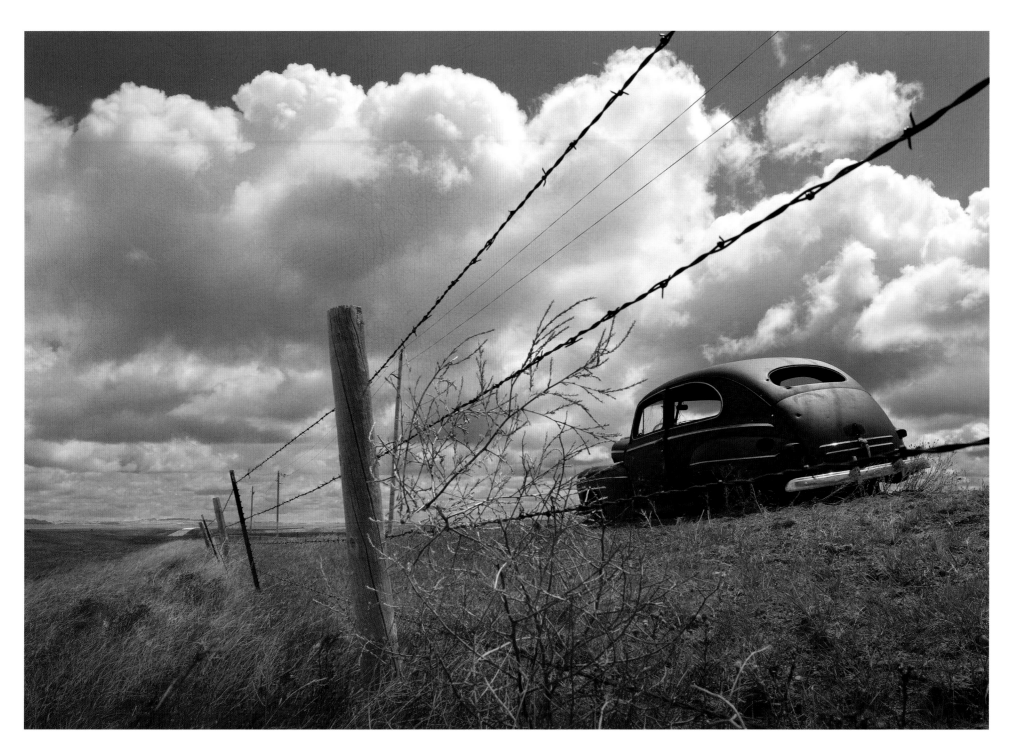

Prairie Plymouth, near Caputa, South Dakota

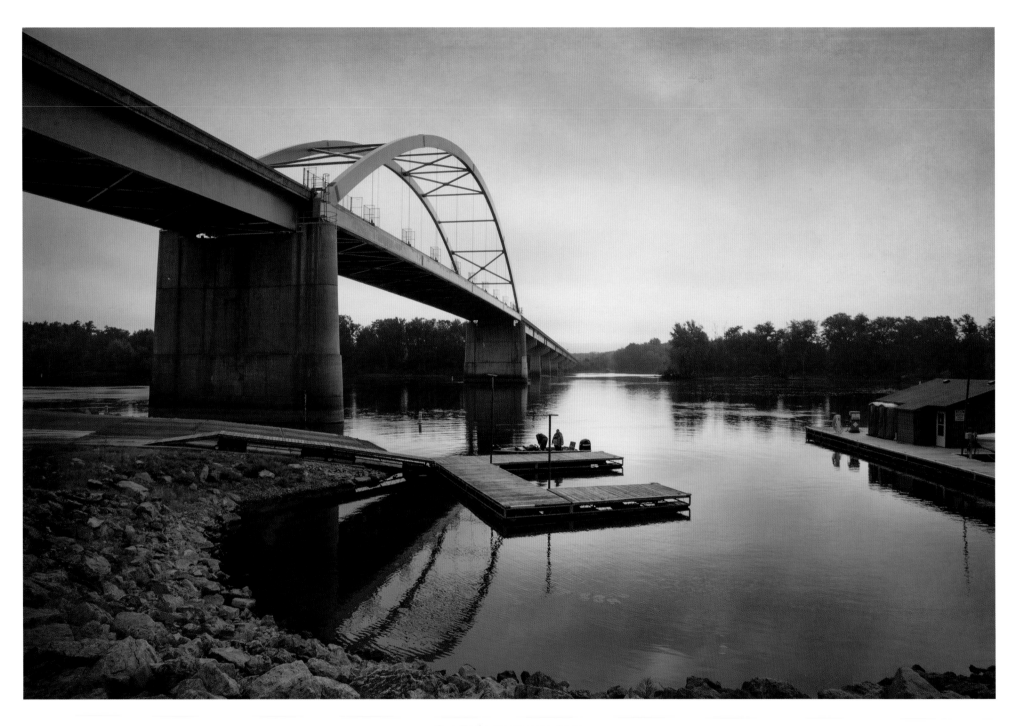

Out Early, Marquette, Iowa

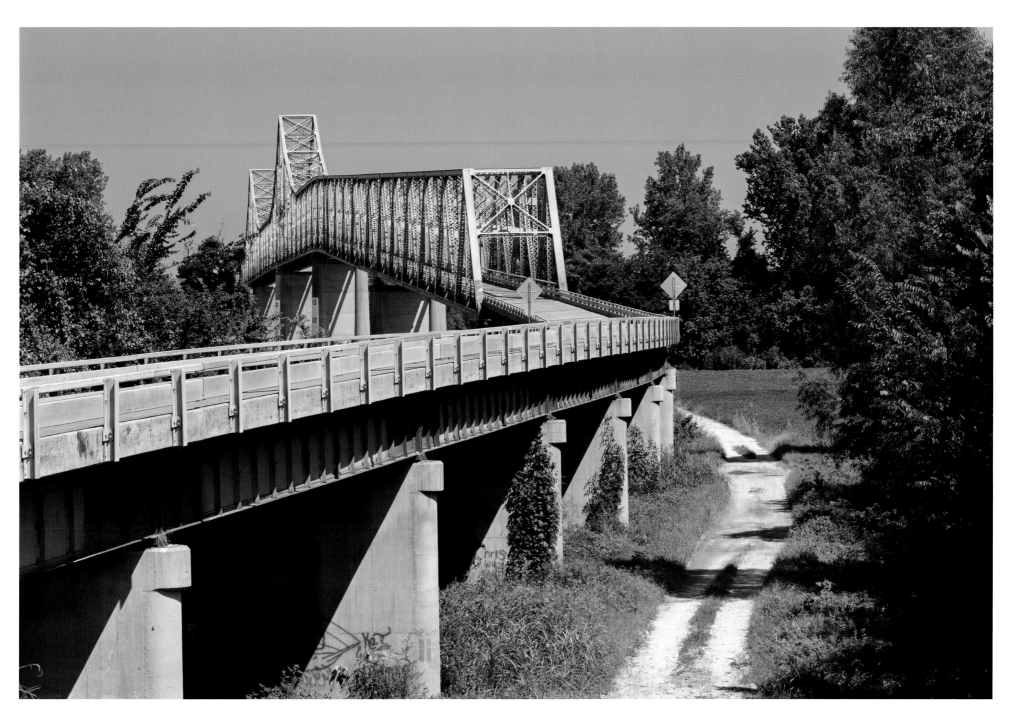

Bridge to Cairo, near Wilson, Missouri

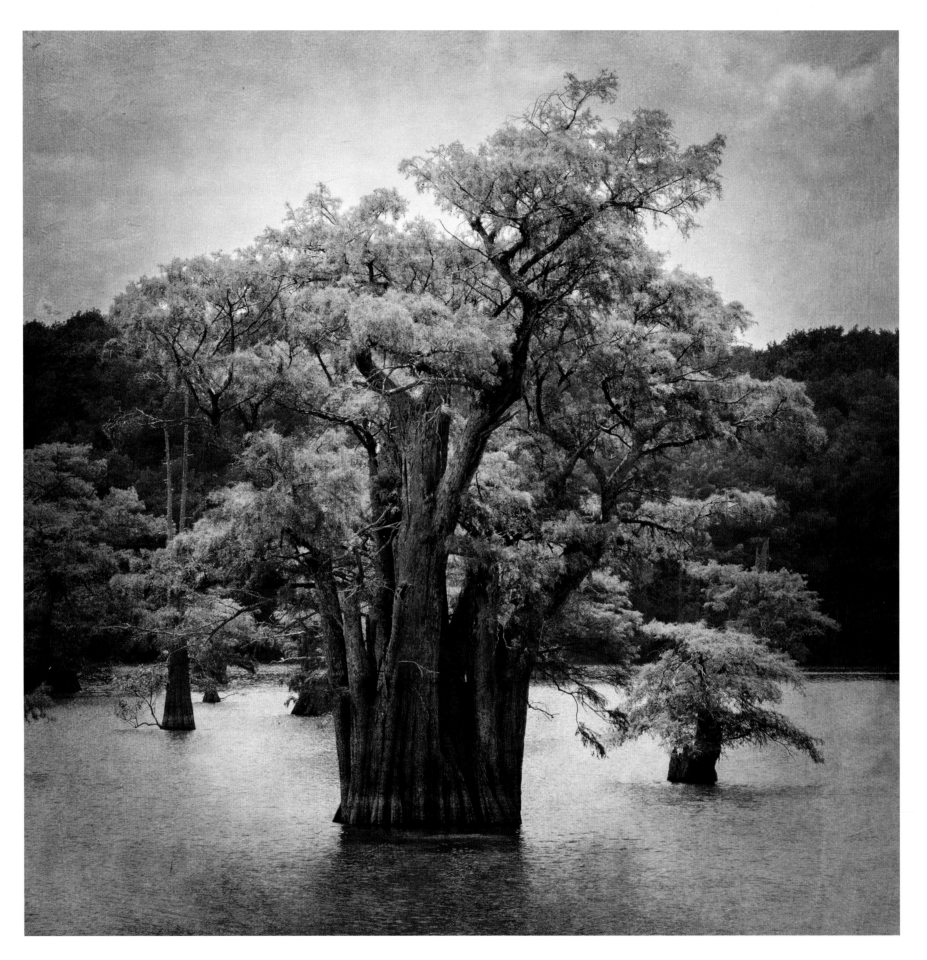

Cyprus, Horseshoe Lake, Arkansas

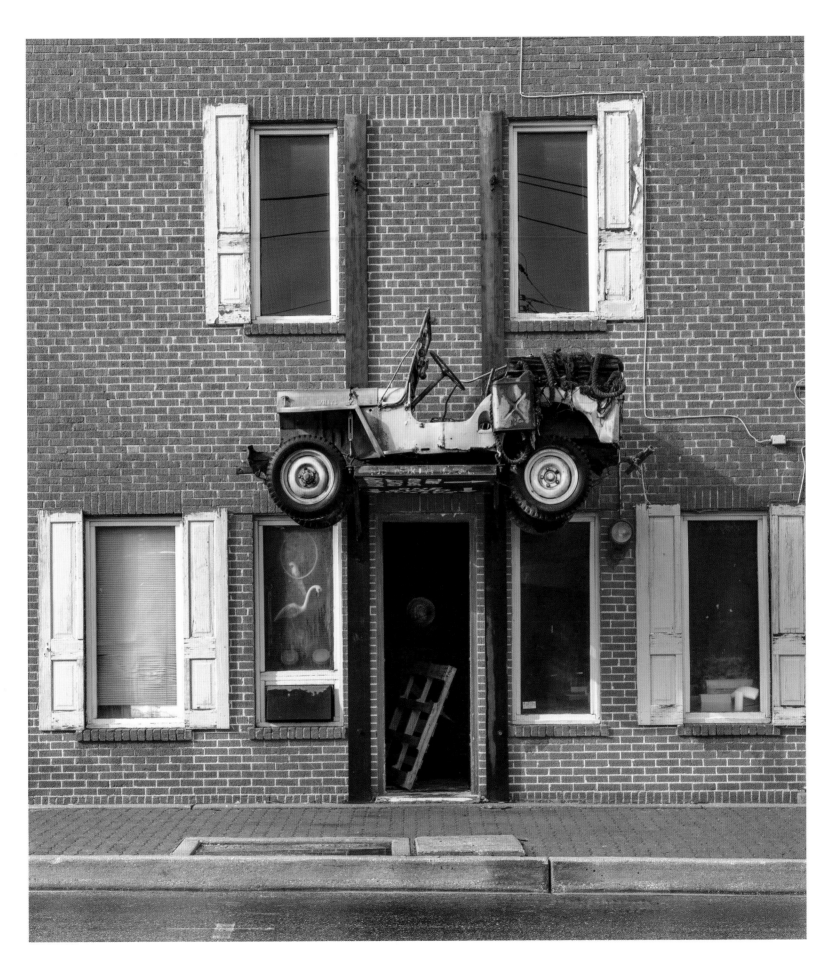

Jeep on the Wall, Mexico, Missouri

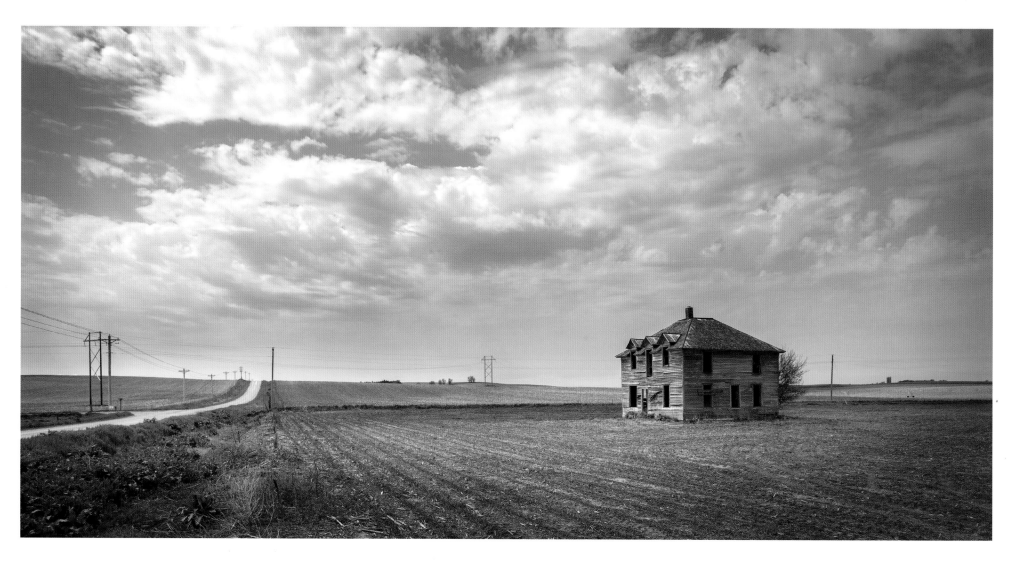

All Gone Now, Nebraska

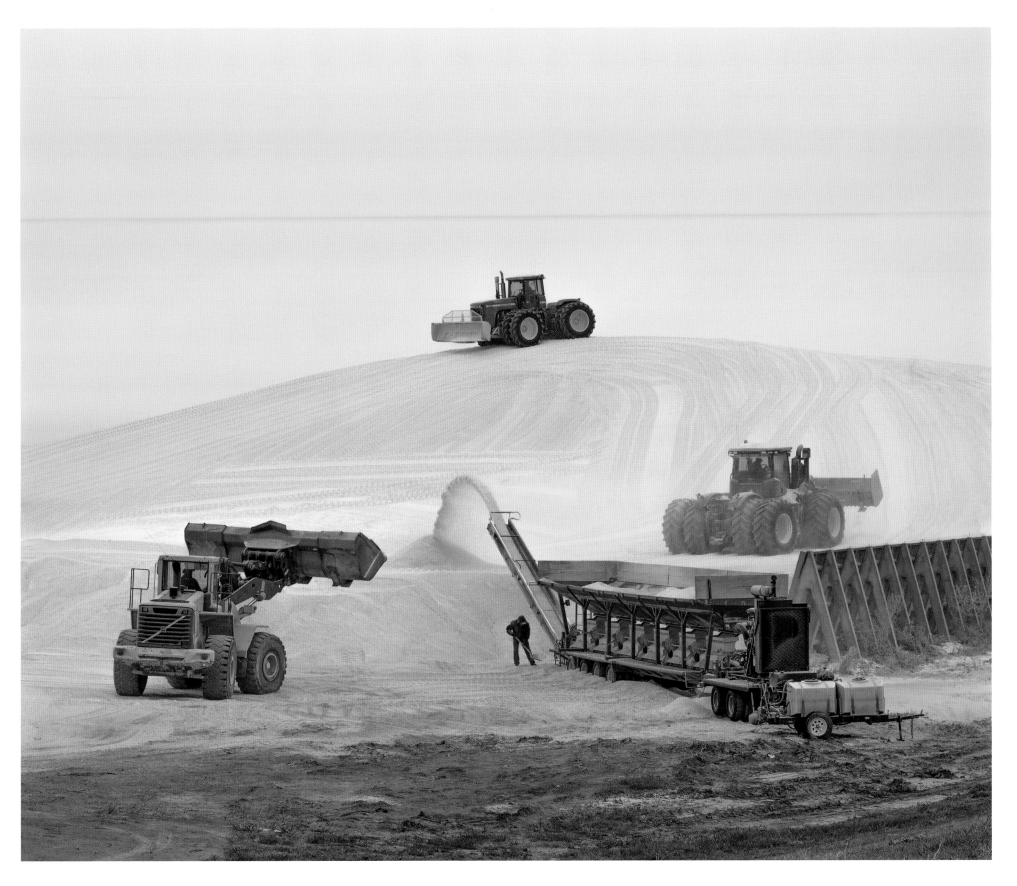

Stockyard Grain Pile, near Hayes Center, Nebraska

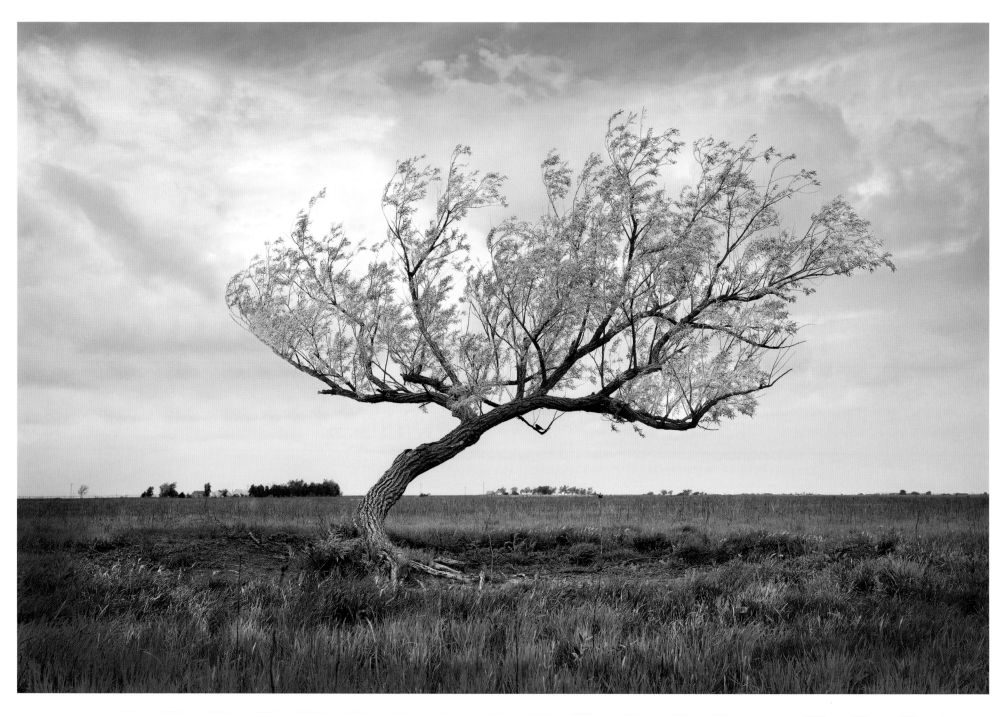

Pressed By the Wind, Kansas

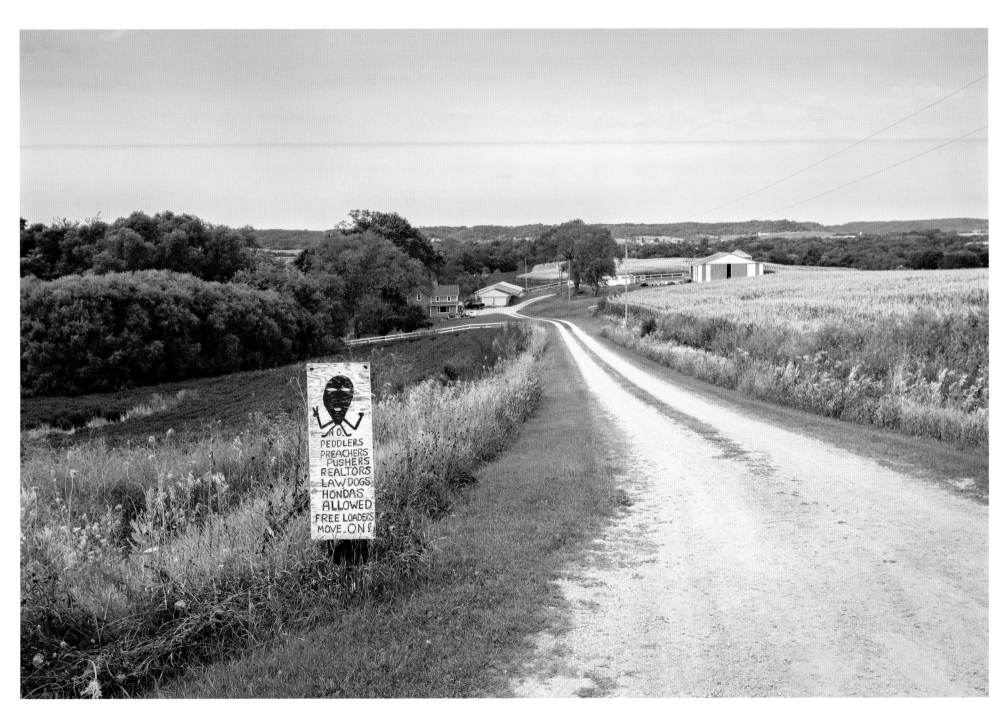

Everyone's Welcome!, near Ball Town, Iowa

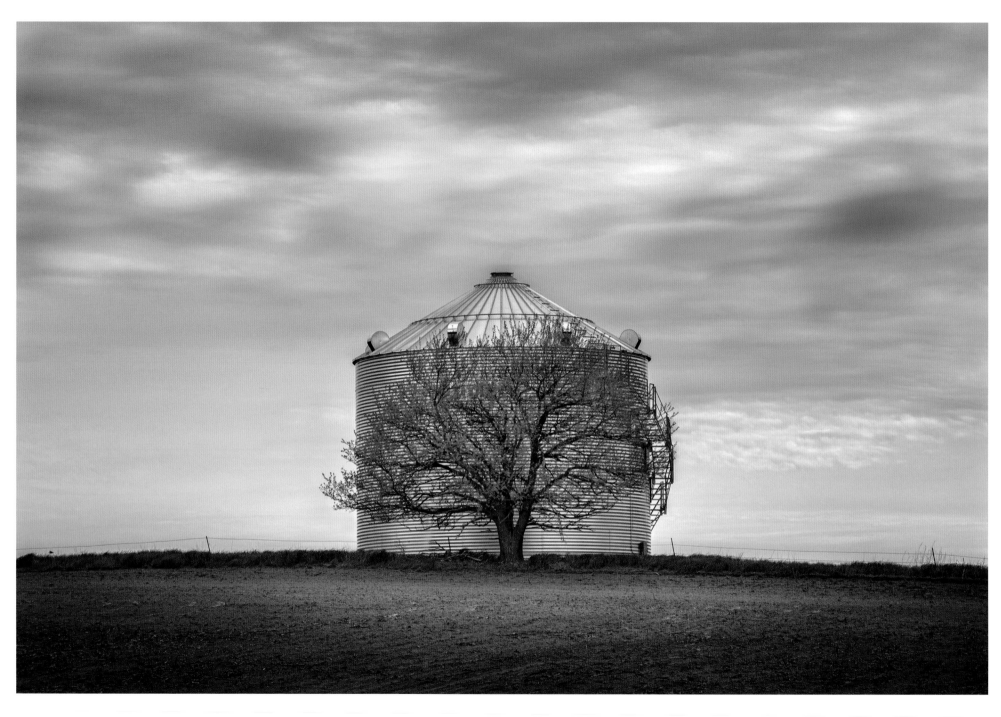

Tree Guards Silo, near Willis, Nebraska

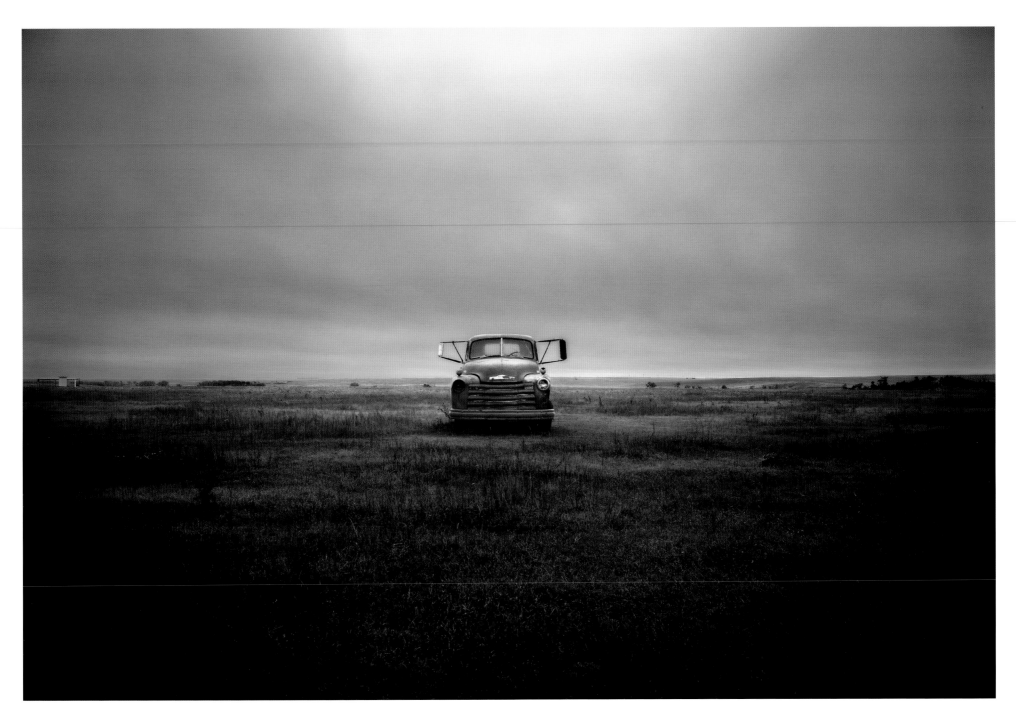

One Eye, near Colby, Kansas

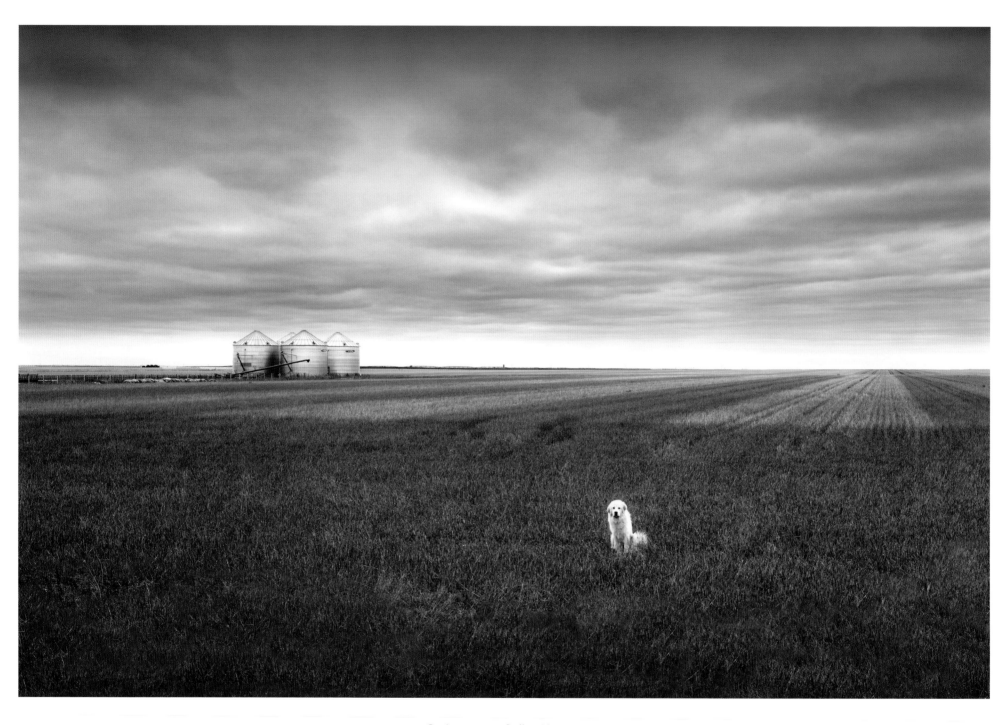

Curious, near Colby, Kansas

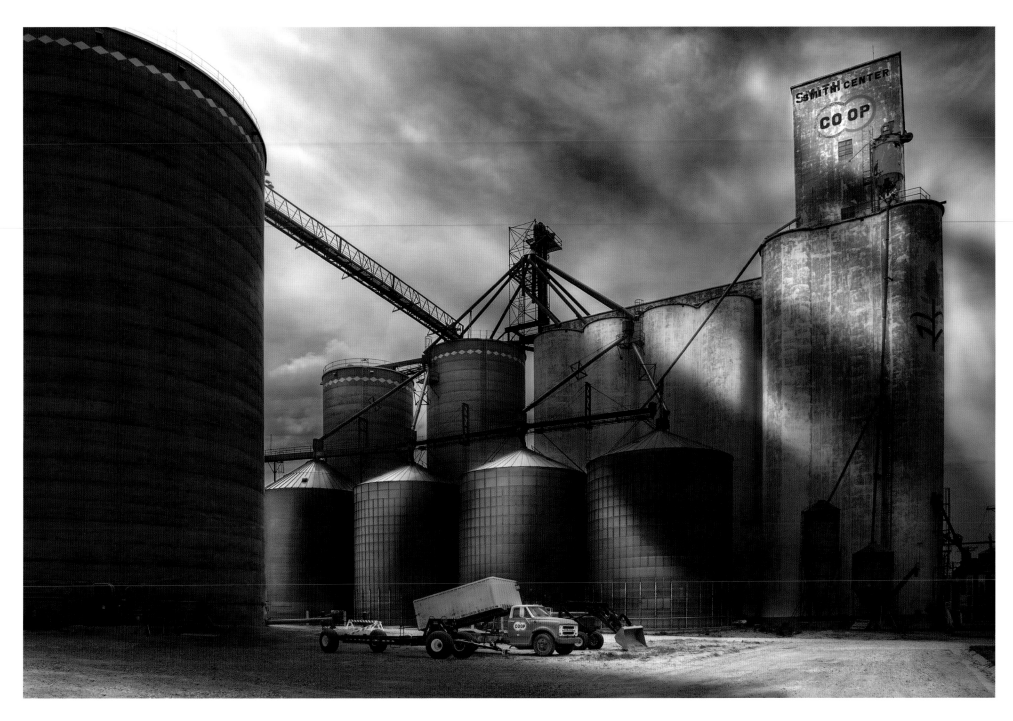

Co-Op, Smith Center, Kansas

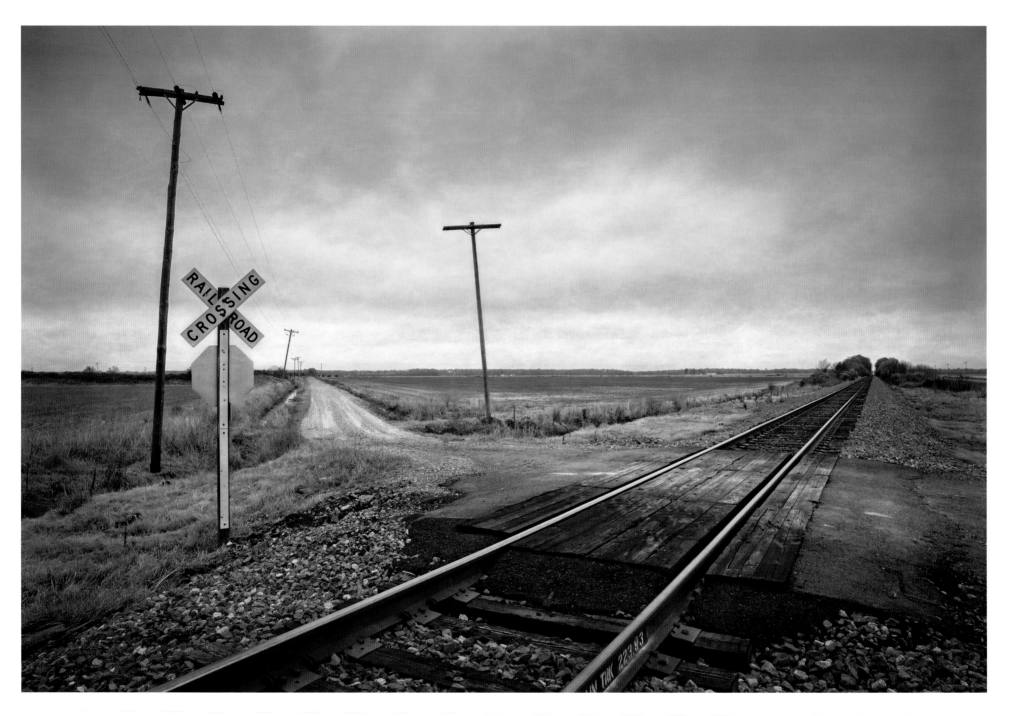

Two Ways, Ulm, Arkansas

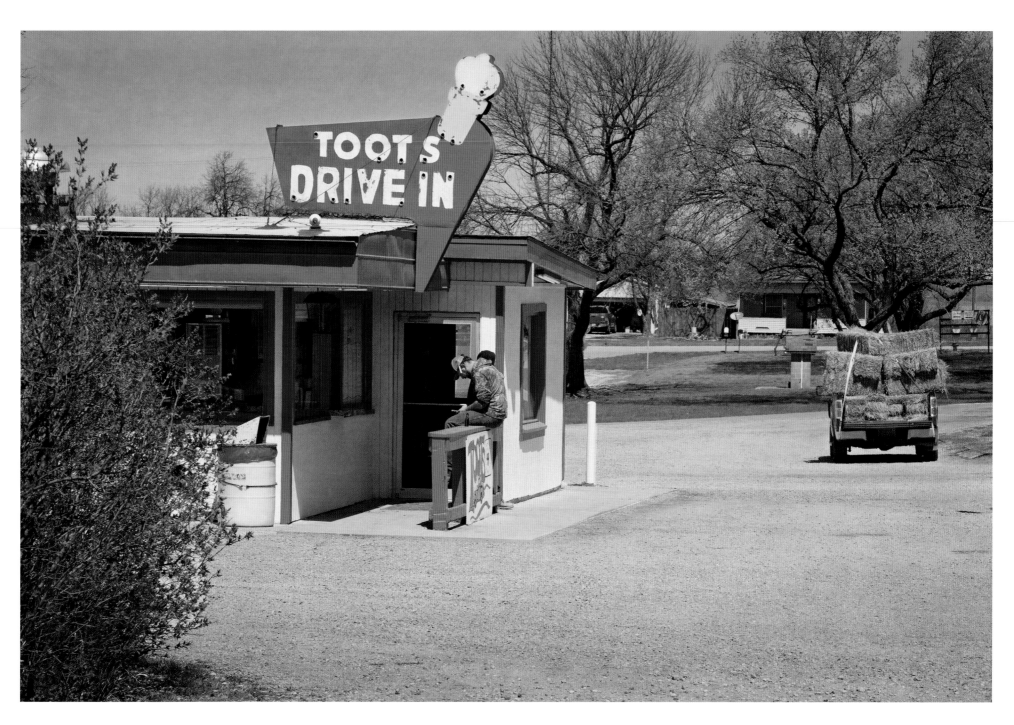

Toot's, Howard, Kansas

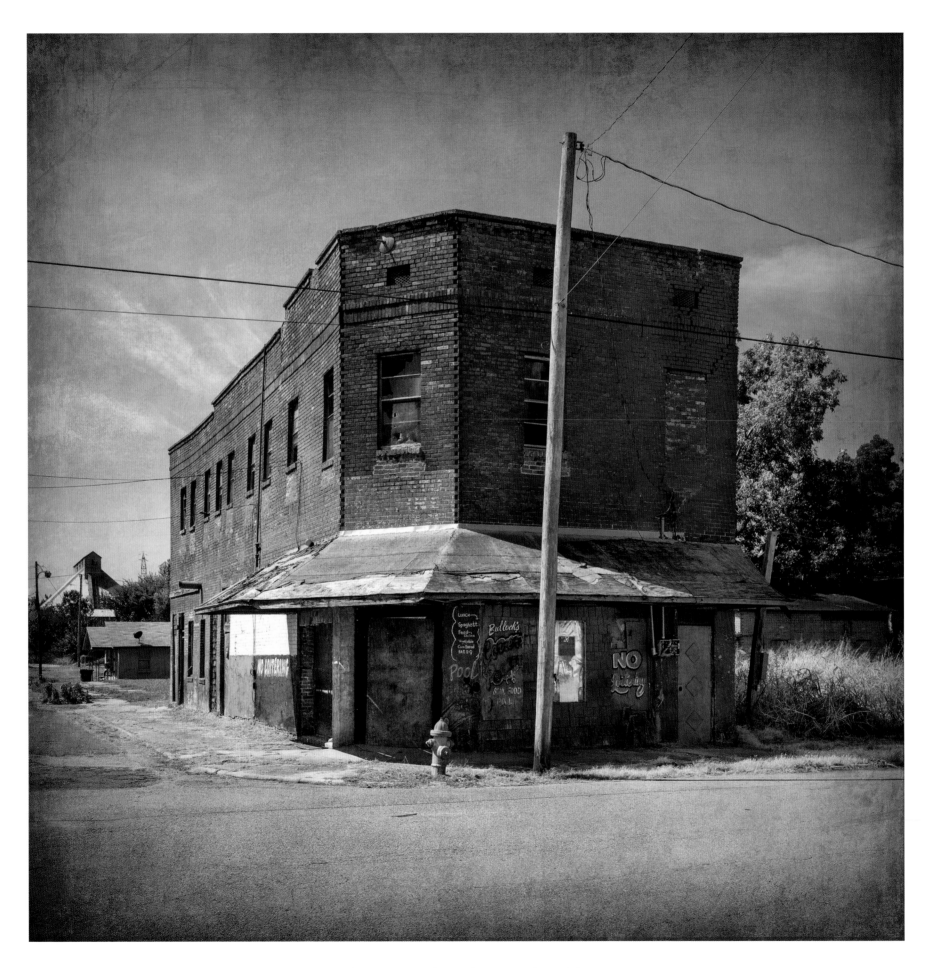

Bullock's Corner Pocket Cafe, West Helena, **Arkansas**

Union Bus Station Cafe, Seminole, Oklahoma

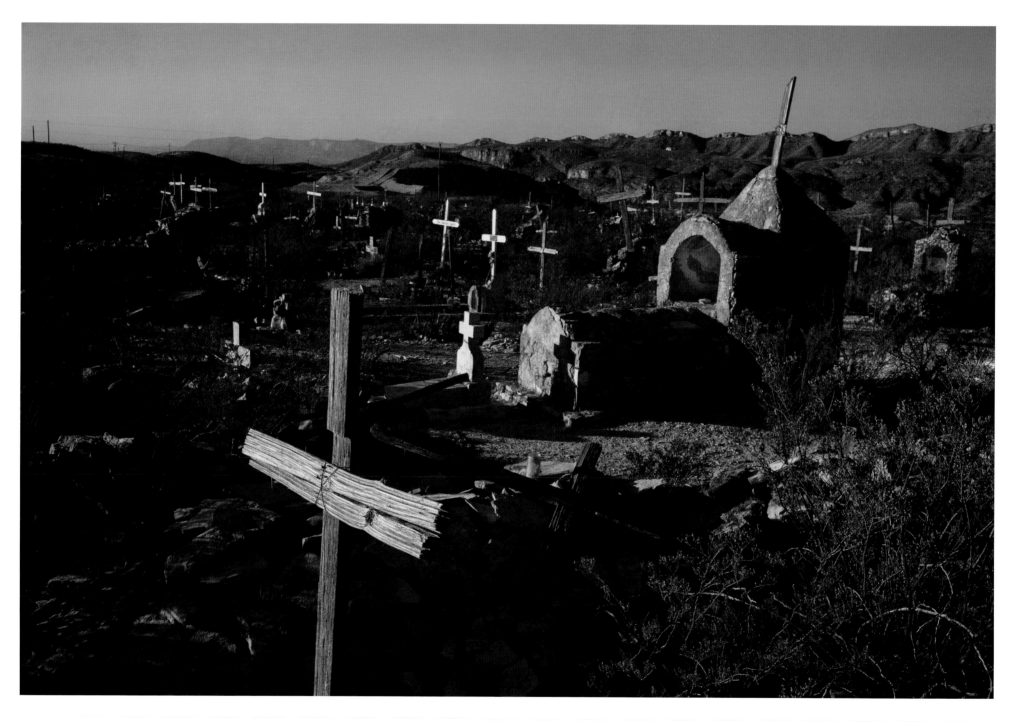

Resting Grounds, Terlingua, Texas

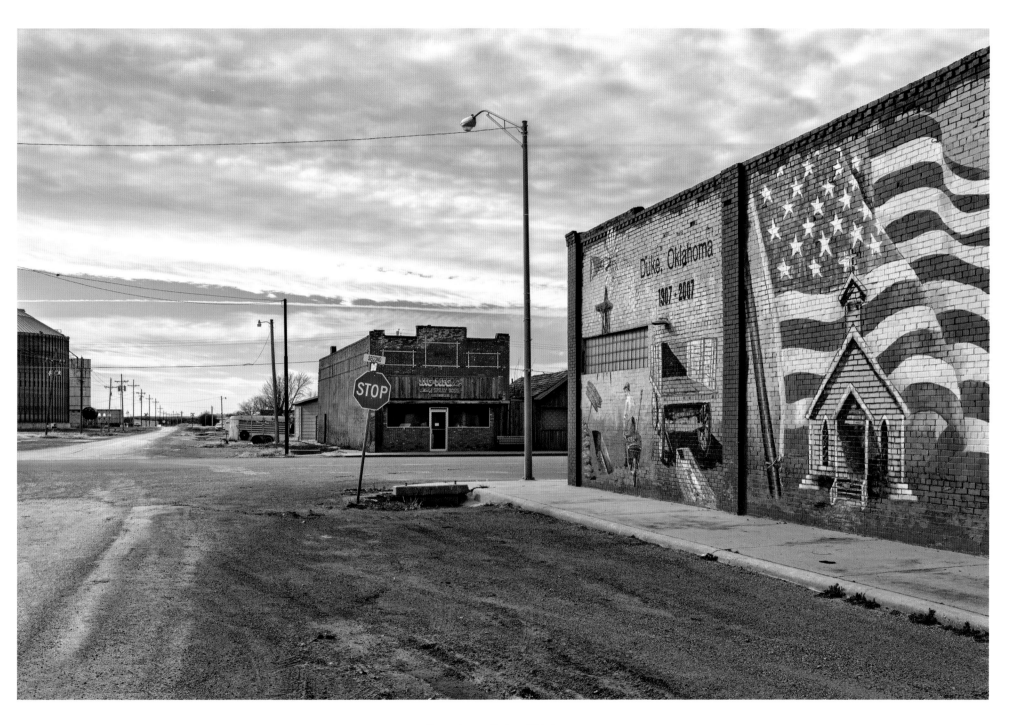

Downtown Duke, Oklahoma

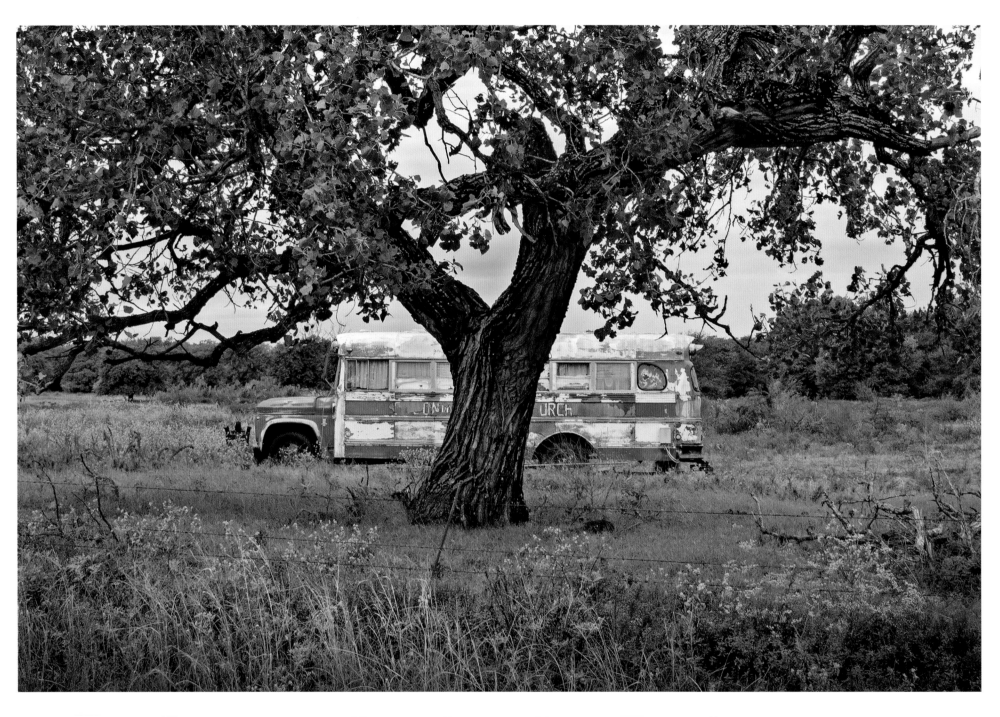

Urch Bus, near Carbo, Texas

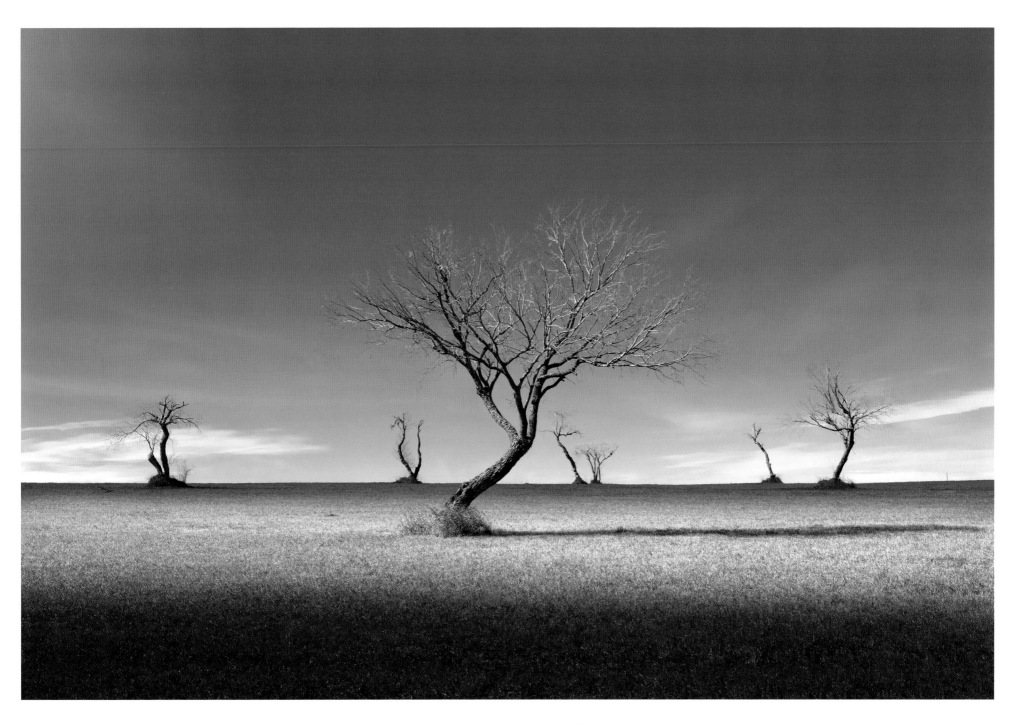

Seven Trees, New Braunfels, Texas

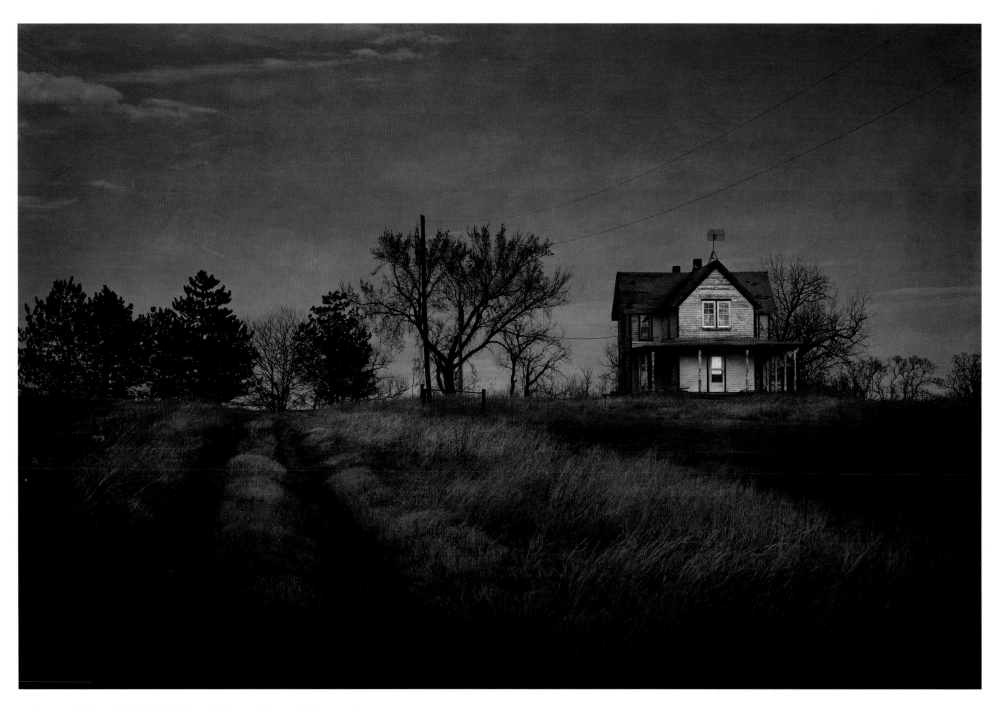

Last Light, near Stillwater, Oklahoma

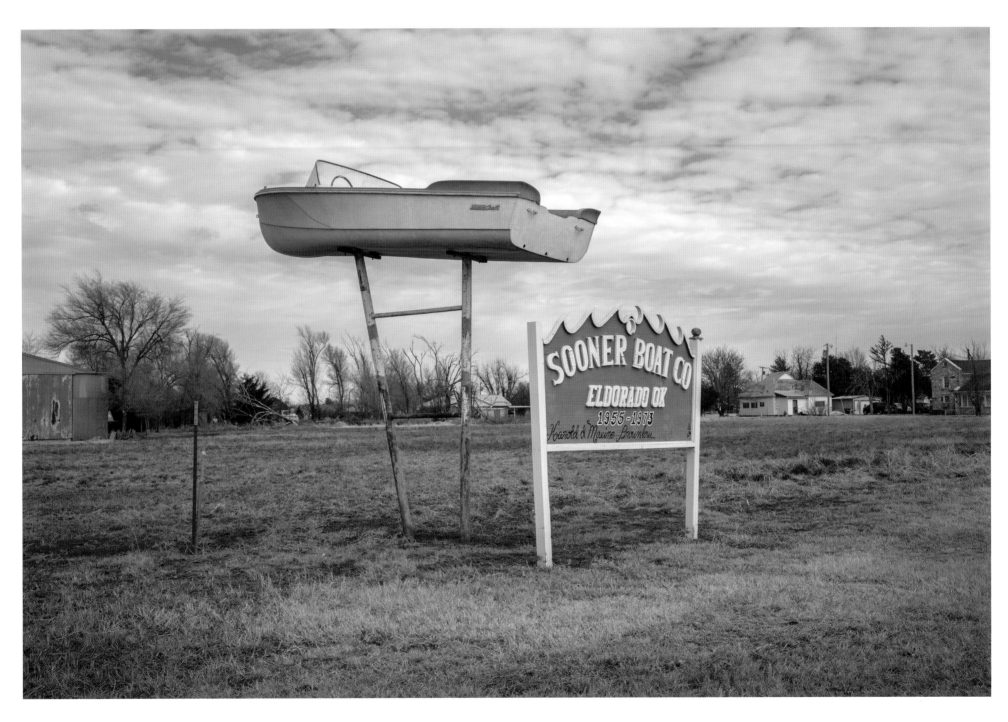

Remembering Sooner, El Dorado, Oklahoma

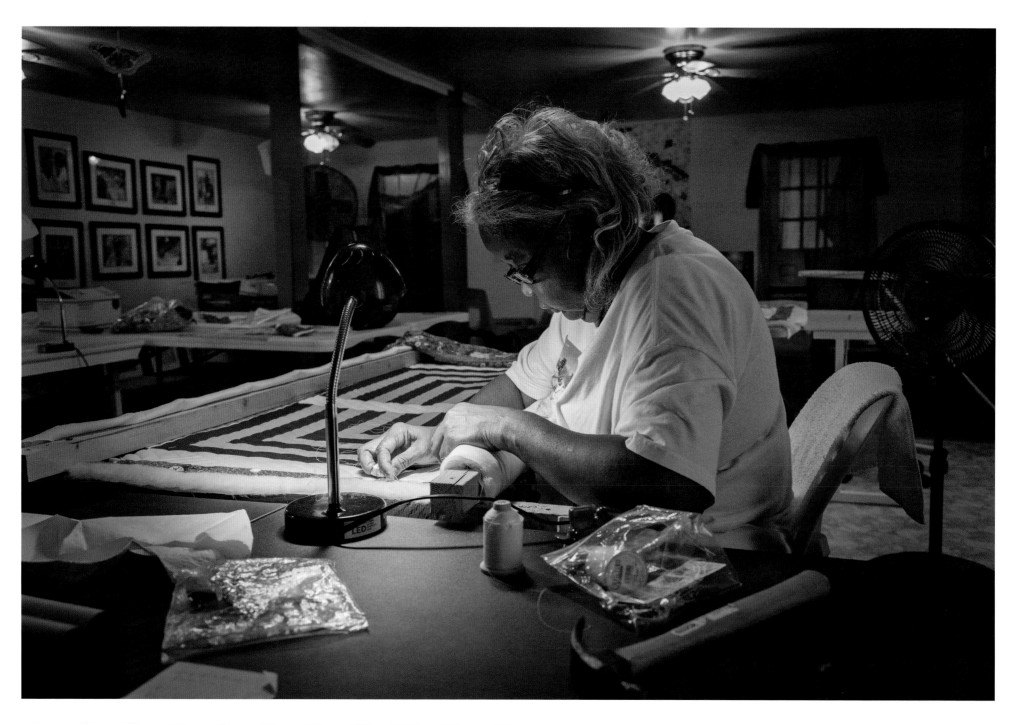

The Sure Hands of Mary Ann Pettway, Gee's Bend, Alabama

GEE'S BEND
February 22, 2018

I first became aware of the Gee's Bend quilts when they were exhibited in Nashville a few years back. I'd never seen quilt designs like these. They were non-symmetrical, rambling, flowing works of art. Not long after that, a 2-hour documentary on Gee's Bend and the quilting ladies there aired on PBS, revealing a story of slavery, isolation, perseverance and community steel that fascinated me.

In early 2018, my wife and I traveled down to Demopolis, Alabama, to keep my grandkids while my daughter and son-in-law luxuriated on a week-long Caribbean cruise. I had decided to use that opportunity to work on Slow Roads America while the kids were in school, taking half-day trips into southern Alabama and eastern Mississippi. Scanning the road map, I spotted a sinuous curve in the Alabama River about an hour away. Gee's Bend. It's not easy to get to. There's only one road in and out, about a 30 minute drive from the nearest thru-road. Well, that and the ferry, which only runs about 4 times a day.

There are several large signs as you drive through the community that have only one thing on them - a painting of a quilt. They're in the front yards of ladies who have been among the stalwart quilters down through the years. The painting is of one of the quilts made by that artist. But, other than that, you can't tell where you are. I turned onto a gravel road lined with small houses and mobile homes and covered with old pick-ups. No sign of any place where group quilting might take place. On my way back out to the paved road, I hailed a pick-up coming in. He pulled to a stop and gave me a warm Howdy. Always a good sign in a situation like this. I Howdied him back and told him what I was after. He started to give me directions and then told me he'd just take me over there, about a mile and a half away. Getting better by the minute.

We pulled into a dirt drive (no paved driveways here) and parked in front of the Gee's Bend Quilting Collective, an old wooden structure with its paint peeling off, propped up on 2 foot high stacks of concrete blocks to see it safely through the flooding times. We shook hands on the way to the door. Willie Pettway was his name. I remembered how in the documentary, one of the main slaveholders back then was named Pettway, and the tradition was that all the slaves and their offspring took their owner's name. He said, "Oh,yeah, most people down here have that name, but that doesn't mean we're blood related". He pounded on the locked door until Mary Ann Pettway (in this case related, as in his sister-in-law) opened up. Mary Ann is the main lady of the Cooperative, the manager of all that goes on there. She was by herself, as she is most days, quilting (what I incorrectly referred to as stitching. She corrected me.) another lady's quilt. That happens as a matter of course - several folks involved on the same quilt, although claiming rights fall to the one who pieces it (designs and sews together). Mary Ann introduced herself and went right back to work.

Spread before me on the walls of the main room was the history of Gee's Bend in black and white photographs. Preachers and deacons and brothers - in one photo were six men, all named Pettway, but only two related) - buildings, and one of the old ferry, the one that was pulled along a rope from side to side when the river was only half as wide as it is today. At the end of the room, a small television played the documentary. Quilts in various stages of creation were stacked or stretched across tables like the ones your church uses on potluck Wednesdays. Off to one side was the "doing business" room, shelves and display tables loaded with an incredible assortment of multi-colored coverings, no two anywhere near alike. All for sale and at impressive prices. Seems all the attention of the past several years have brought people and collectors in and the prices up.

Back in the main room, it was no problem at all for Mary Ann to do her exacting work and carry on a wide-ranging conversation at the same time. She's been at it all her life, as have most of the Gee's Bend women (and even a 15-year old boy that jumps in from time to time). This is what they do, their lives, their livelihood. Originally, the quilts were crafted out of pure necessity. To keep warm. And new material was not readily available. Quilts were made from clothes and sheets that were ready to be discarded. That played a big role in the abstract nature of the designs. Now, though, most of the work winds up in the hands of museums, galleries, collectors, and ordinary folks who make the trip into the Bend to witness the beauty and the process for themselves.

Mary Ann and her colleagues enjoy the trips they take from time to time to open an exhibit, visit museums, and meet dignitaries who've fallen under the spell of their story and their art. As she pulls through another stitch (excuse me - continues her quilting), she recalls when the old, rope-pulled ferry was still being used. That ferry was pulled out of service in the '60's by powerful people in order to isolate the community, and thereby cancel the votes, during the civil rights struggle. She and I and Willie wondered aloud why good church-going folks back then, and even today to some extent, didn't see the obvious hypocrisy between what the God they worshiped had to say about the value of every person and the way they treated each other. A maddening, stubborn obstacle to living out the Kingdom here on earth.

We talked about the difference between going to church and "having" church, gospel singing (Willie's in a group), the old hymns, and the tallest preacher - there was a photo of him on the wall. A few more reminisces and it was time for me to take my leave. Mary Ann got up from her work and came around the table. She asked me my name again and gave me a big hug, warm and strong, like she'd known me a long time. As I turned to go, she said, "now when you talk to folks about your trip here, you don't need to tell 'em about me. You just tell 'em about Jesus!"

Back out front, I shook Willie's hand and told him I'd flagged down the right guy. He laughed and told me to come back any time. As his truck pulled away, I was filled with gratitude for finding places and people like this. And they're all over the place. You've just got to have a tank full of gas, a curious nature, and flag down the right folks.

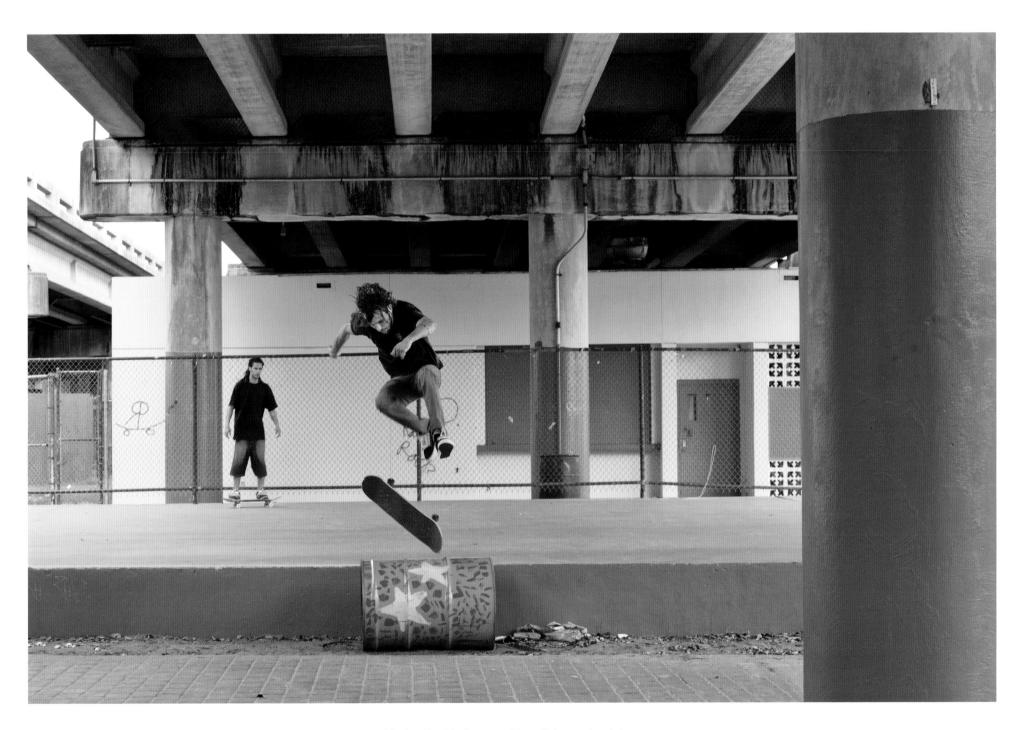

Under the Underpass, New Orleans, Louisiana

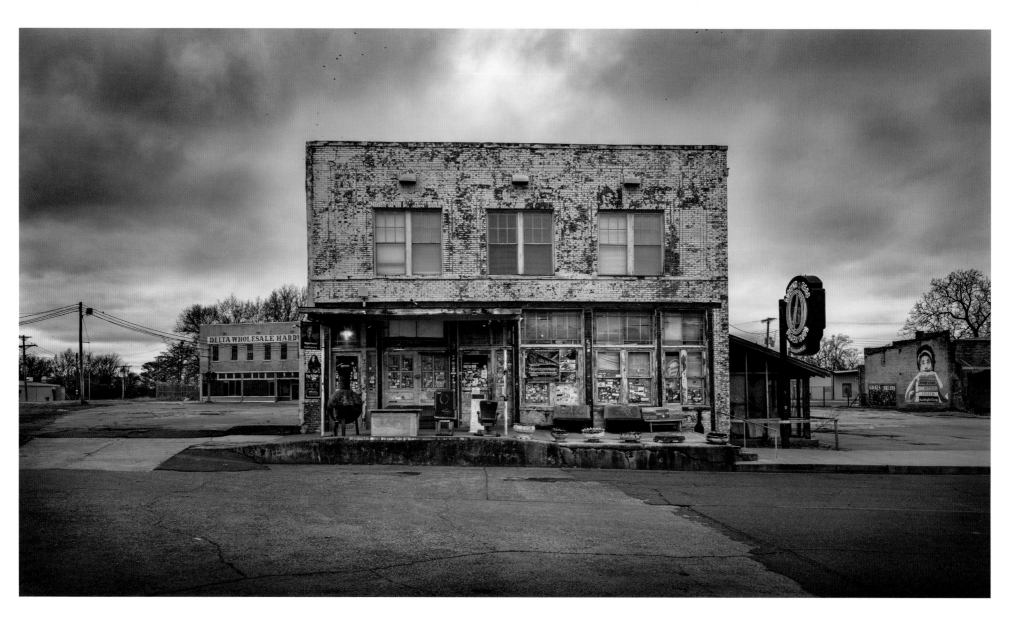

Ground Zero, Clarksdale, Mississippi

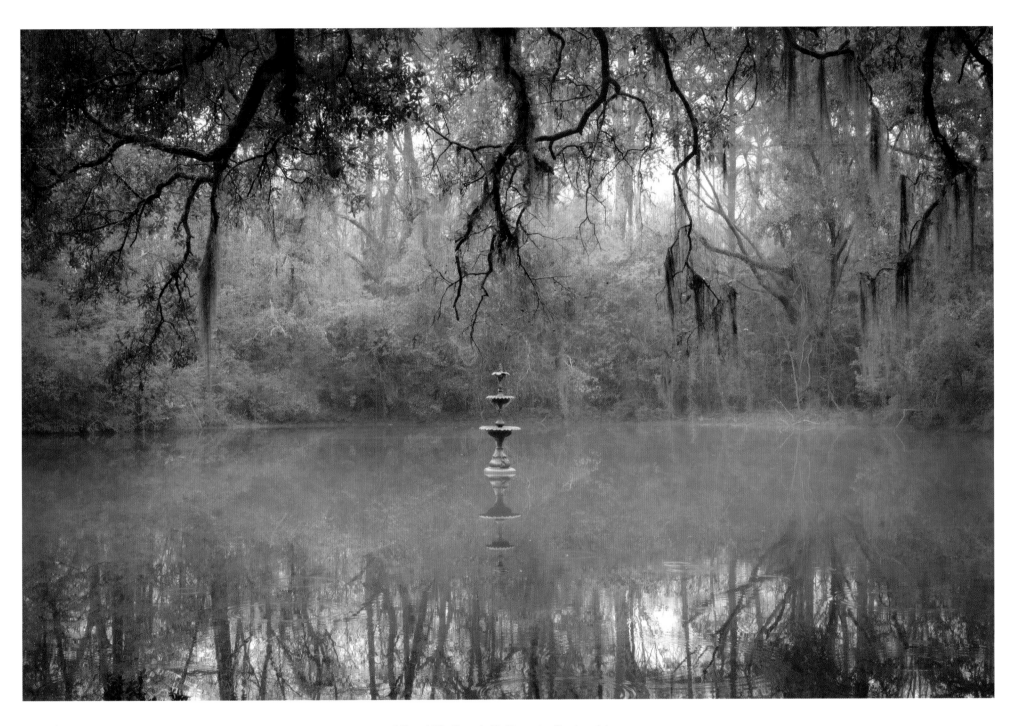

Afton Villa Pond, St. Francisville, Louisiana

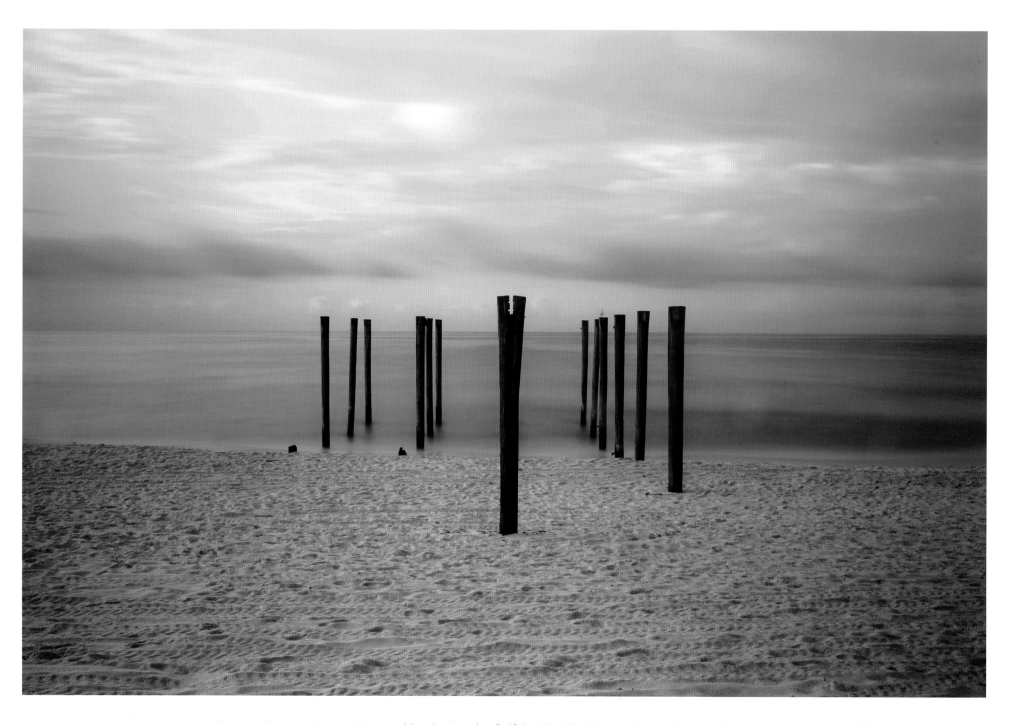

Morning on the Gulf, Destin, Florida

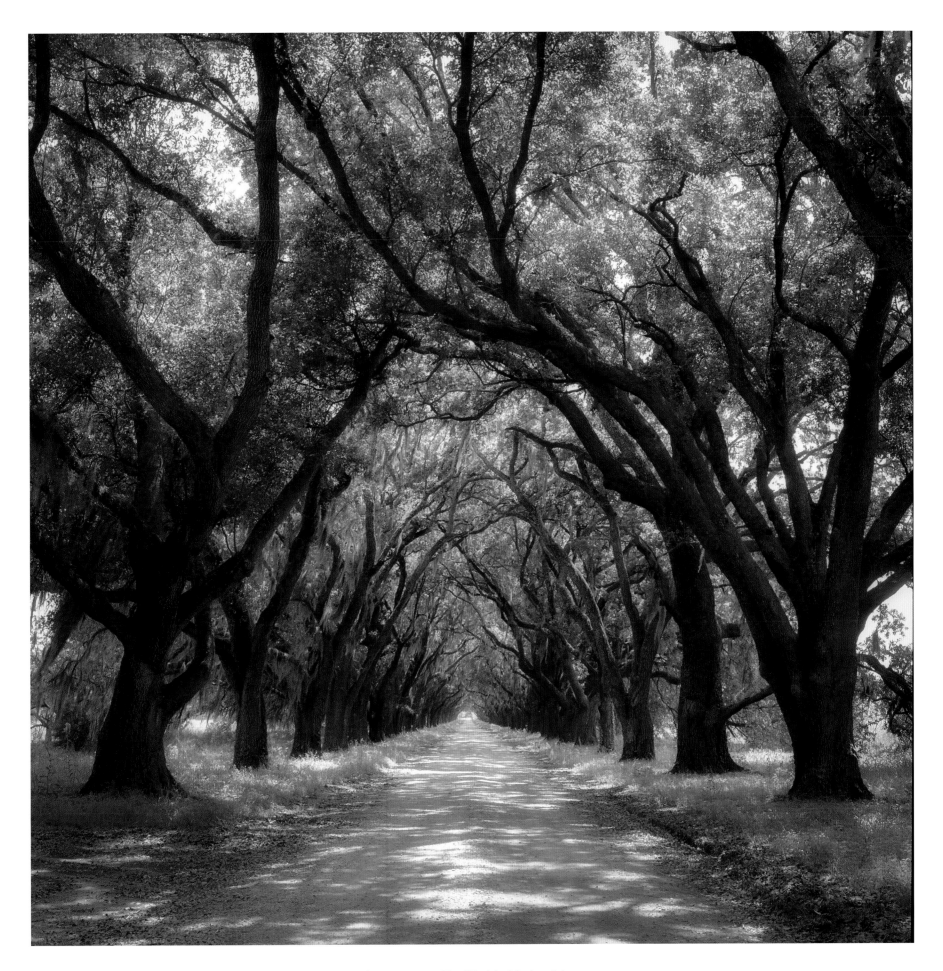

Avenue, near The Big Muddy, Louisiana

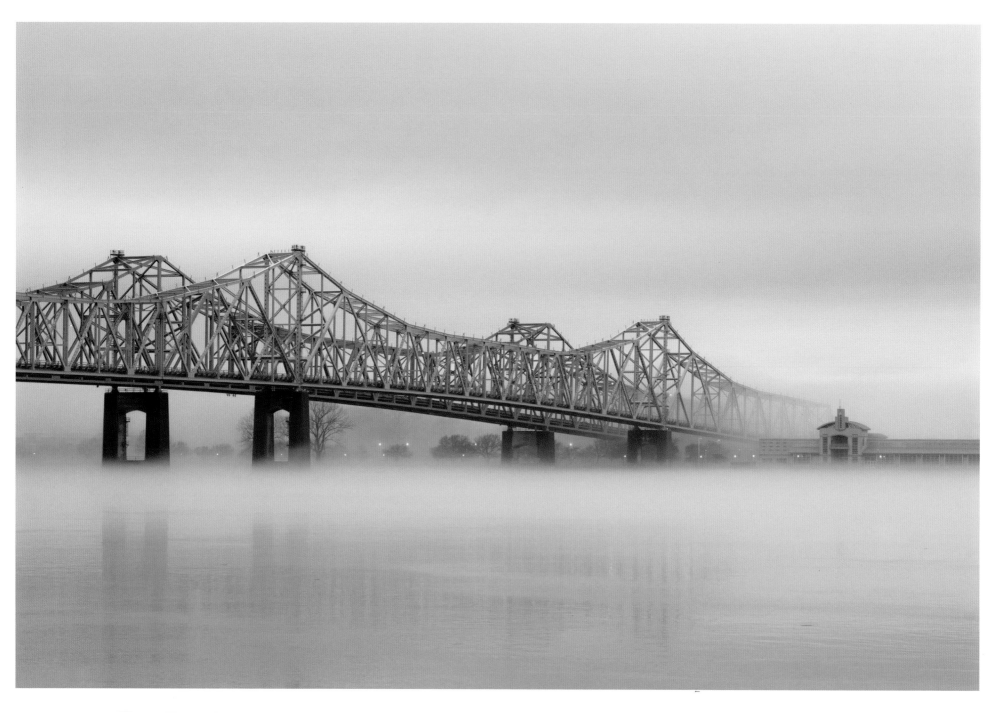

Bridge From Natchez, Mississippi

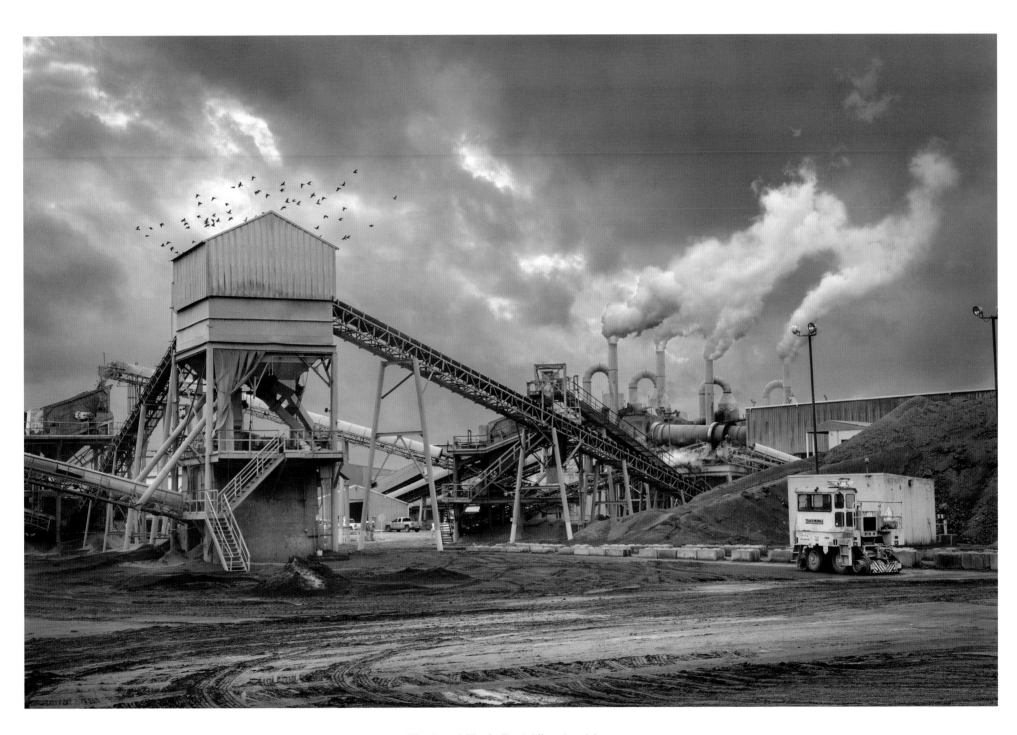

Plant and Flock, Port Allen, Louisiana

Waiting, Laurens, South Carolina

Veterans' Day Parade, Beaufort, South Carolina

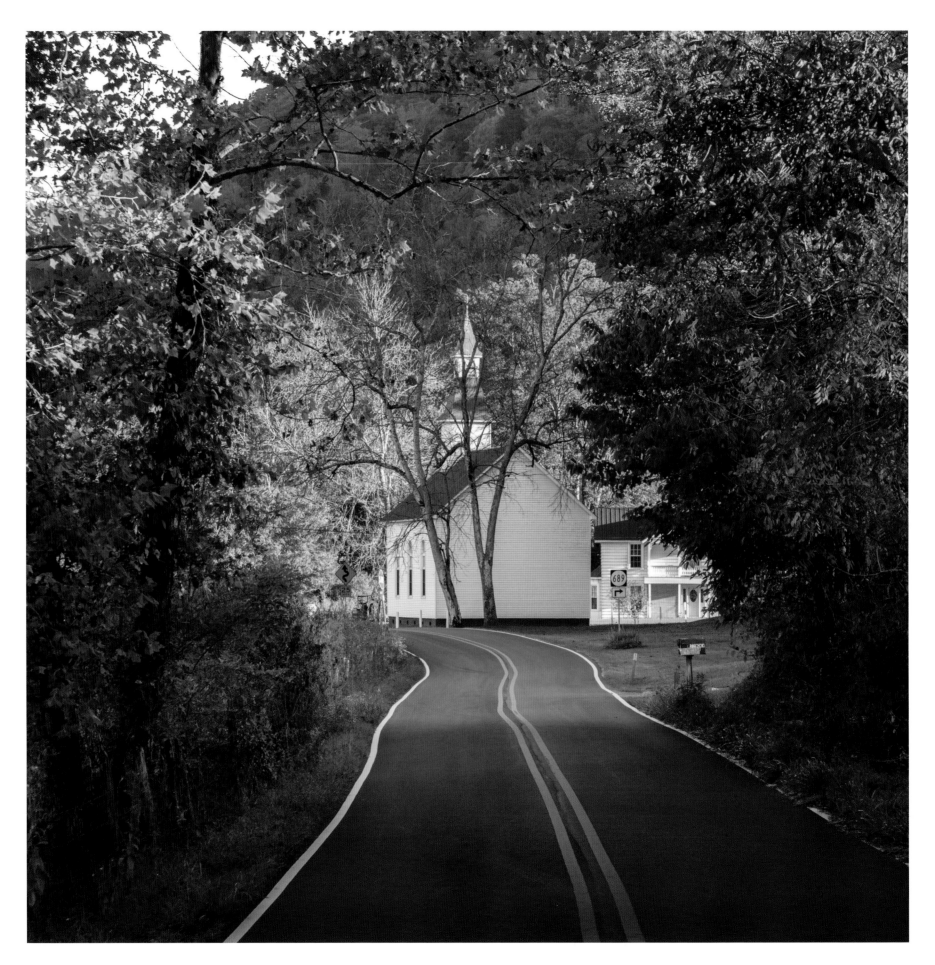

Church In the Country, Hayter's Gap, Virginia

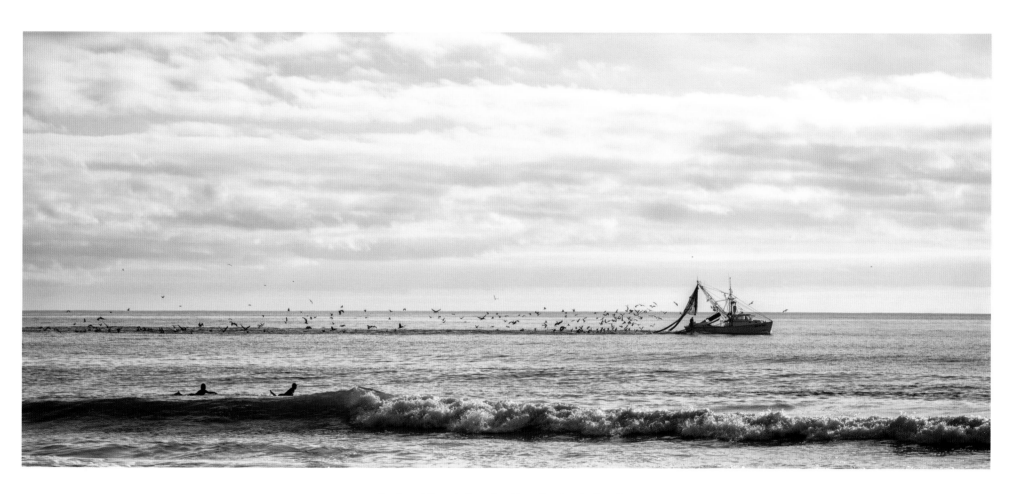

Surf and Trawl, Carolina Beach, North Carolina

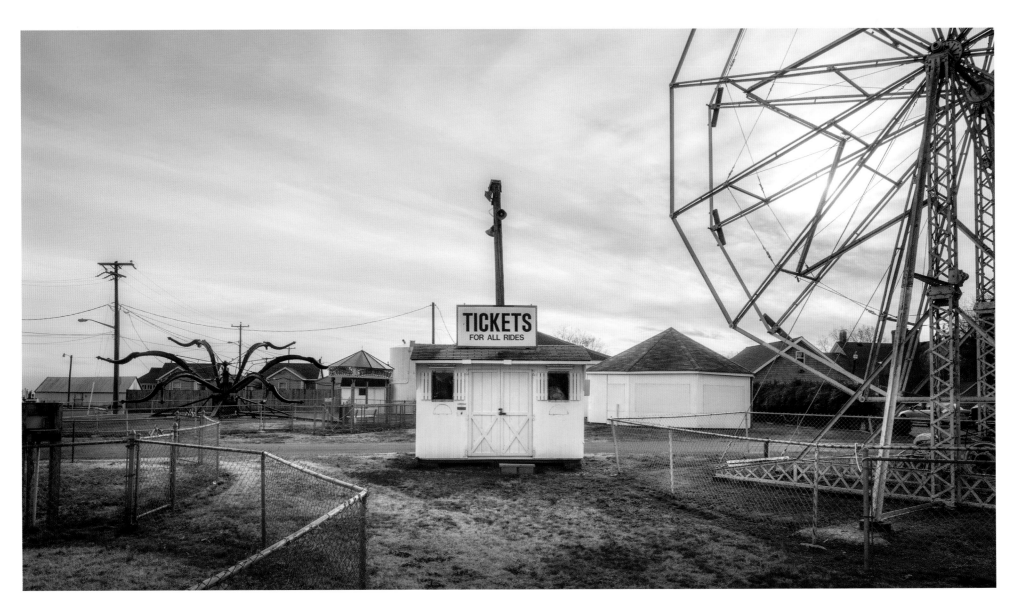

Waiting on Summer, Wachapreague, Virginia

A Summer in Lofton

March 24, 2018

"Mama, I'm going down to Rudy's!" Steven yelled. "Want anything?"

"No, Honey, I'm fine. Wear your heavy coat, now, that wind is really up today!"

"Yes ma'am."

Why did she always tell him that? He was outside a lot more than she was. Even now, in late January. Dangit, he wasn't stupid! He was 15, after all, and had lived here on the shore all his life.

He shut the door behind him, turned up his collar, and headed left at the end of their walkway. Left toward town. It wasn't much of a town, Lofton, especially in the winter. A city hall building that opened primarily for Carl, Lofton's lawman, to come inside and keep warm. A few stores, a senior citizens' center in the old shoe shop, and Rudy's. Rudolph McNairy, the grocer, who'd taken over the store that sat just off the beach when the Willetts had given up and gone back to Ohio in the '50's. He was the only one who stayed open all year. With about 350 year-round people in this remote corner of Virginia depending on him and with the nearest competition 55 miles away, it worked out good for everyone.

The amusement park was pretty much the center of the village and Steven headed that way now. It was only a block out of the way - nothing in Lofton was more than a block out of the way, two at the most. Even though it closed right after Labor Day and didn't open back up until the Friday before Memorial Day, Steven was drawn to it year-round, like it was too much a part of who he was to not wander through there on a regular basis. So many memories of him and his buddies meeting at the ticket booth two or three evenings a week in the summer, poking cotton candy in each other's face, punching each other on the arm and throwing out dares to do some crazy fool thing, racing to the next ride to get their choice of cars. The Spider was by far his favorite. Steven liked the way he got all dizzy and light-headed when the Spider dipped up and down the same time it picked up speed going round and round. The cars spun, too, tripling the forces that grabbed your equilibrium and tossed it around like a tornado. If it was a slow night, the operator would let the boys stay on the ride way past the normal two minutes, until some times Steven worried that he might give the cotton candy right back.

But now the park was quiet. All the cars were stored away out of the weather. Not just the Spider, but the Tilt-a-Whirl and the Ferris Wheel, too. Steven jumped up and grabbed one of the curving arms that normally held the Spider's cars. He did three chin-ups and then just hung there for a bit, the bone-chilling cold of steel seeping into his fingers. Dropping back to the ground, he stuck his hands up under his armpits and slowly turned his head toward the Ferris Wheel. Painful memories at the end of that glance, but he looked anyway. He couldn't stop thinking about it. About her. Samantha. Beautiful Samantha.

The summer between 8th and 9th grade, her family had traveled from the western part of the state to spend July and August in Lofton. They'd met her first week in town, on July 4th, when crowds filled the park grounds and lines were at their longest. She was standing by herself at the concession stand, the blinking lights of the Tilt-a-Whirl tiny bursts in her eyes, a mystery about her that made her seem out of place but, at the same time, the herald of a new drama that was already in play. After going round and round with himself and a good bit of prodding and ribbing from his buddies, he screwed up his courage, asked her if she'd like to share a car with him on the Ferris Wheel, and, are you kiddin' me, she said Yes! Neither of them spoke as the giant wheel creaked backward into motion and made a couple of rotations. And then it stopped, as, from time to time, it would, it being older than anyone could remember, the chain jumping off its track or a nut unwinding itself from a bolt and landing with a dull thud on the grass. So there they were, 40 feet off the ground, rocking back and forth in the breeze, the winding soughing through the beams. Samantha reached over and grabbed Steven's arm, spilling out her fear of heights and hoping he wouldn't mind if she held onto him. Mind? Well, the conversation got a whole lot easier to have at that point, and by the time the mechanics finished and the wheel ground back into motion, 25 wonderful minutes had passed and life would never be the same again.

They agreed to meet at the pier the next day and there would not be another day that golden summer when you saw one without the other. Anybody not half blind could see that, even at 14, the age-old dance had begun between Steven and Samantha, or Stevie and Sam, as they dubbed each other. Warm, breezy afternoons chasing each other up and down the beach, making sure it didn't take too long to get caught and wrapped up in slender, darkening arms. Fishing at the end of the pier, the sea gulls's squawking turned positively tuneful, part of a melodic score on which their story was composing itself. Their families met and traded invitations to supper every couple of weeks, everyone retiring to the den after dessert to watch I Love Lucy, or Father Knows Best. Stevie riding Sam around on the back of his Columbia Flyer, her towel and change purse in the basket up front. There were a couple of miles of pavement north and south from town before the road ended and they had to turn around. Two-wheelers were no good in sand.

If Stevie could have frozen time, he would have. He would gladly have traded all the future growing up might hold in exchange for this summer, these halcyon days. They seemed perfect and he would just stay in this moment with this girl if he could. But, the summer seemed to pull away from his grasp and accelerate toward its dreaded end. The Tuesday before Sam's family was due to pack up and head back home, Stevie rode her to the south end of the beach road. They got off the bike, took off their sandals and threw them in the basket. Stevie reached for her hand and they walked without saying much at all along the shore. After a few minutes, they veered out of the water as he nudged her toward the sand dunes. Once behind that first tall dune, the wind died suddenly, and he was sure Sam could hear the pounding of his heart. His throat was dry as a desert and his palms were sweaty. The look in her eyes as he turned and took her face in his hands told him everything he needed and wanted to know - she felt the same way.

There would be no way Stevie would ever be able to describe to his pals what that first kiss was like. He'd never known a sensation like that. A tingling, almost like an electric current, raced through every part of his body and into his hands, his lips, his cheeks. Sam reached around his suntanned back and hugged him to her. Stevie had never felt more alive.

"I don't want you to leave."

"I don't want to leave, but I have to. I have to go back to school. But my daddy promised me that we'd come back next year and I promise you we'll make it 'til then.

The rest of the days of that last week were filled with indescribable joy and excruciating agony. From the time he left his house after breakfast until he drug himself home at night to fall into bed, Stevie was with Sam. All day long, they'd look over their shoulder to see if they were safe and slip behind a building or a telephone pole or a truck for a quick kiss or two. Or five. A good thing, kisses. If they were drugs, the two of them would be addicts. They couldn't get enough.

They swore they'd write often and that they'd stay true to each other. They'd count the days until next July 1st. They lingered at their last kiss Friday night under the pier. That would have to do, because no way they'd kiss in front of their parents the next morning before Sam and her brother and parents got in the loaded down car.

The driveway up to her cottage was made of crushed shells and gave off a popping sound as her dad backed out onto North Beach Road and headed south. At the amusement park, he turned west toward home. Sam watched Stevie out the back window until she couldn't see him anymore.

So, here he was, roaming around the slumbering park on a Saturday in the middle of winter, nothing really to do when he wasn't in school or running around with his buddies. Even that died way back when it got so cold it wasn't much fun outside. It wasn't so bad when he was marking off the days on his calendar until the summer. At least he had something to look forward to. But then he got the letter. Samantha had written right away when she got back home and two or three times a week after that. Steven had never cared much for writing, but he found himself filled up with words that needed to be expressed and that just bubbled out onto the page. He used up stamps as fast as his mother bought them.

The week after Christmas, Samantha wrote one last letter to say that her daddy had lost his job at the mill and they were headed to Oregon where her uncle said there was plenty of work. They wouldn't be coming back to Lofton next summer. Or ever, most likely. She said that, as hard as it was, they probably shouldn't try to hang on to each other, the distance being what it was. She would never forget him, she vowed, and would always remember those glorious days and how green his eyes were and how sweet he was to her. She must have started wearing lipstick, because just below "Forever in my heart, Sam" she had pressed a kiss. The bright red outline of those pedal-soft lips stuck him like a dagger, those moments on the pier, behind the dunes, under her front porch light rushing back to torment him, now that all they'd ever be were memories. There would not be another summer.

Carl must've seen him leaning across the top of the fence that circled the Ferris Wheel, and he punched his siren for a half-second as he loved to do whenever he wanted to say hello or just show off. Steven couldn't remember a time when Carl had turned it on in an actual law enforcement situation. This was Lofton, after all.

"What's happening, slugger? You all right?"

"Yeah, I'm good, Carl, just headed over to Rudy's."

"All right, then. Stay outta trouble. Wouldn't wanna have to run you in!"

Carl's attempt at humor did nothing to cheer Steven up. As the deputy waved and drove slowly away, Steven thought he might never smile again. He couldn't imagine finding anything funny about life from now on, now that Sam was not in it.

His hands deep in his pockets, and his head down against the wind rolling in off the ocean, Steven headed back in the direction of the grocery store. He kicked a rusted Falstaff can out of his way and trudged through the knee-high, brittle grass, last mowed the week the park closed. Maybe he could fake his age and join the Marines or go work on a barge in Louisiana or something. The thought of walking out of school on the last day in May and facing summer without Sam was unbearable. Life had gone from the pinnacle to the dungeon in one two-page letter.

Steven three-fingered the Merita Bread screen door handle and heard the familiar, and now almost mournful sweak, as he pulled it aside to get to the main door. in the summer, the solid door was closed only when Rudy locked up for the day. The screen door let the salty freshness of the shore in and aromas of ground coffee and baked bread out onto the street, a double flap announcing the arrival or departure of a vacationer or a regular. Steven was struggling with whether he wanted to be around anybody or just go walk on the beach by himself when Rudy looked up and hollered.

"Hey, young man! Am I glad to see you!"

That sounded sorta strange, Steven thought. Rudy was always pleasant enough to him, but what in the world did that mean?

"My son has moved back home to Lofton with his family and will be taking over the store in a couple of years when I hang it up. So, I'm a happy man! Got my son back, I'm already dreaming of fishing all day long, and my grandchild is helping me out on the weekends. Anyway, I thought you might serve as a good tour guide, living here all your life like you have. Lily? Come on out here, Honey, I want you to meet somebody!"

Steven would remember everything about that moment for the rest of his life. Lily's wavy auburn hair as she wiped her hands on her apron and pushed a wayward strand away from her cornflower blue eyes. The warmth of her smile as her grandfather introduced them. The way she seemed to have been waiting for him to show up. A glimmering light seemed to wrap itself around her as she walked up to him. How soft her hand was when he shook it. Rudy was still talking but Steven heard an orchestra somewhere. Time stood still as Steven's world came to a halt and then started off in another direction.

A long time later, he would reflect on what his 15th year had taught him about discouragement and hope, about hope in the midst of discouragement. About keeping the faith over the long haul. How sometimes the hardest moments sweeten up the good ones that follow. He had lost the dream of a summer that would be one for the books, but found a year of perfect love and companionship that would be followed by another year, and then another, and then another.

When he got home late that day, he told his mom that Rudy had said hello, hung up his coat and floated back to his room.

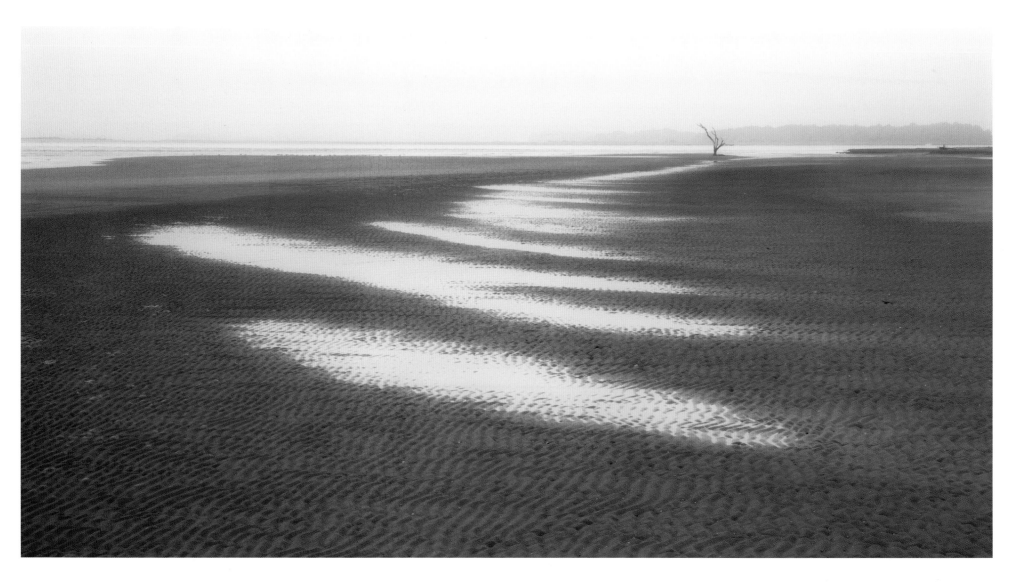

Puddles to a Tree, Folly Beach, South Carolina

Path, Hunting Island, South Carolina

Surface

March 16, 2014

A world on either side

of a silvery blue glaze.

One ghostly, one glorious.

Both terrifying, both stunning.

Held apart by immutable laws

Of gravity and pressure.

Sunning, Reelfoot Lake, Tennessee

Paradise, Carlos Park, Florida

Swamp Buddies, Everglades National Park, Florida

Grazing, Marshall County, Tennessee

Good Advice, Lexington, Tennessee

Algonquin Airliner, St. Simons, Georgia

Cropduster, near Indianola, Mississippi

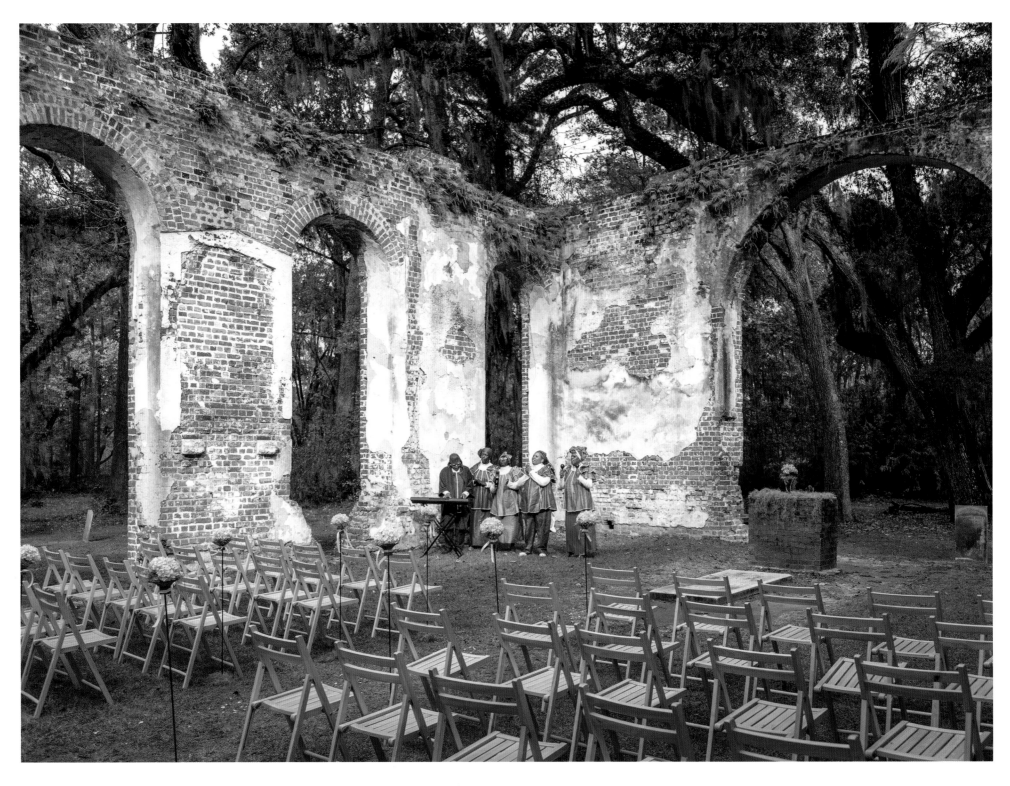

Warming Up For the Wedding, Old Sheldon Church, South Carolina

On the Point, Everglades National Park, Florida

Reaching, near Hillsville, Virginia

Valley Road, Blowing Rock, North Carolina

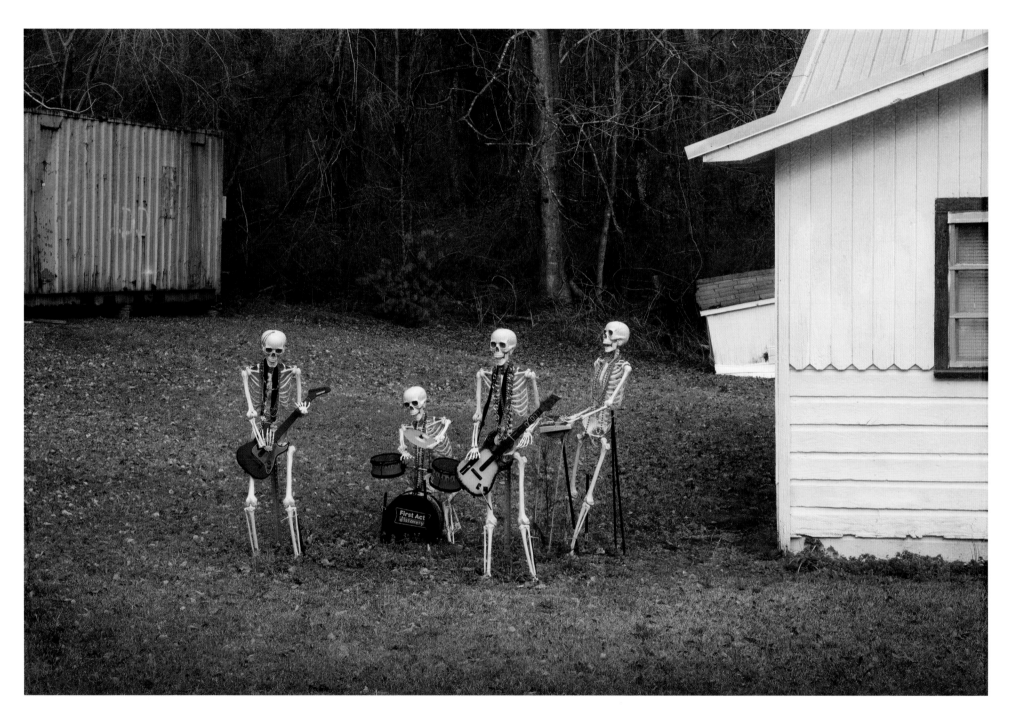

Skeleton Crew, Alabama

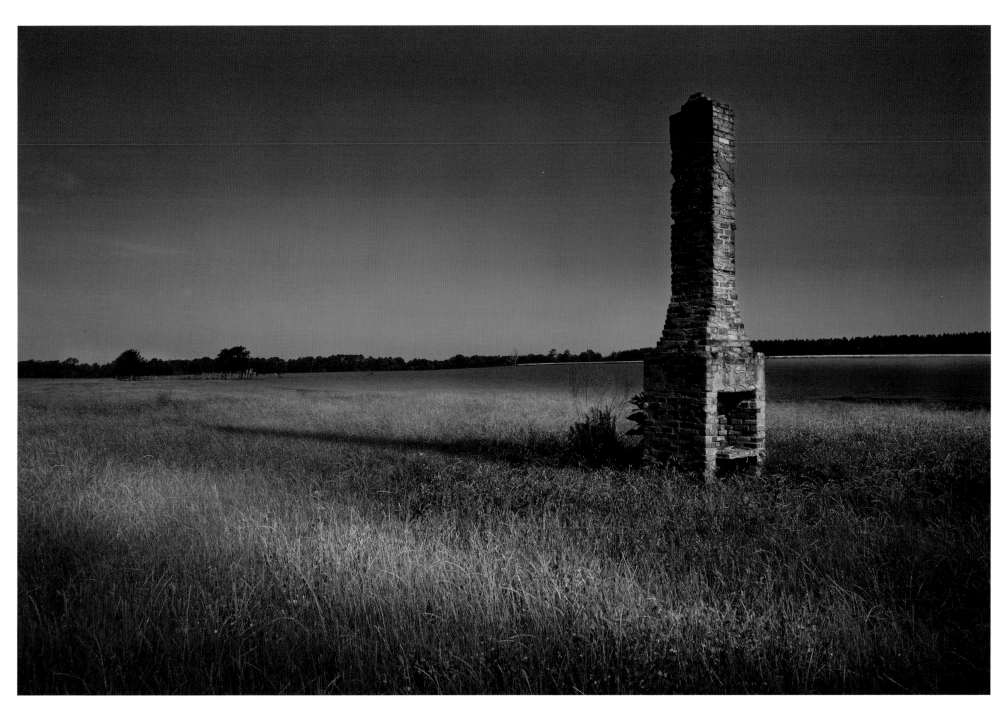

Chimney, near Fort Gaines, Georgia

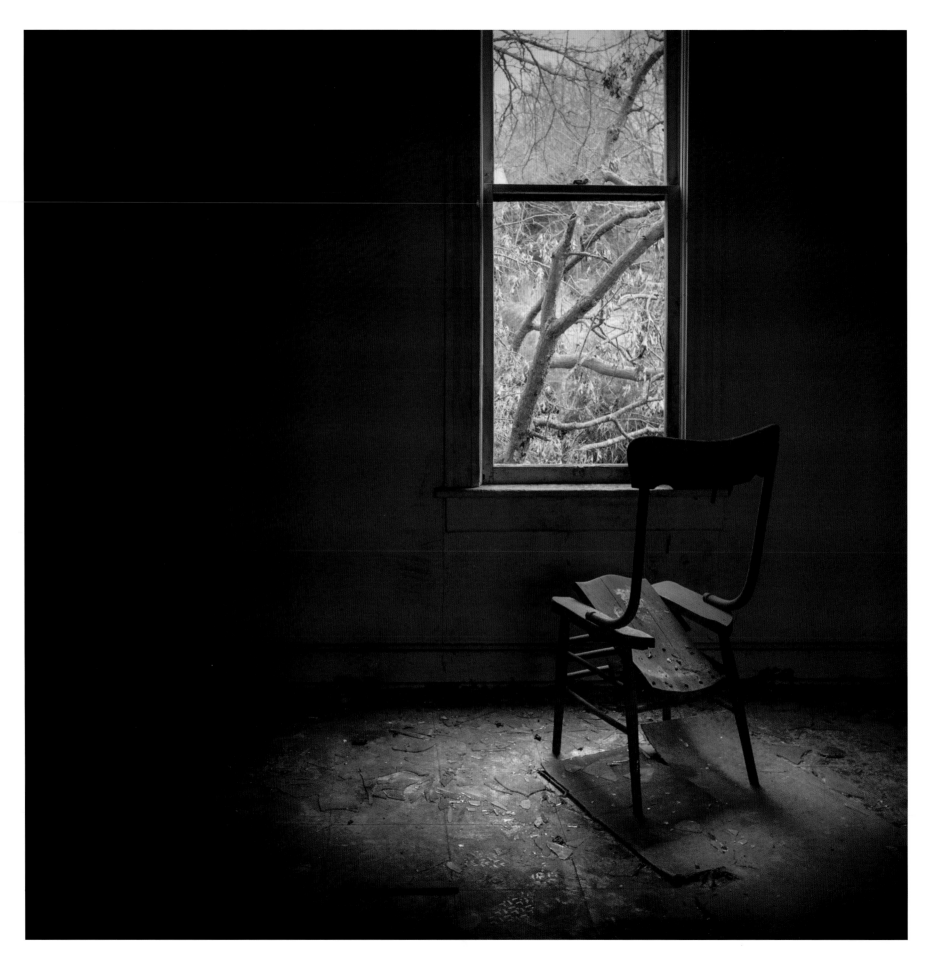

Believing, Nolensville, Tennessee

The Chair
July 6, 2016

They didn't have much at all where she grew up. Furniture was sparse and that chair was used for all sorts of things. When she was born, her daddy lost himself in her, became enamored with her baby's head smell, the soft, peach-like texture of her little cheeks, the way the sun lit up the edges of her hair. He watched her crawl her first time from his perch on the chair. He would lean over with outstretched hands, "come to Daddy, Baby Girl". When she would cry out at night caught in the middle of a nightmare, he would gather her up in his arms and take her to the chair in front of the fireplace, rocking her until her cries turned to sniffles and those to a steady breathing.

At mealtime, it was Daddy's chair at the head of the table. Sometimes, when he would come home from a long day at work, even though he had worn himself out, he would sit her in the chair in the middle of the room, hand her a glass of kool-aid and one of her mama's chocolate chip cookies that always seemed to be around, and tell her that the chair was magic, and if she imagined wonderful things happening to her, they would all come true one day. She'd squeeze her eyes shut really tight and let her dreams and fantasies take over. Sometimes, she'd concentrate so hard, she'd be somewhere else in the world and be surprised when her Daddy shook her gently back to reality and she'd realize she was still in the chair. Years later, when she'd have homework to do, she'd use Daddy's chair at the kitchen table instead of her own. She adored her Daddy and the things he thought up for them to do together. She wanted more than anything to make him happy.

He was a God-fearing man who'd been brought up to believe in the Word, every word of it, just like King James intended it to be understood and the preacher intended it to be obeyed. As his daughter bloomed and blossomed into a beautiful young woman, she began to dress for school and get-togethers with friends in a manner that he could not abide. His idea of "suitable attire" was pretty narrow. He forbade her to wear "hussy" clothes, jeans, and tight blouses and close-fitting sweaters. She tried for awhile to go back to the conservative dresses like her mother wore, but she just couldn't stick with it. The embarrassment was too much. Besides, she was 17 and, in her opinion, old enough to make those kinds of decisions

for herself. She loved her Daddy with all her heart, but there were stronger needs and drives now fighting against what he demanded she do. Then came that moment of no going back where, for the first time, she chose what she wanted over what he wanted. The makeup began to be applied a little thicker, a little more experimentally, a little more, well, sexy. She had to wait until she got to school and go into the girls restroom to put it on. She'd go through packs of tissue wiping it off on the way home. She began to sneak out at night and meet other girls. And, it didn't stop there. The girls would meet boys and one night, her daddy was waiting in the dark of the living room, in his chair, when she tried to sneak back into the house. Her makeup was smeared and her hair a little mussed as she quietly opened the front door.

He exploded. How could she do this? All the love he'd given her and here she was, turning into something he couldn't understand and could not allow. She had betrayed him and broken his trust. He wanted no explanation. In his heart, there was no acceptable reason a young girl would defy what she knew to be right and do these things. She was no longer a "good" girl. And he screamed every bit of this at her, adding that she was no longer his girl, either. She'd not done anything bad wrong, not gone "all the way", but she knew he wouldn't believe that, not right now, so she kept quiet. The last thing he said was that he wanted her gone from the house in the morning and stomped off to his bedroom.

In the morning, she was gone. He made his wife swear that she would never talk to their daughter again. And she always did what he wanted, because that's the way she'd been raised, too.

Days, agonizing, soul-rending days went by, then weeks, then months. As his anger and disappointment faded, a new, horrifying emotion crept in, stronger than any he'd ever felt - remorse and self-loathing. He came gradually but irretrievably to the realization that he'd made a devastating mistake, that he'd put the wrong thing at the top of the list. He'd thrown away the finest love he'd ever known for a rigid set of rules that he thought were required for eternal life. He felt betrayed by the Bible and quit reading it. All his life, he'd marched in a straight line, and this is what it got

him. A ruined, empty existence, the person most precious to him pushed completely out of his life. He began to drag the chair to the window and watch the road for hours, hoping against hope some miracle would bring his daughter walking up the road that ran out front. Sometimes, he'd take the chair out on the porch, occasionally down to the side of the road as if that would make it easier for her to find her way home. He quit going to church, couldn't even think of it and the preacher and all the stupid rules without tasting the bile in the back of his throat. He quit going to work and they soon fired him. He'd left them no choice. His wife swallowed her own disappointment in him and herself for awhile, but, after a year, there was no love left between them and she finally got up the courage to leave. He sank deeper into his sorrow and before long forgot to eat. One day, the mailman, curious as to why no one had emptied the mailbox in weeks, came up further onto the porch, looked tentatively through the front window and saw him there in the chair, slumped over. When the sheriff and the ambulance showed up, they determined he'd been dead for 5 or 6 days. He'd starved himself to death.

The girl had an older brother who'd left home when he got out of high school. She'd let him know where she'd gone when she'd been kicked out and they'd stayed in touch the whole time. She couldn't let her parents know where she was, but she couldn't bring herself to completely step away from where she'd come from either. Deep in her heart remained a shred of hope that one day, this nightmare would all be over. Something as wonderful as what she had before her Daddy threw her out couldn't die forever, could it? Her brother told her about their dad and strongly urged her for her own sake to come to the funeral and have some sort of concluding moment beside the casket, something to help her get past the disappointment that now would never be reversed, never be made right. She knew she must do this and she did, struggling to accept the crushing finality of her daddy's death. No chance in this life for redemption, for restoration. Everyone was at the funeral home, including her mother, who never knew her son and daughter had stayed in contact and who was shocked to see her daughter. Shame and regret flooded through her as she begged her daughter to forgive her. Over time the daughter thought she might be able to and tentatively returned her mother's embrace. But, she couldn't make herself look at her father lying there in his casket.

The next day, she went out to the old home. It was ruined, run down quickly under the neglect of her father. It was never in that good a shape, anyway, and it would have to be torn down now, and the land sold. The chair was still there, in front of the parlor window, facing out, just like it was when her father, ever hopeful, breathed his last. She went over and gingerly sat down, looking, as her father had for all those months, down the road that led up to the house. Now she could sense her daddy's presence. Memories, the sweet memories of the good days washed over her and she came apart. After some time, her emotions freed up, she realized that the chair, a key player in the love story that built their family also symbolized the destructive rigidness that tore the family apart. Such love her Daddy expressed through that chair, but, in the end, that's where he sat, hoping for her return and his redemption, after he'd chosen an extreme, grace-less, misguided belief system over her, self-righteousness over mercy.

She carried the chair to the car and took it to an old friend there to be restored. The rest of her life, the chair would go wherever she went. It would always be the first thing packed and loaded. She left it unadorned with cushions, wanting to keep it as it was; the memories came easier that way. Sometimes, she could see herself sitting there, sometimes it would be him. Sadness and unsolvable loss would come over her in its presence, but it seemed vital to her future to always remember what had happened in the past around that chair, both the cherished and the lamentable.

A couple of years later, she fell in love with a man she met at church back in her new town. They married and were soon blessed with a little girl. Mother would sit in the chair and watch her baby learn to crawl. She would lift the curious, tow-headed child up to her lap and read stories to her. Sometimes, they were Bible stories, and the Bible she was growing to depend on so much now described a love based on grace and forgiveness and acceptance. They didn't talk much at her church about rules. When her child would fall or run into something and burst out crying, she'd swoop her up and comfort her with a gentle rocking in the chair. From time to time, she'd be the one crying. She'd never be able to change what had happened before, but she determined to let it shape her into a parent who loved her child just like she was, who would pray her way through the tough years, and whose love would last a lifetime and beyond. She would make her new life a reality so complete, so wonderful, it would be one she could never have imagined all those years ago when she sat in the magic chair with a glass of Kool-Aid and a cookie and dreamed her dreams.

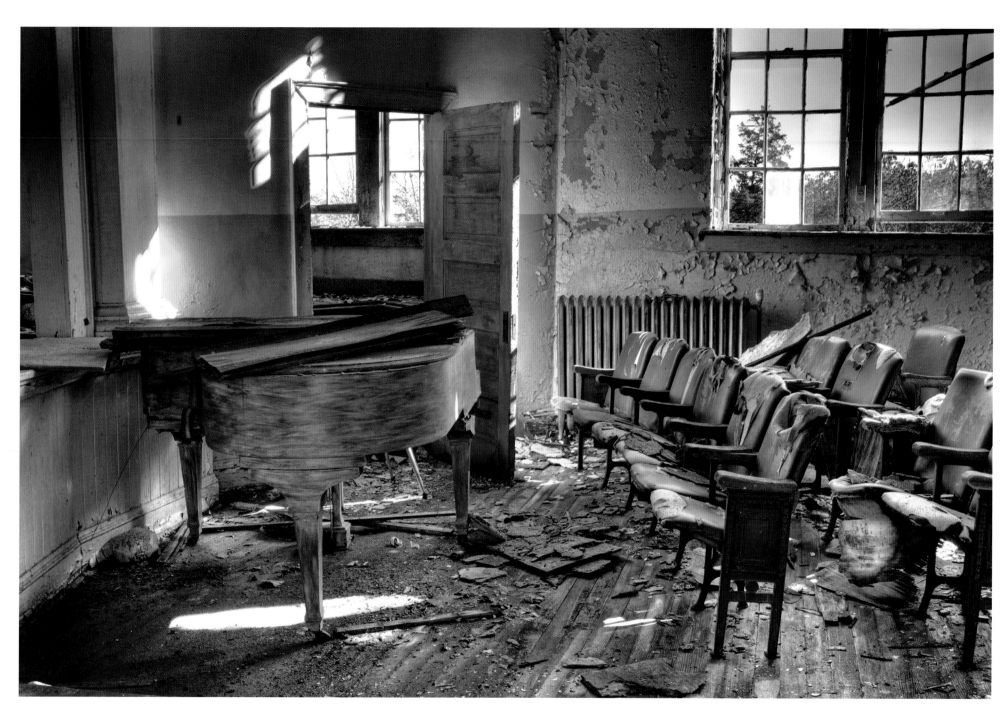

Out of Tune, Uniontown, Alabama

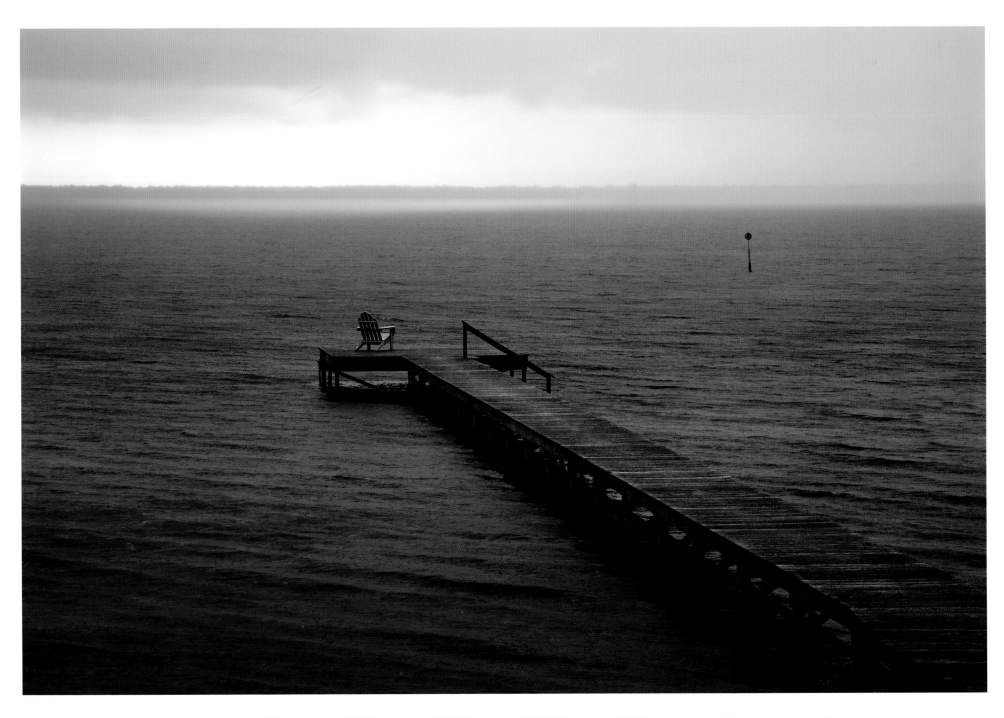

Idyll, Lake Waccamaw,, North Carolina

Mason County Courthouse, Maysfield, Kentucky

Summer Fair, Lacon, Illinois

Little Man Gone, Indiana

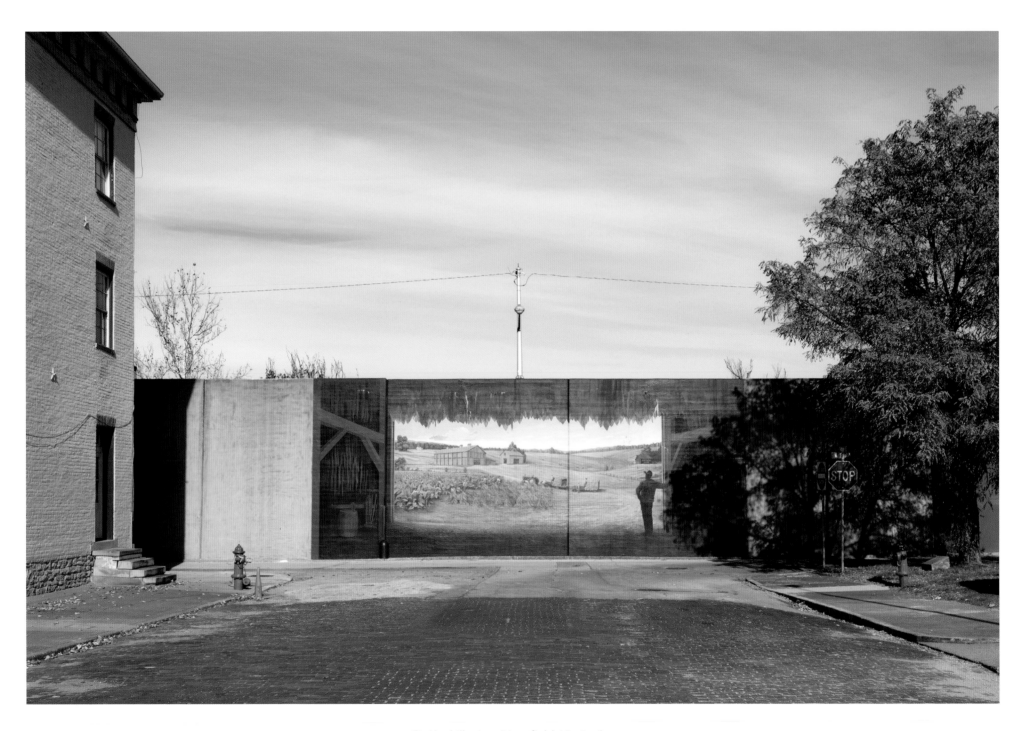

Optical Illusion, Maysfield, Kentucky

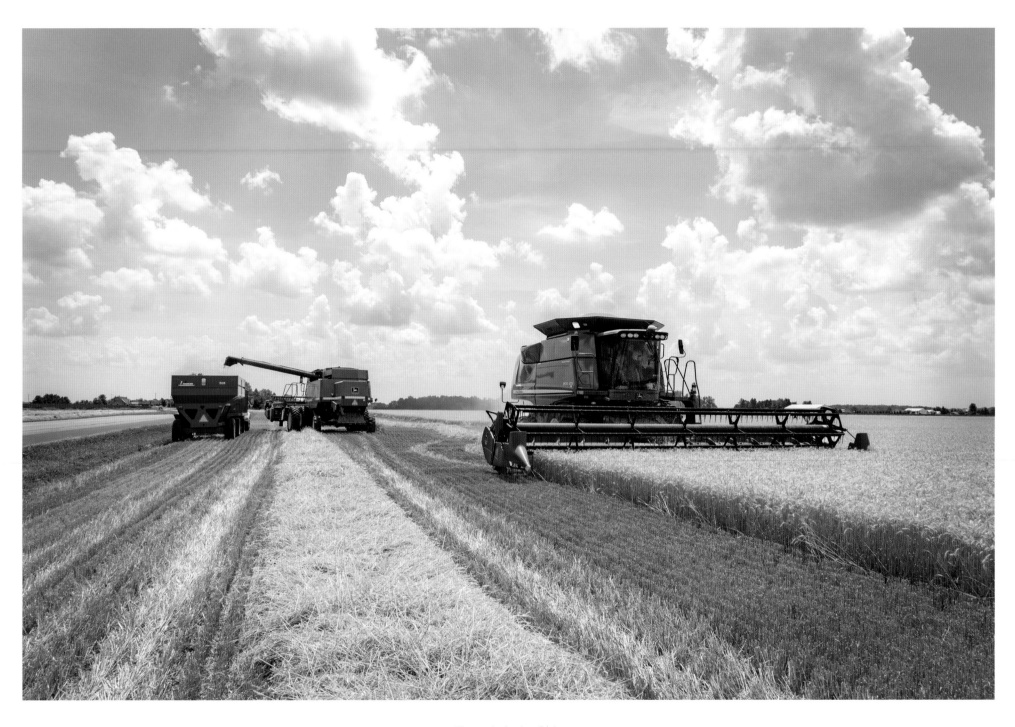

Team, Leipsic, Ohio

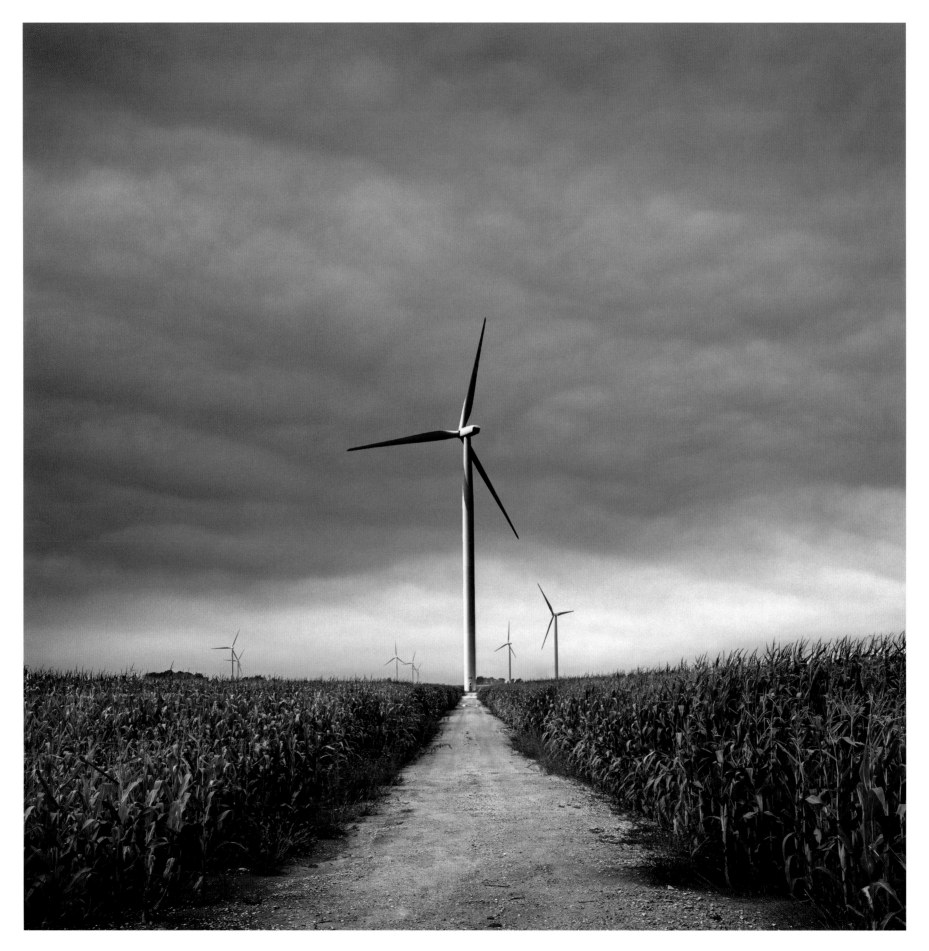

Wind Power, near Elwood, Indiana

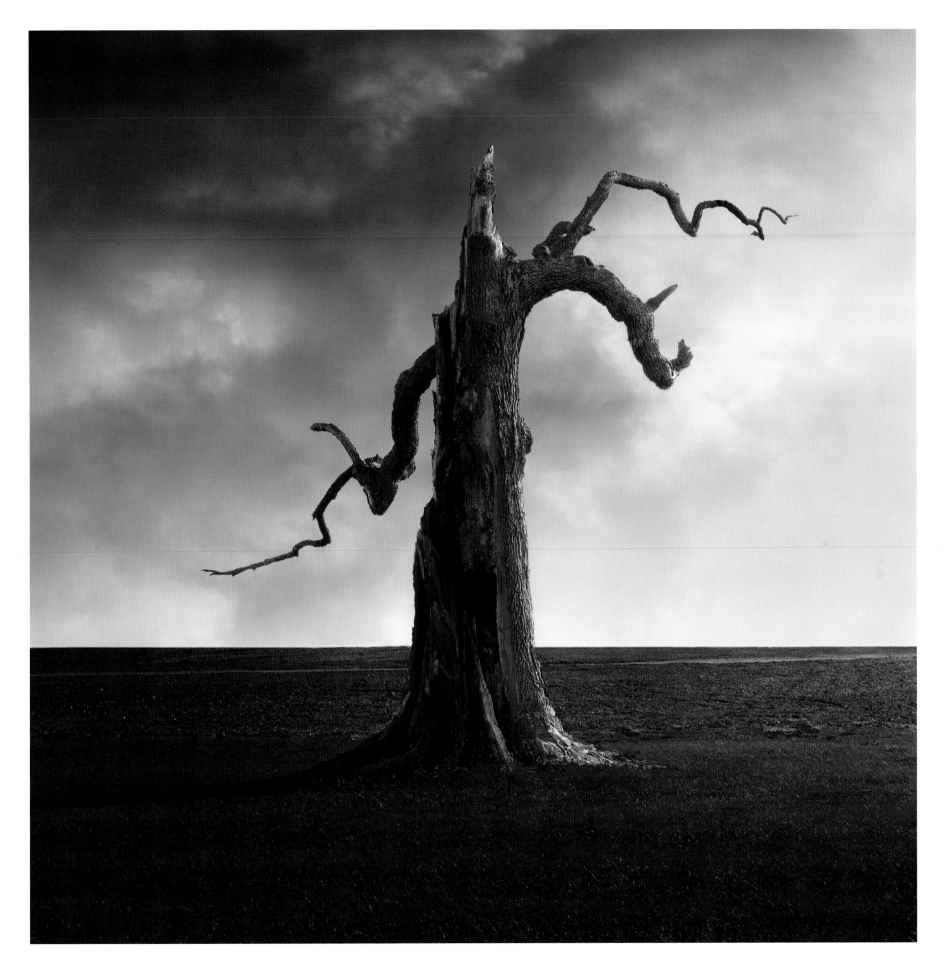

Still Here, Rushville, Indiana

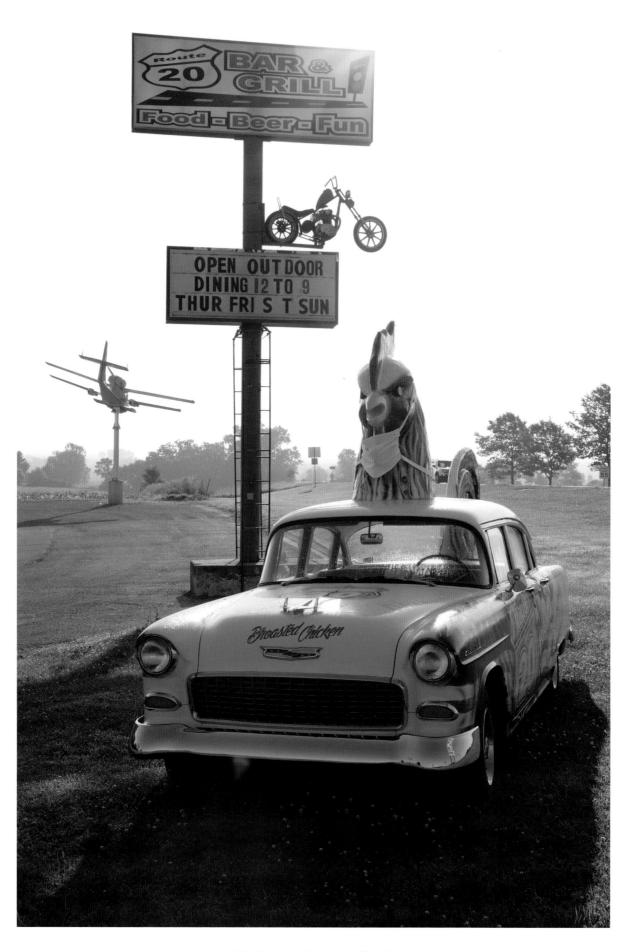

'55 Chicken, Freeport, Illinois

Round Red Roof, near Hillsville, Ohio

Cat in the Window, Camden, Ohio

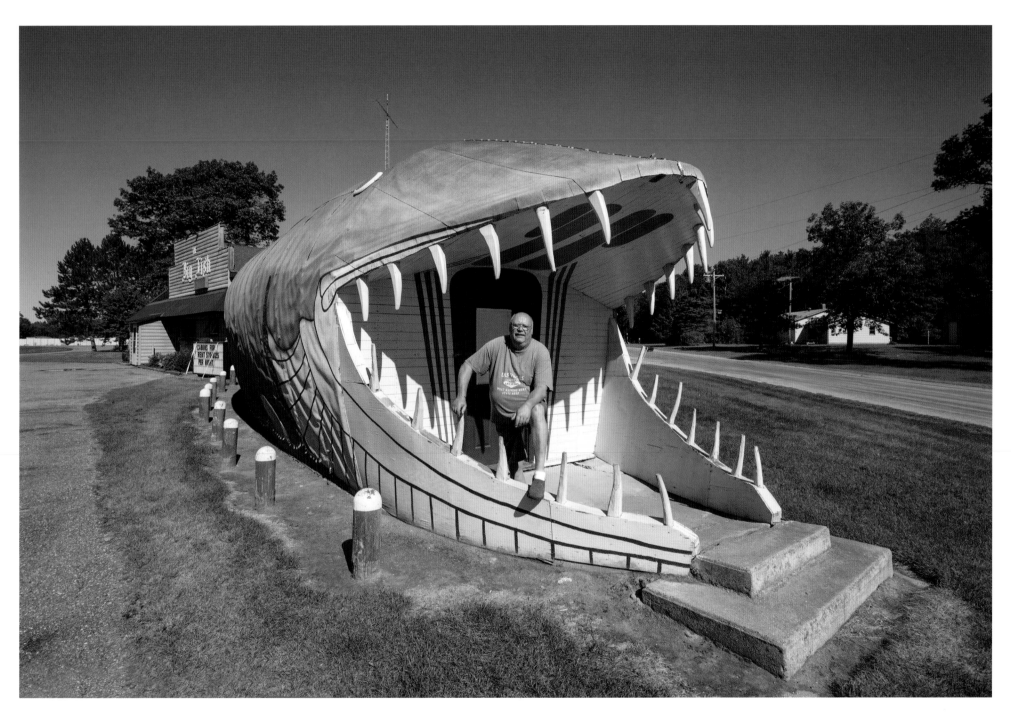

Big Al, Big Fish, near Bena, Minnesota

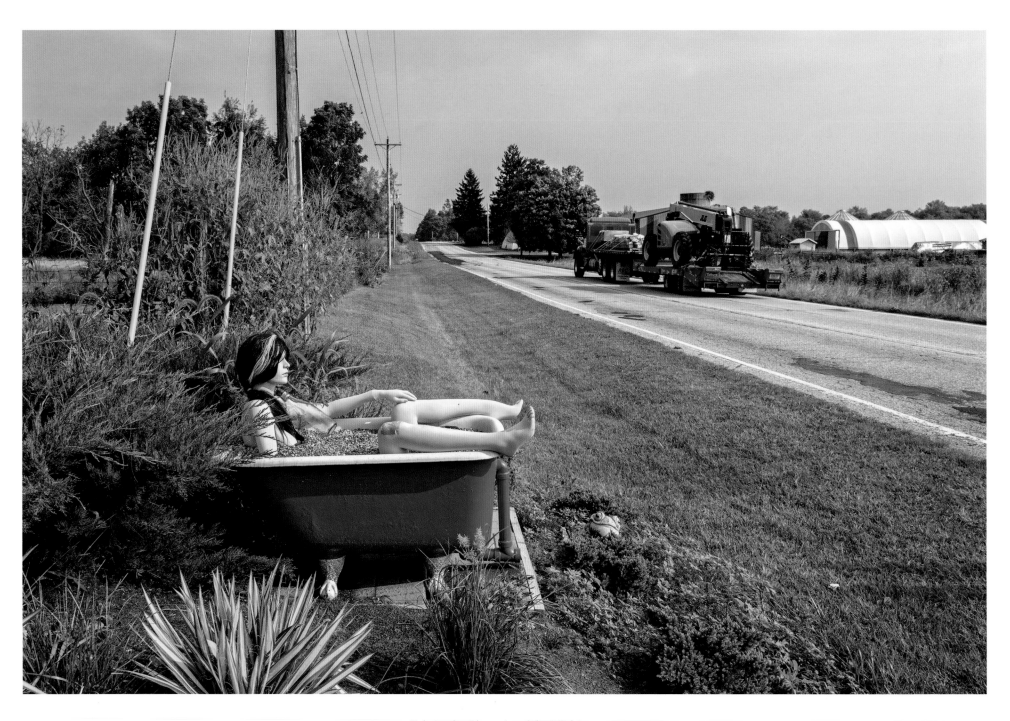

Tub Lady, Bloomingdale, Michigan

Stay Home, Be Safe, Marinette, Wisconsin

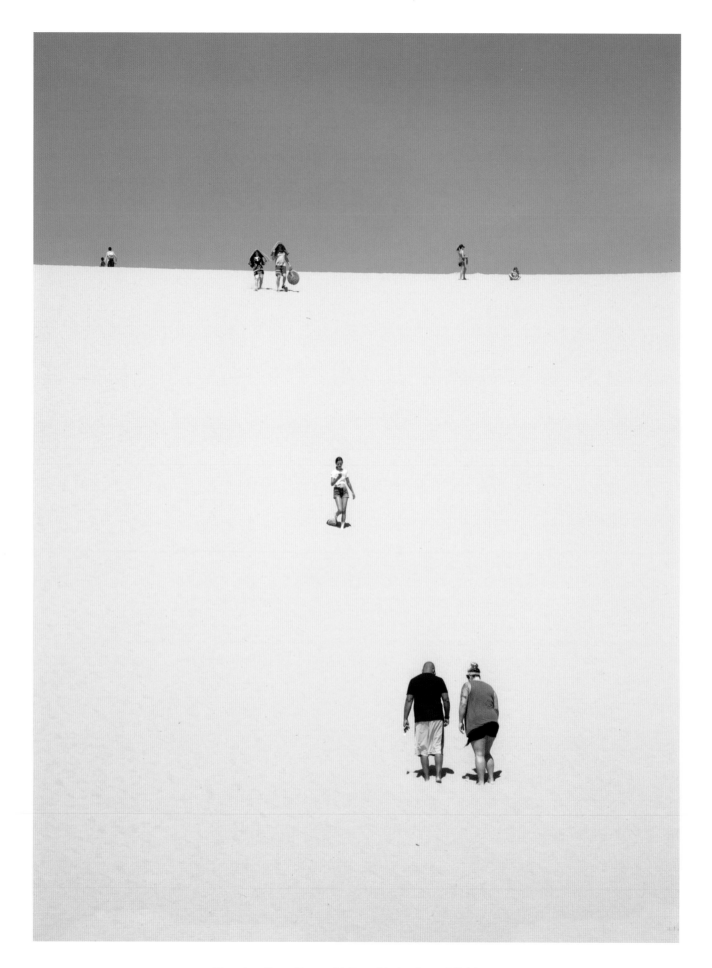

Sleeping Bear Dunes National Lakeshore, Michigan

From the First Bridge Over the Mississippi, near Lake Itasca, Minnesota

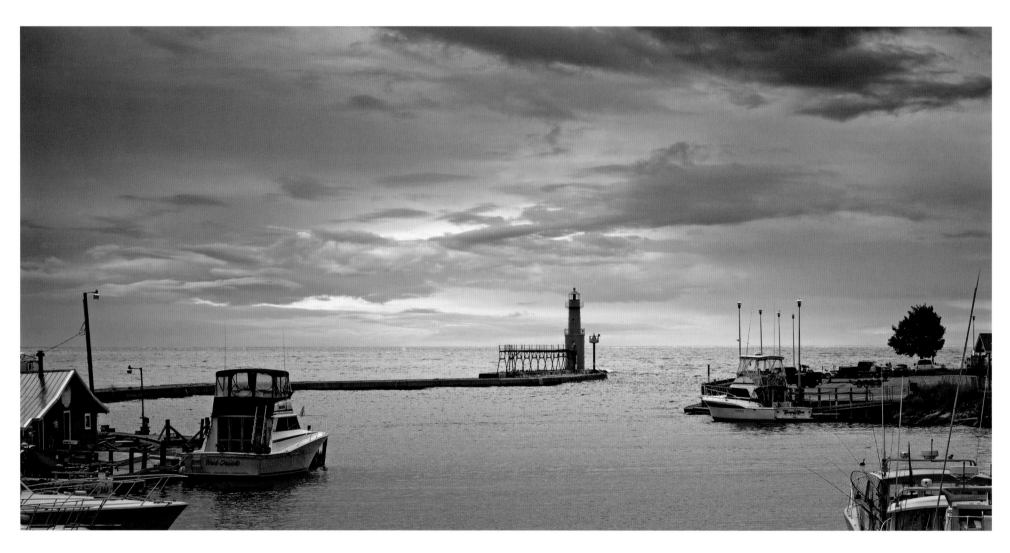

Guardian, Algoma, Wisconsin

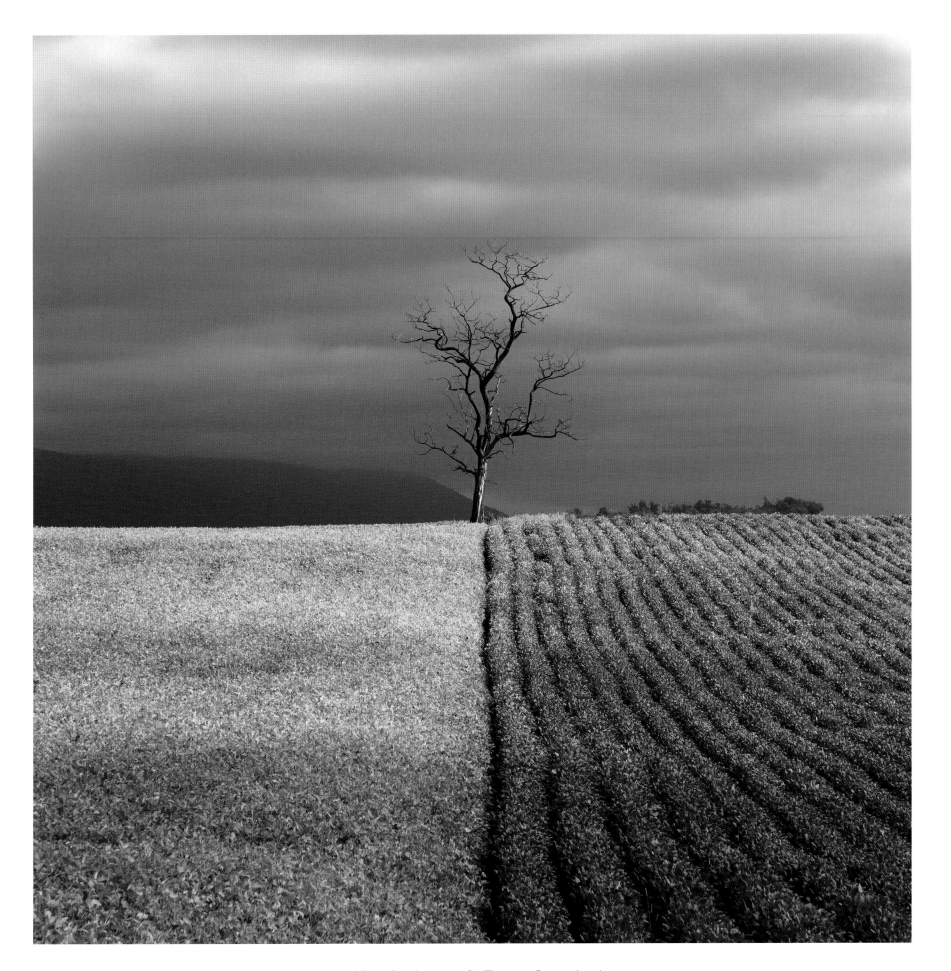

Holding the Line, near St. Thomas, Pennsylvania

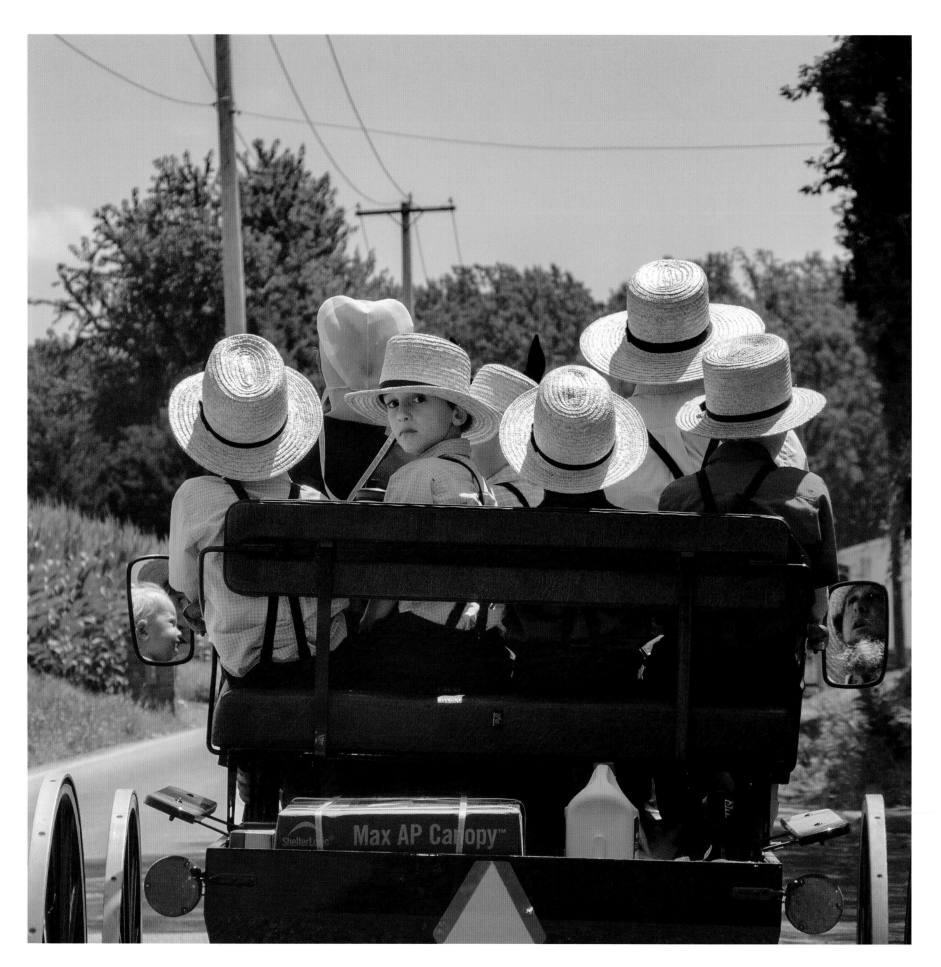

Sneaking a Peek, New Holland, Pennsylvania

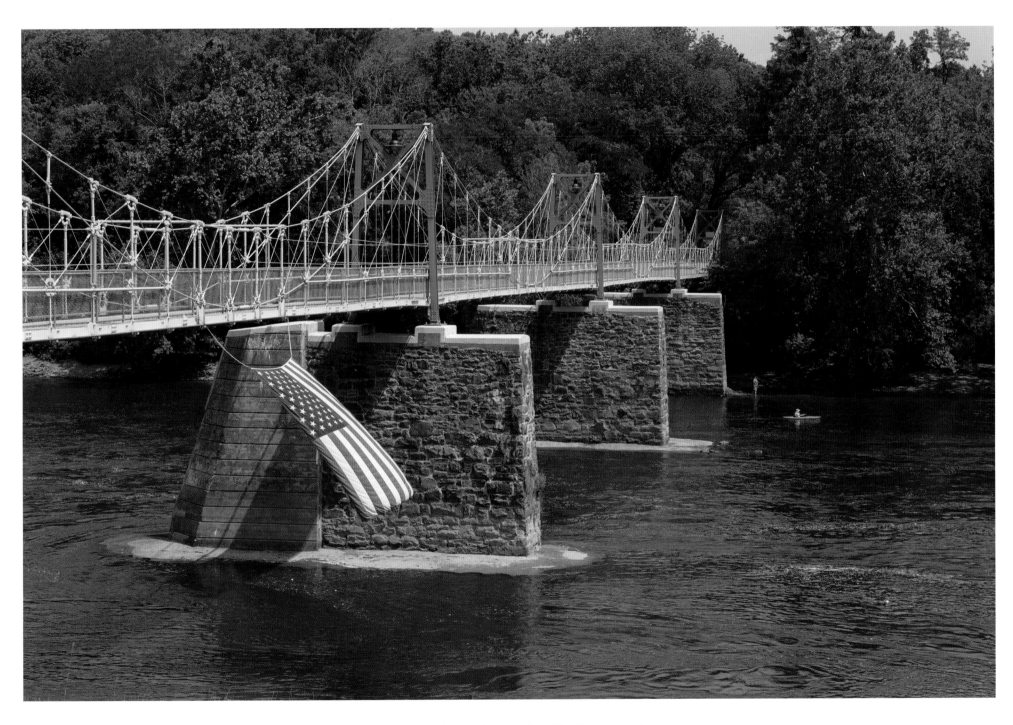

Flag Under the Bridge, Lumberville, Pennsylvania

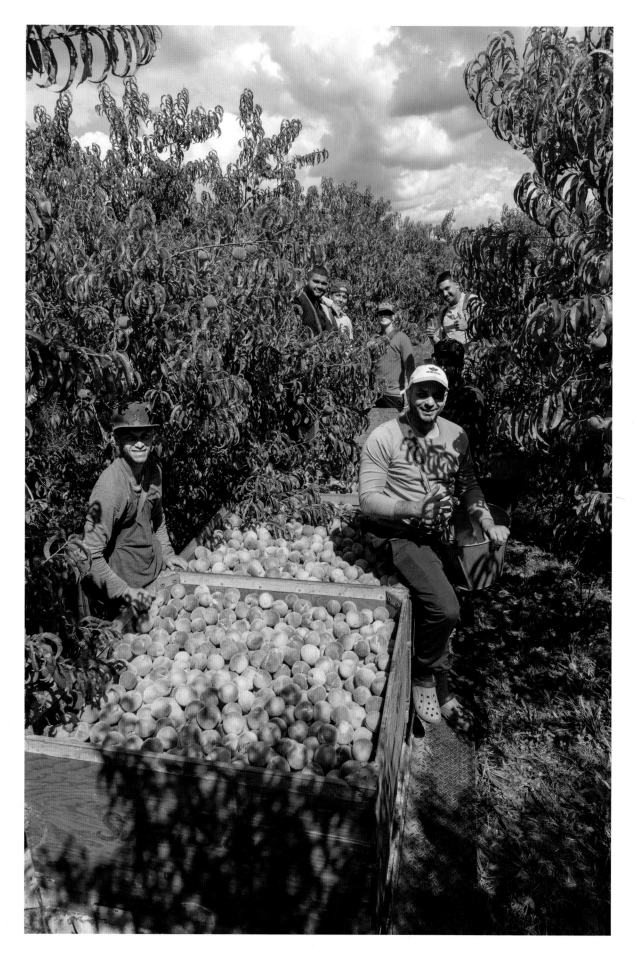

Peach Pickers, near Bridgeton, New Jersey

Off the Rails, Georgetown, Deleware

Bus Plus, near Summerville, West Virginia

Breakthrough, near Snow Hill, Maryland

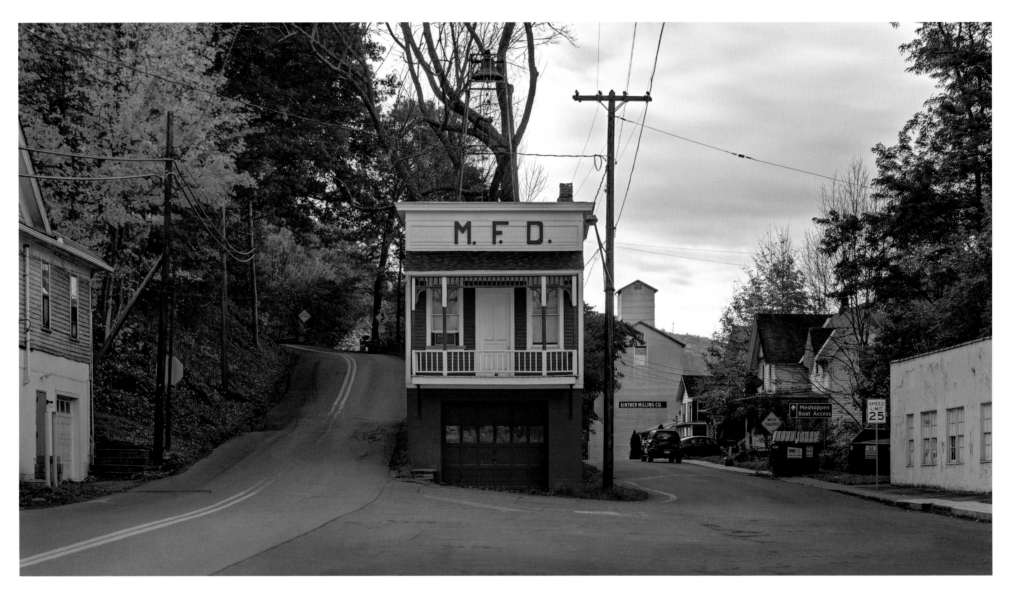

Meshoppen Fire House, Pennsylvania

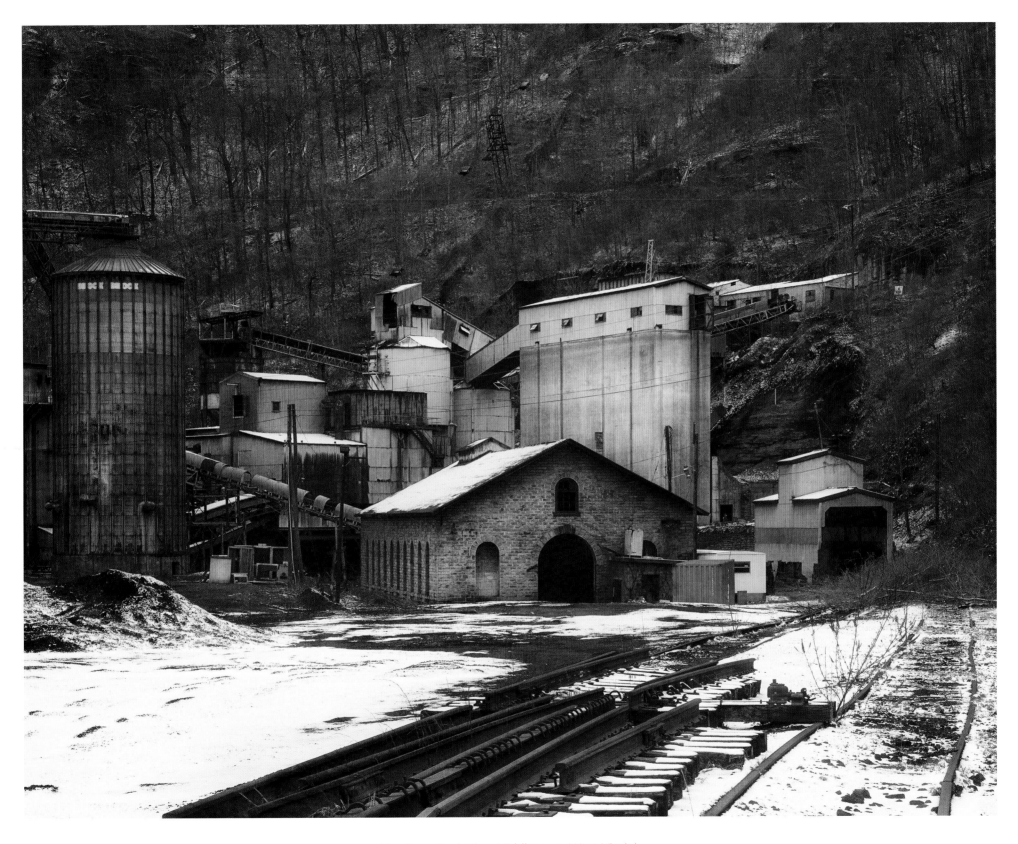

Keystone Coal Mine, Middletown, West Virginia

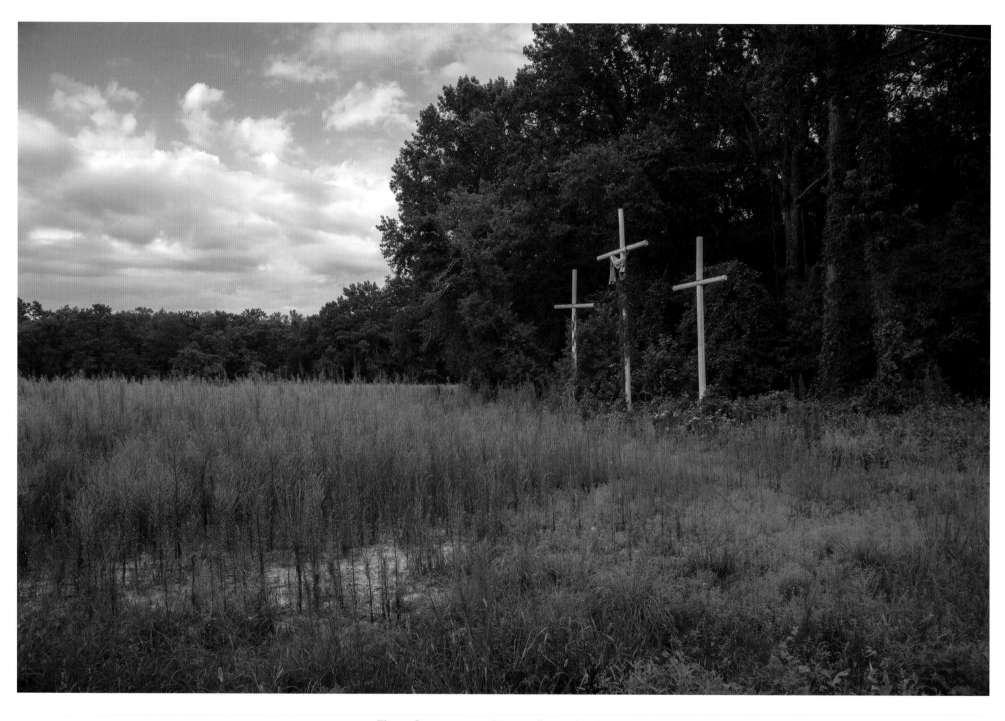

Three Crosses, near Snow Hill, Maryland

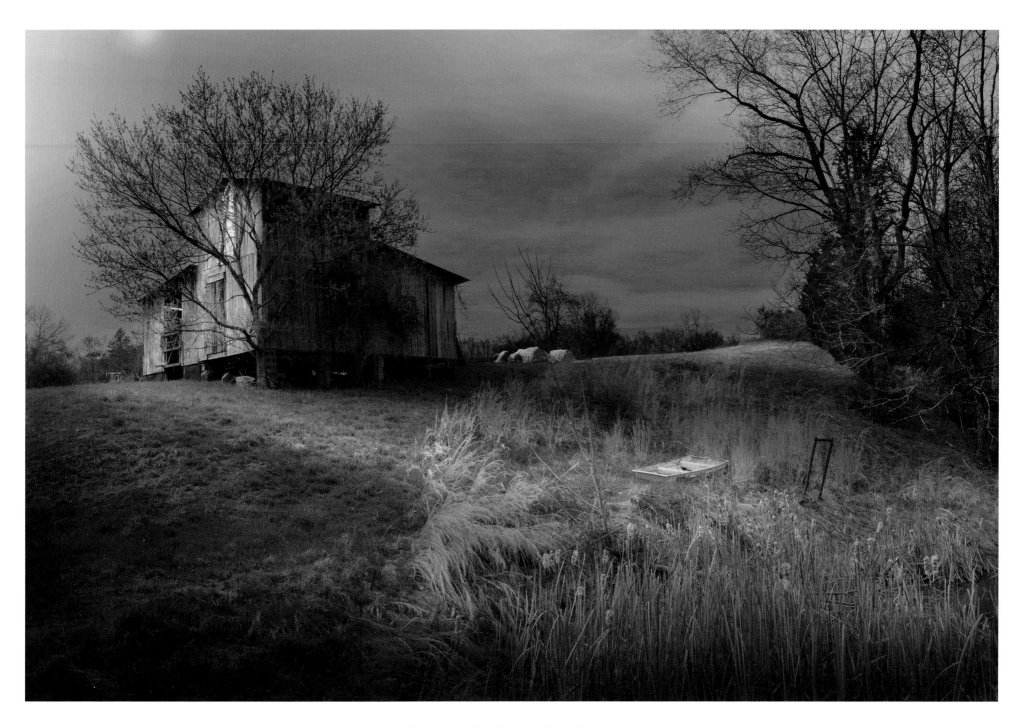

Flatboat In the Weeds, West Virginia

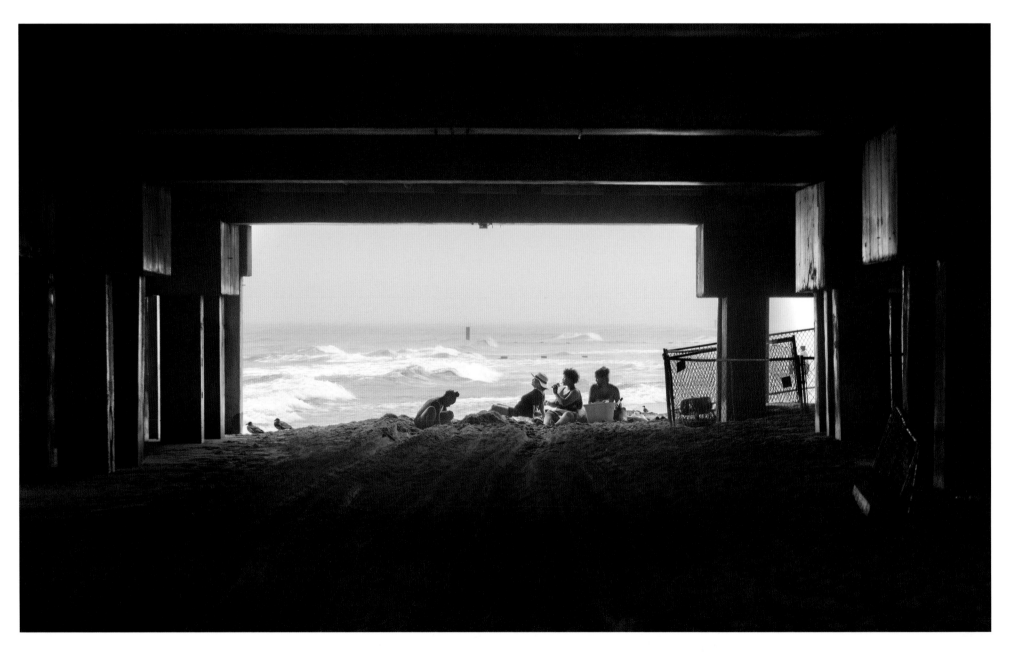

Cloudy Day Picnic, Atlantic City, New Jersey

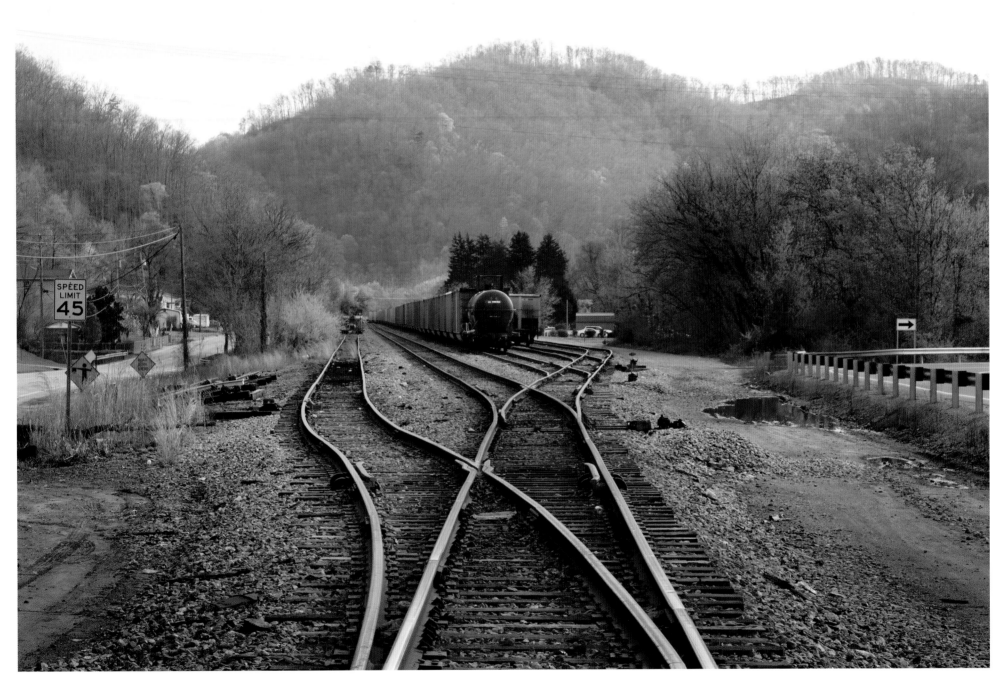

Convergence, Mingo, West Virginia

Branch Library, Falls Village, Connecticut

Gremlin, Randolph, New Hampshire

Still, East Calais, Vermont

A Place to Pause, New York

Working on the Railroad, Stockbridge, Massachusetts

Logger, Tamworth, New Hampshire

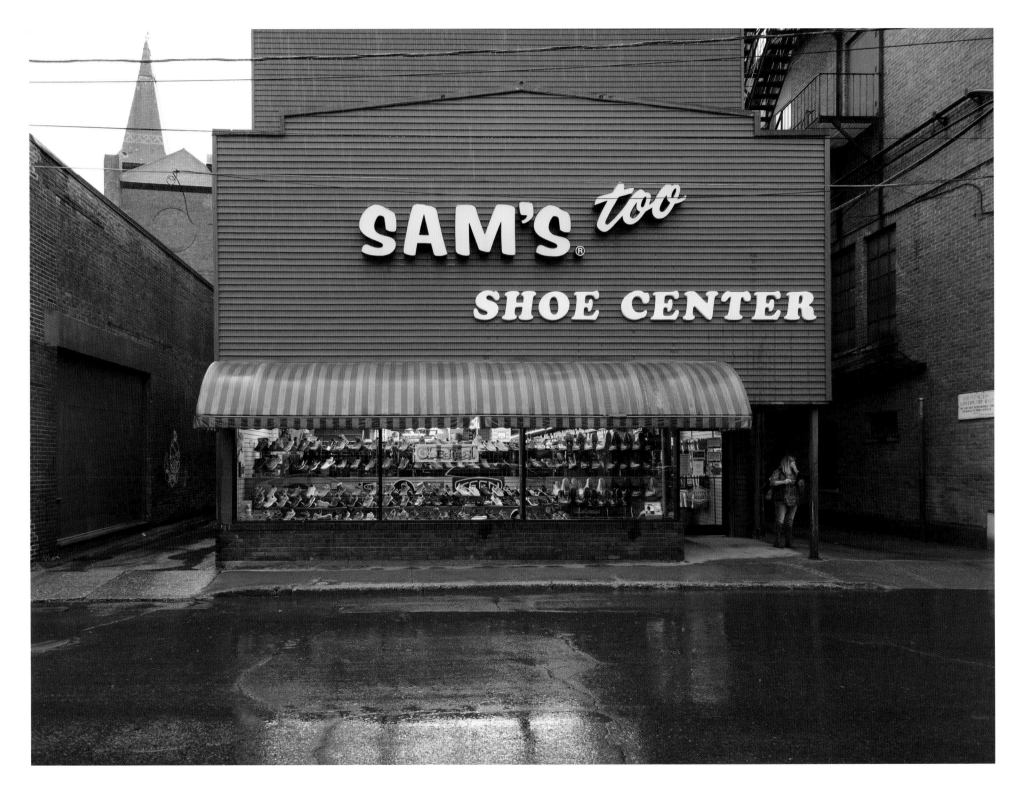

Sam's, Too, Brattleboro, Vermont

The Chasm
December 10, 2014

The monthly meeting of the county school board was promising to be anything but business as usual. When the issue that had been building for some time in the community was announced as the central focus of the next meeting, emotions flamed up, trust began to fray, and long-held relationships found themselves on shaky ground. The site was moved to the high school auditorium to handle the crowd and still left people standing in the back. A breezeless Indian summer night brought no relief through the opened windows. Fans waved, ties were loosened, sleeves rolled up. The atmosphere in the room crackled with menace. Never before had anything threatened to dismantle the community like this.

Charles swallowed hard and stood up. "Friends, it seems to me that God may have done some pretty important things that we might have to admit to not really understanding, and that we have to be willing to trust that it is still Him doing them. On this particular subject, we know that animals, for example, have changed over time. We have fossils of dinosaurs and birds and fish that clearly demonstrate that. Those creations are no longer here and new creatures that weren't around back then have replaced them. Is it not possible that the same thing is true of us? Of man?"

The rumbling snapped to life like a dozen race horses bursting from the starting gate at Churchill Downs. Russell jumped to his feet, barely ahead of several others. "You're telling us that we came from a bunch of apes? That doesn't square with anything the Bible I read says! God made the animals and THEN made Adam and Eve! And in HIS image! You're claiming God is a monkey?!"

Murphy took up the protest, "Yeah, and He did it all in seven days. If He'd done it over a billion years, He would've told us that in the Scriptures! You weren't there, none of us were there! That's why He gave us His Word to go on. How come you think you're smarter than us? Smarter than the Holy Bible?"

Russell again, sweat rolling down his back: "I'm sick of scientists trying to rewrite history. If they don't believe, that's between them and the Lord. But, by God, don't come in here trying to get me to believe it!"

Charles paused for a few moments to let a little bit of the tension settle back out. Keeping his voice calm, "What if there is no conflict between science and faith? What if science is actually given to us to get to know God better, to use and stretch our God-given minds toward a righteous purpose, to actually know Him more clearly. Half of the scientists I've read about in this matter are Christians, after all."

Betty stood and showed that not all the women in the county were willing to hold their tongue in public, to let the men have the only influence in something so near and dear to the whole family. It had been almost 20 years since the trial over in Dayton had settled things, and this issue needed to stay settled. "Are you expecting us to throw away everything our mamas and daddies and their mamas and daddies believed all their lives? On something that goes against the very Word of Almighty God? Shame on you!" Turning to the school board and pointing a hard, steady finger at the chairman, she went on, "I'll tell you this. If you bring this sacrilege into our children's classrooms, if you put this garbage in our textbooks, you'll not see my kids in the schoolhouse another day of their lives! I'm not subjecting my babies to a bunch of poison-spewing lunatics who are on their way to hell!"

The War had ended a couple of years ago, but this one, much closer to home, was ramping up to full, combustible speed. And the sides were just as far apart, each just as convinced of their rightness. The chance for any compromise, any leeway granted the other view, just as hopeless.

"Ma'am, I'm so sorry. I checked the stockroom and we don't have that in your size." Charles sighed as the customer left, a chance at a much needed commission gone with her. He had gotten a call the morning after that school board meeting by the head of the Board of Deacons to tell him that they had convened an emergency meeting over breakfast and the vote was unanimous - he was no longer welcome in the pulpit. His time as Senior Pastor of the Mt. Sinai Independent Church was hereby terminated. The chairman suggested that Charles might want to consider moving his family to another town. Which he did, over here to Jackson. No church would touch him and he finally found a job in the shoe store. His wife had to go to work. His 9-year old daughter still misses her friends and doesn't understand the whole thing, including why her Daddy had to say those things that made people so mad. Sometimes he wonders, too, as they struggle to make ends meet. But, the same faith that was at ease with God doing things in ways that he doesn't fully understand, believes that the three of them will never fall outside of His all-sufficient grace and care, and that God isn't done with him yet. Nor with Man.

173

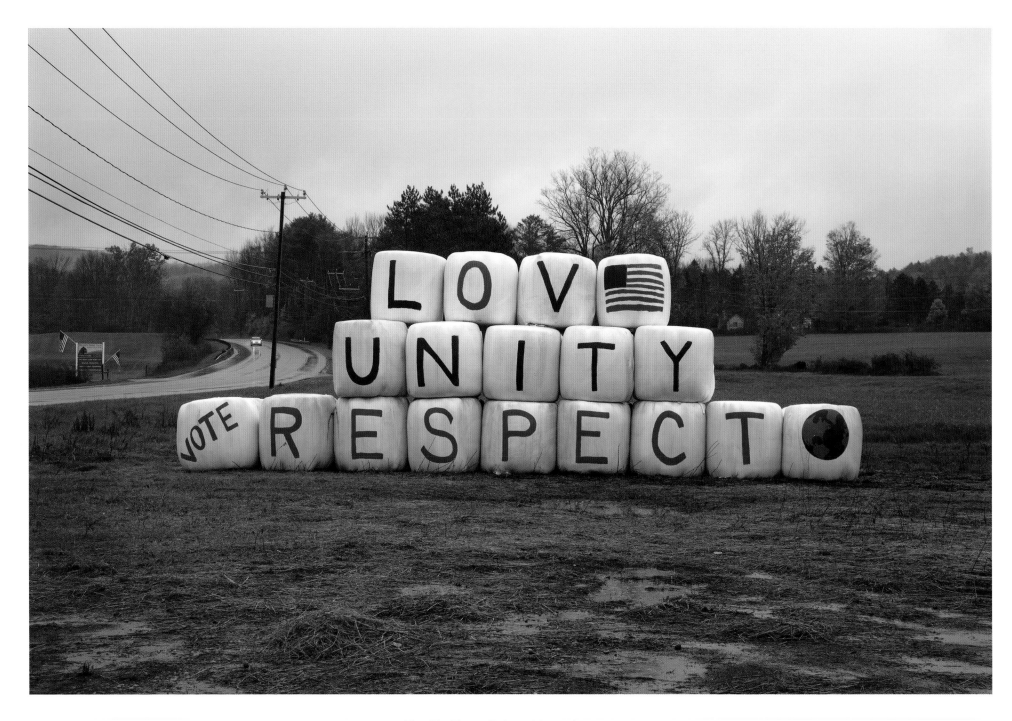

The Big Three, Dalton, Massachusetts

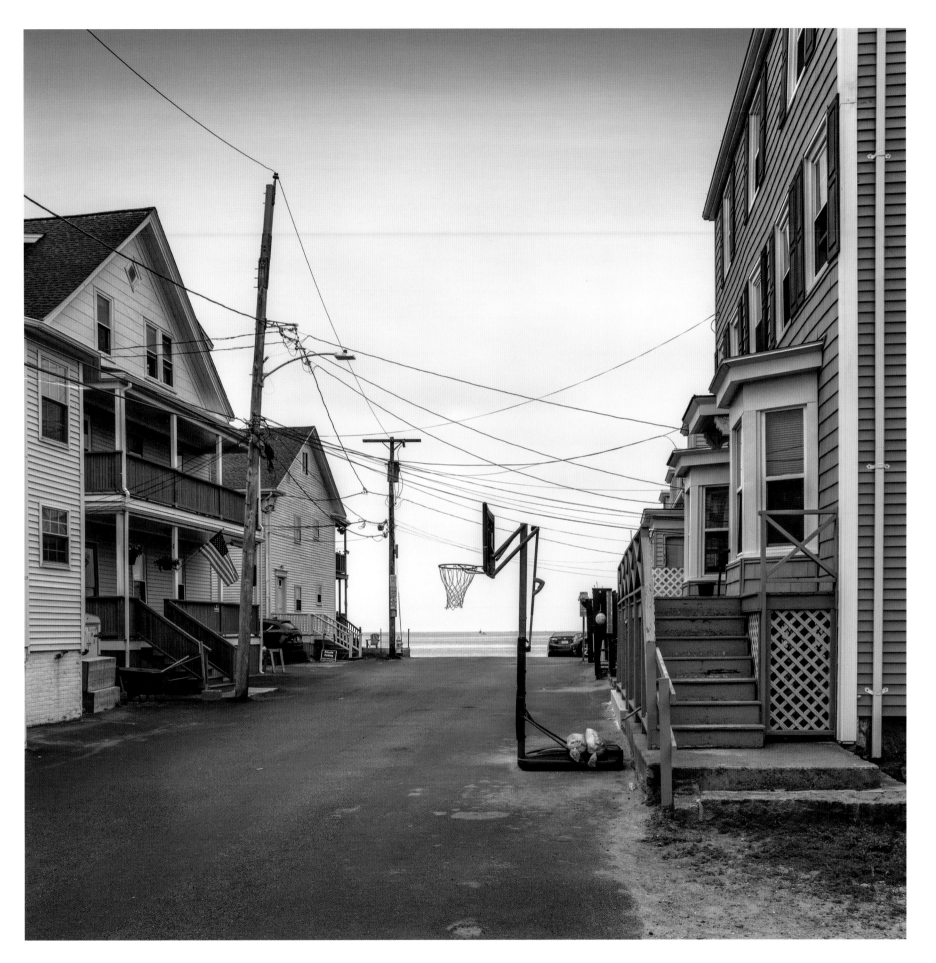

Backstreet Basketball, Glouchester, Massachusetts

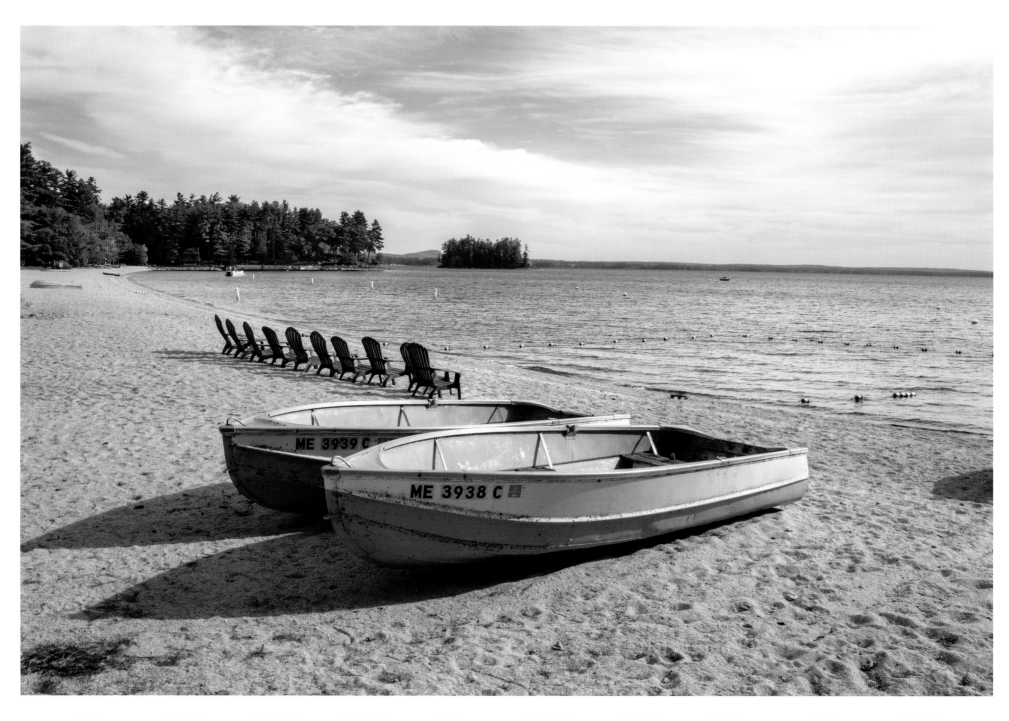

Boats and Chairs, Sabago Lake, Maine

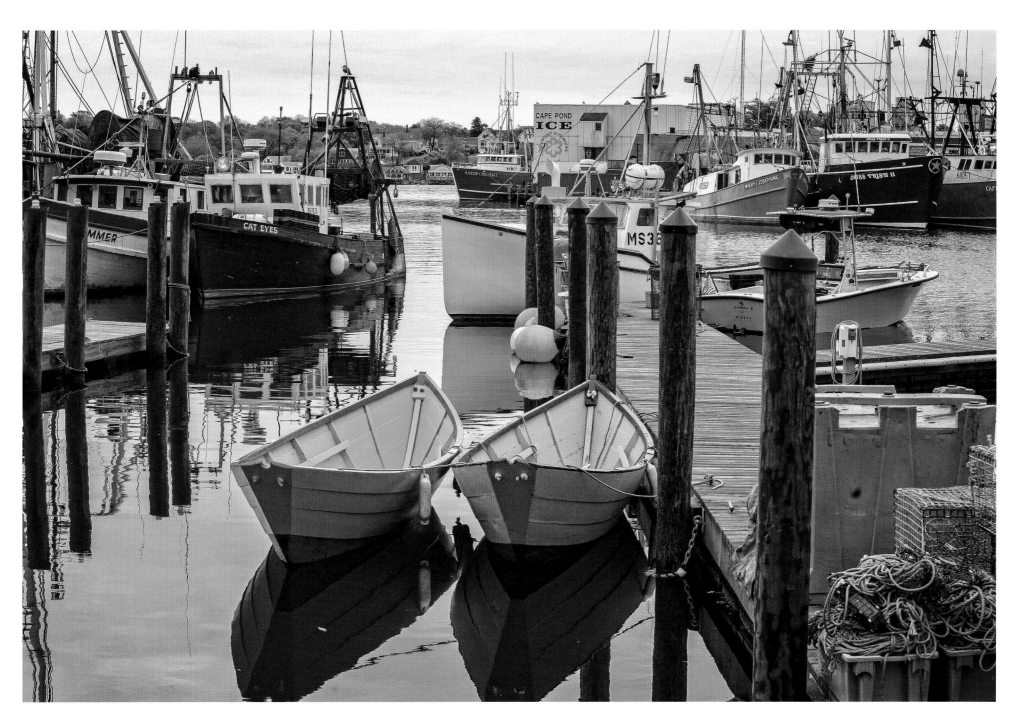

Two Boats, Gloucester, Massachusetts

Come Back Tomorrow, Weekapaug Beach, Rhode Island

Blue Chair, New York

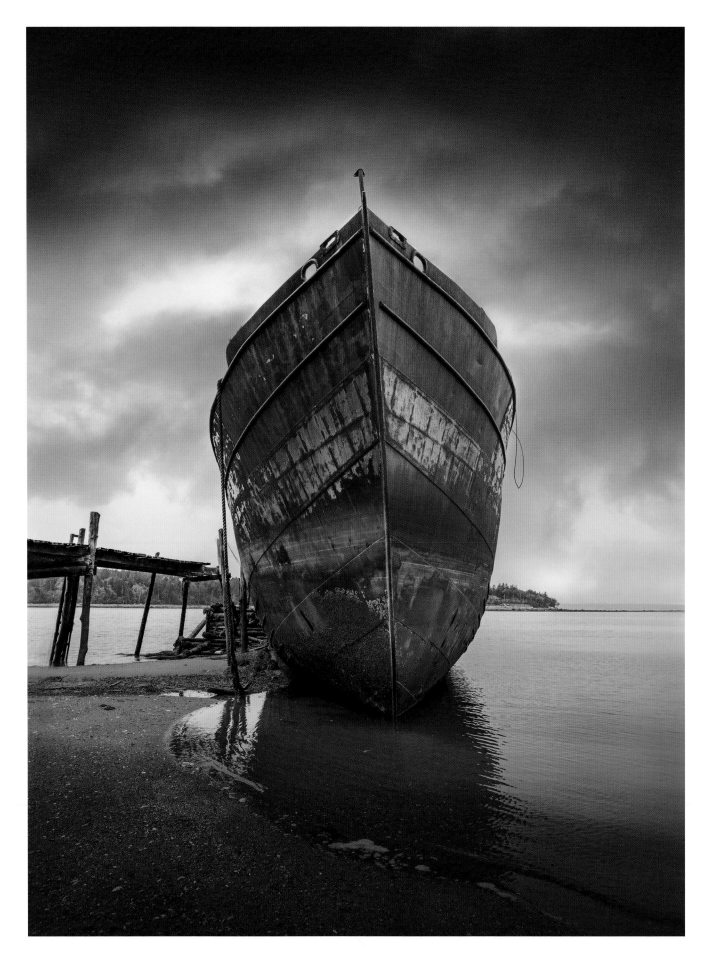

Rusted Hulk, near Castine, Maine

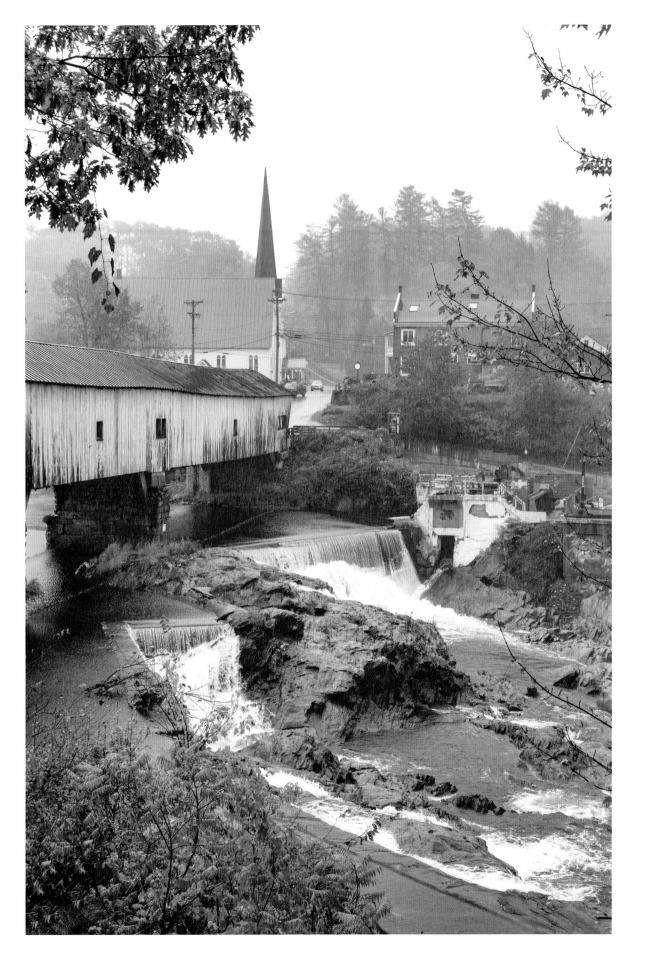

Falls at Bath, New Hampshire

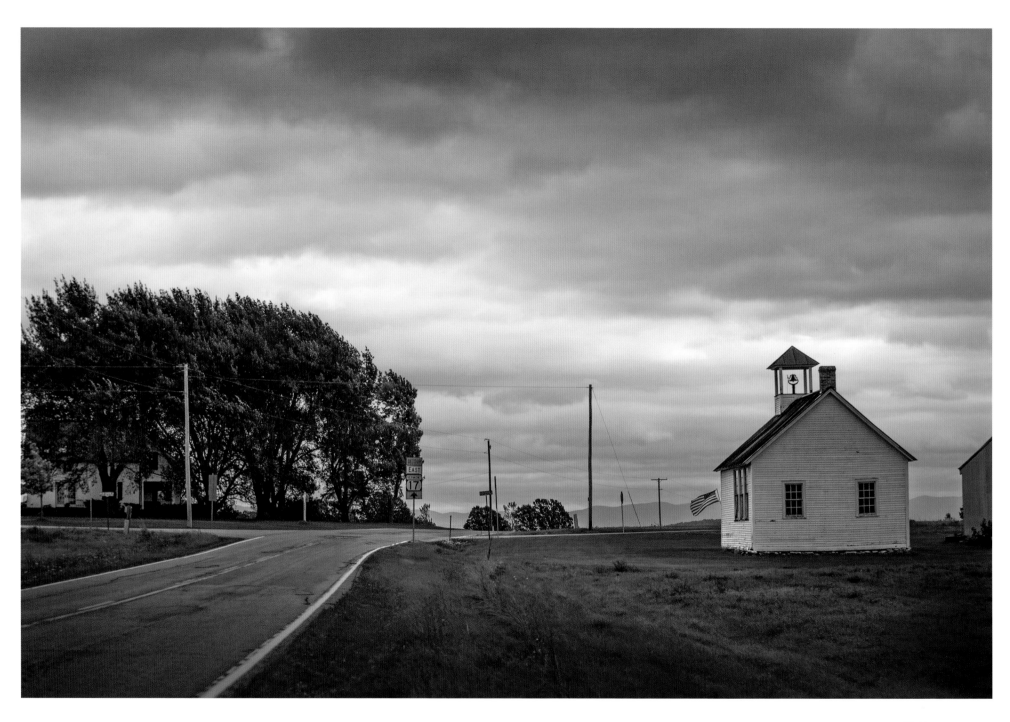

Crossroads Classroom, Vermont

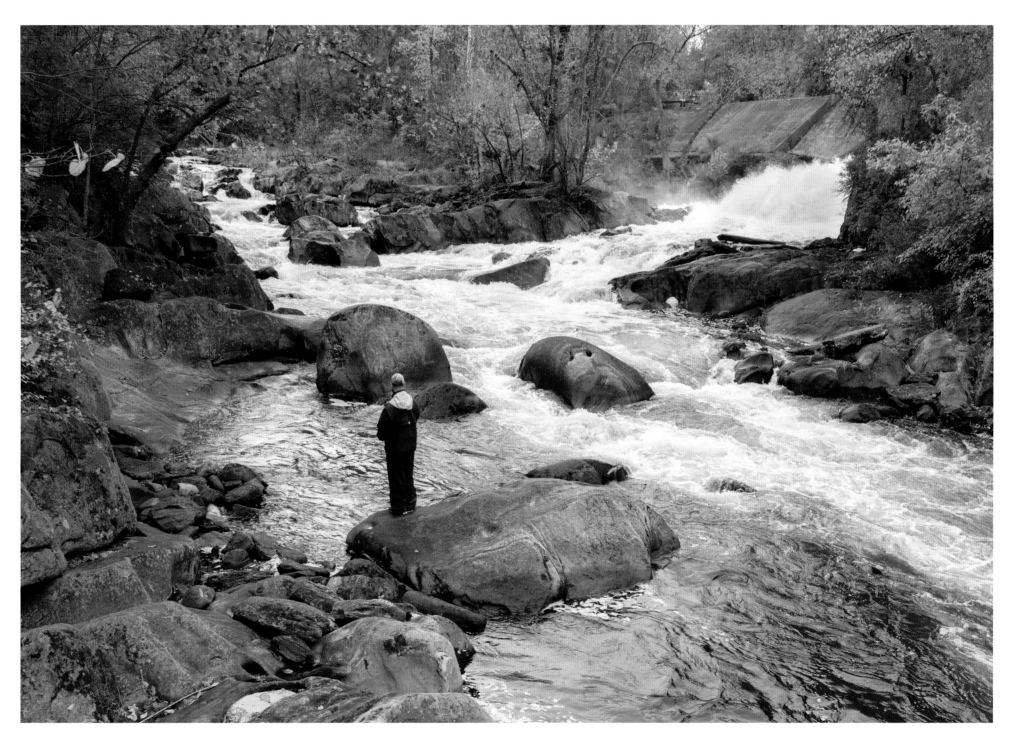

Fishing on the Housatonic, Kent, Connecticut

All to Myself

December 12, 2018

I pull into an empty parking space. Well, they're all empty this time of year. I grab a bottle of water and a sandwich from the trunk, turn the collar of my windbreaker up and lock the doors. Across the lot and onto the lined planks of the boardwalk, admiring for the umpteenth time how much care someone put into the design of the decktop. Diagonals meet squared off frames of boards with lighter and darker groupings of wood making you think of a child's game. Despite that, I feel no inclination to hop, skip, or jump.

I think today I'll sit on the middle bench. A football field of boardwalk to my right and to my left. The beach stretches south to the jetty. Soft waves break lightly on the shore and the late morning sun glimmers on the water as it slides back lazy into the surf. A half mile north, a pointed shoal pierces the tide like the prow of a sea bound ship. The coast beyond is a mystery. Cottony clouds scud across the breezy spring sky, paling out the deep blues as they go until the cloud tails slide past and the blue is still there, rich as ever. Are there patterns up there today? Nah, not really. A scattering wind has seen to that, grabbing the whole and pulling it apart like cotton candy, wisps trailing in every direction. This time of day, I'm still in the sun and I'm thankful for that. It feels good on my shoulders. My palm rubs the ash-bleached wooden seat, worn smooth by decades of out-of-breath kids sliding to a stop for the fewest of seconds and people like me who ease into the curve of the bench and reluctantly ease back up when it's time to go. I unwrap my sandwich and trap the cellophane under my leg for the moment. The tuna tastes better out here, like this is where it is meant to be eaten, closer to where it came from.

The sounds are familiar, as dependable as the ebb and flow of the tide. There may be no other folks here, three weeks before Memorial Day, but the sea gulls and the terns are, just like always. They caw and call in recognition and invitation and celebration. The wind is powerful, forceful, yet the birds, light as a handful of flesh and feathers, apply the curve of wing and twitch of tail to the bluster and make it take them where they want to go. To soar and feed and fight. To come to earth and take off again. And the water...crashing ashore in a muted explosion, then sliding backward in soft fizzes, a mist releasing upward until it thins out and becomes part of the air. Sometimes, if the drift is just right, the sea booms into the jetty, reminding me of just who it is I'm in front of. The wind hisses through the screened porch of an off-season cottage close by, the unlatched door flapping against the frame.

And then, there're the smells. Warm, sun-baked sand, dotted with life recently of the sea. Creosote laced pilings holding up the empty pier. Salt laced breezes that I inhale as deeply as I can, trying to capture some of it to take home with me. Oh, to have a way to record smells and rebreathe them later....

When I was a kid, a summertime trip to the beach made the difference between just a regular old year and a year I would talk about and remember parts of forever. The more people, the noisier, the more friends I could take with me, the better. Up early, out in the sun all day (boy, get out of that water for a minute and come put this sunscreen on!), fried food and ice cream, and fall in bed exhausted. But now, the off season is my season. I don't want a lot of people around. I get plenty of that on a regular basis. As a 10 year old, I guess, I needed the activity and the interaction, even the noise to make the experience come alive. It was more exciting that way. But now? I don't need anything extra. Nothing to filter out one iota of the essence of the beach. The sun on my face, the wind in my hair (such as it is), the sounds and smells. My only obligation being to let my senses loose to take it all in.

And, as I have found, this is an easy place for reflection. Superfluous stuff gets swept away with the swirling breezes out here. When you're this close to eternity, you tend to think a little more clearly, more long term. The right things ease their way to the top of the list and the junk slides off the bottom. It's especially clarifying if I haven't been here in awhile.

Hey, I wonder if my book is still - I pat my jacket pocket - yes! Good. I find the dog eared page, flip back to the start of that chapter to get caught up and slip into the stream of the story, where I stay - off and on between nod offs - for the next hour or so.

Well, it's getting on past mid-afternoon and I'm feeling a little stiff. I close the book, stand and stretch and decide to walk down to the jetty and back before I head home. Goodness knows I could use the exercise. I put my trash in the barrel and step onto the sand. Hmmm....I think, as I look out to the horizon, maybe one more visit before Memorial Day.

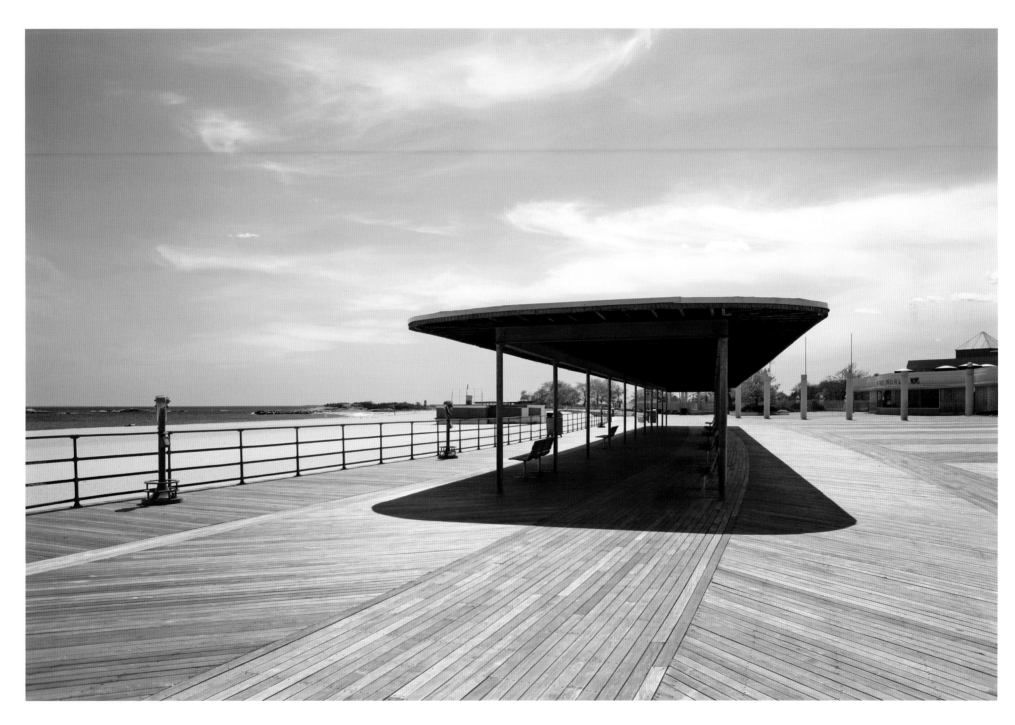

Off Season, near New London, Connecticut

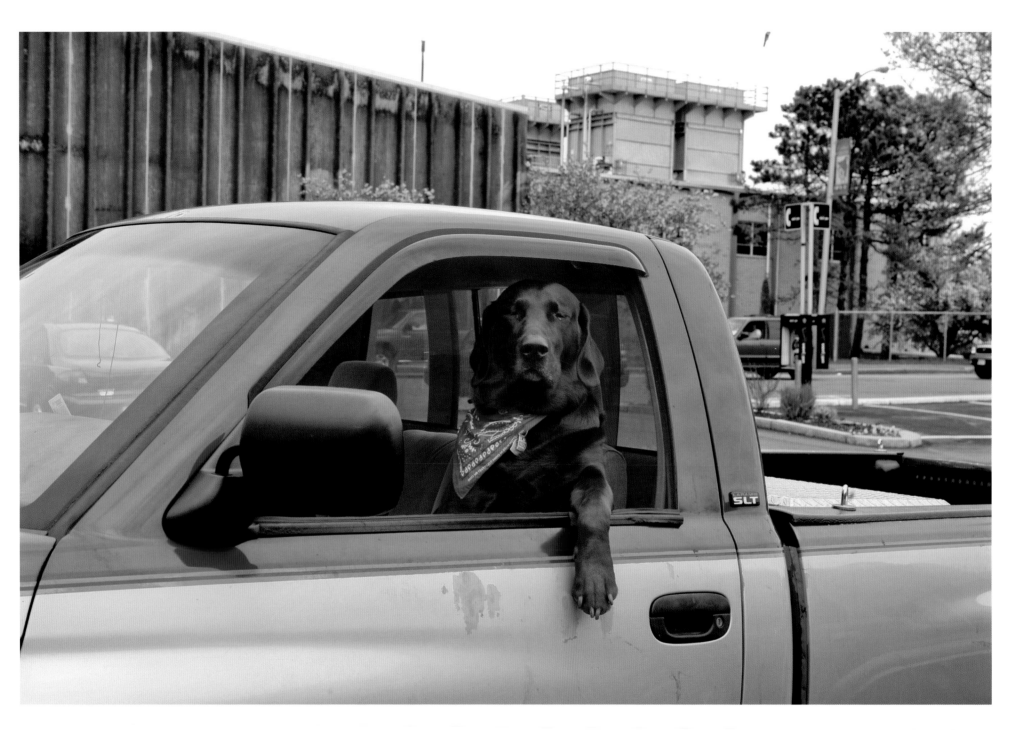

Truck Driving Dog, Gloucester, Massachusetts

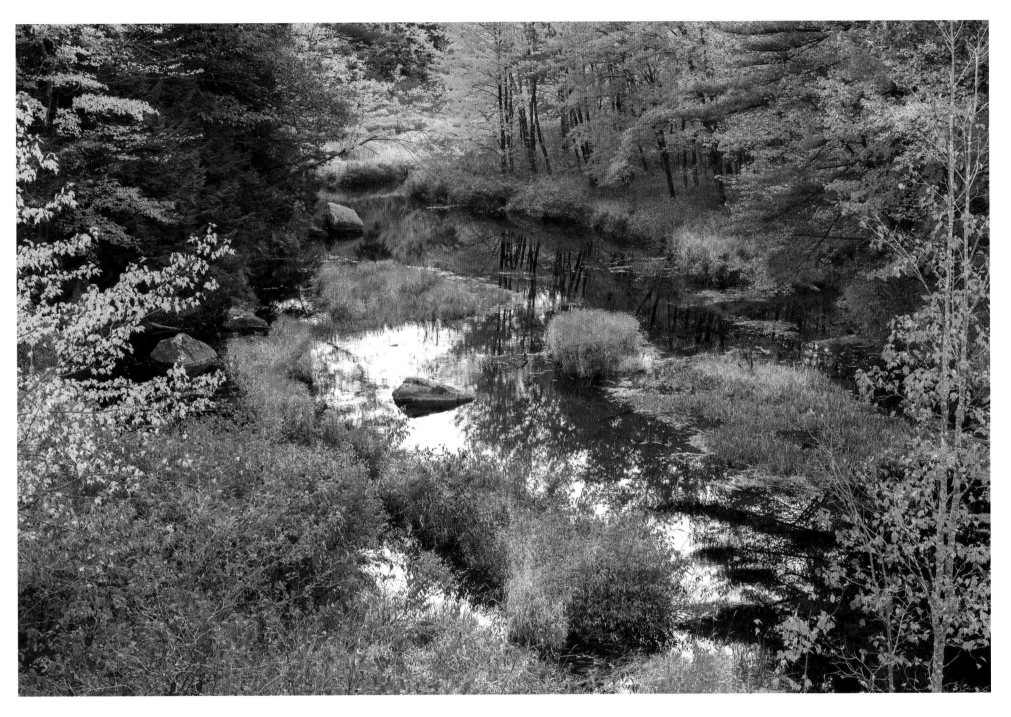

Fallburst, near Turner, Maine

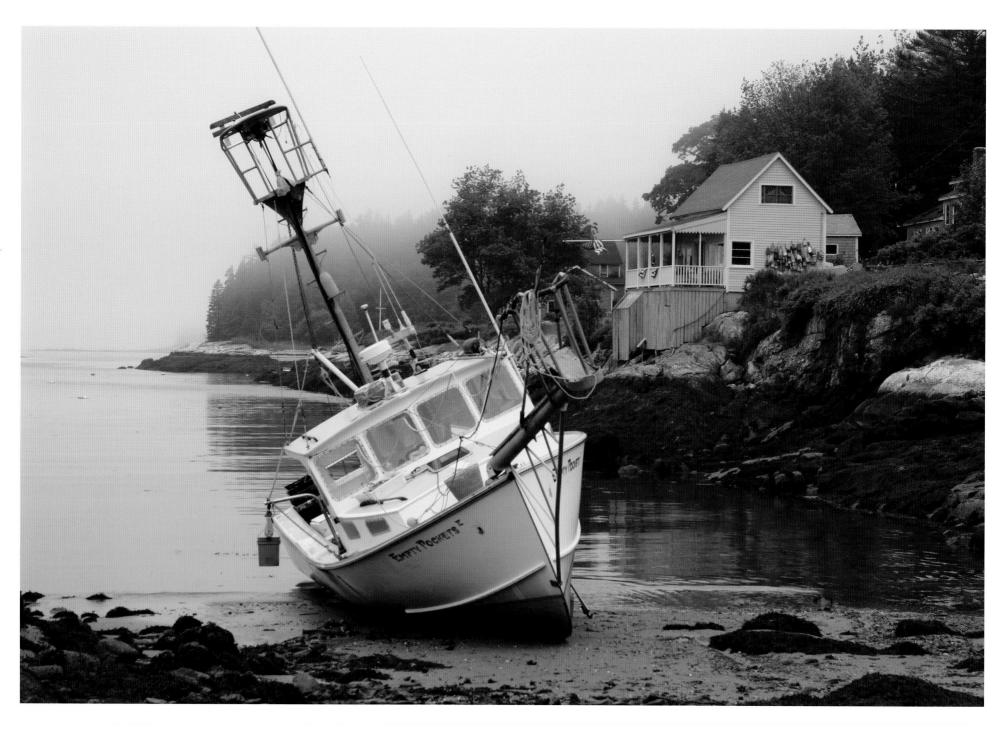

Beached, Five Islands, Maine

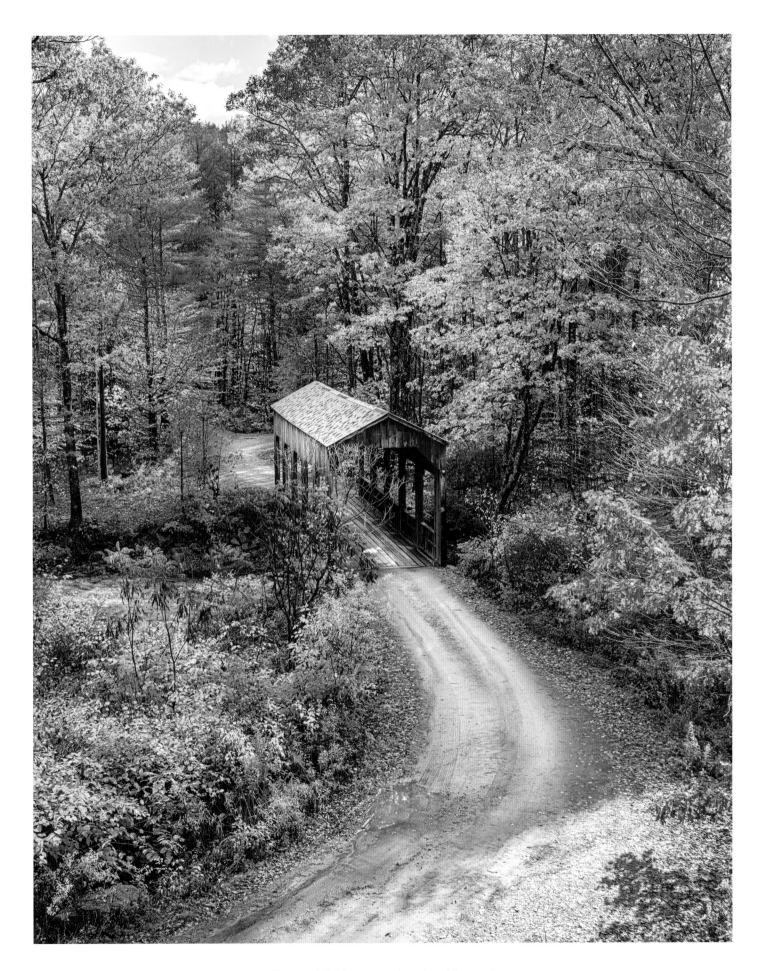

Covered Bridge, near Jamaica, Vermont

Appreciation

The sweetest moments of achievement are always those where you had a lot of help from people you care about and who care about you and did their best to help you.

Such as....

All the folks who, after reading my books on Tennessee, encouraged me to step beyond the borders of our fair state and expand the search.

My shotgun-riding, picture-taking, cigar-smoking podnuh, Robert McCurley, who rode shotgun on so many trips and thousands of miles.

New neighbors in Montana and New Jersey and South Carolina and Pennsylvania and all across this great land who seemed genuinely fascinated by this project and couldn't wait to suggest where to go next.

The good people who go to work every day in Tennessee bookstores and have helped shoppers find my first two books.

And, of course, Julia, who is my champion, my believer, my encourager, and most of all, my love.

Index of Photographs by State

Prints of photographs are available for sale.
Email jerryppark@comcast.net for sizes and prices.

INDEX OF WRITINGS

Back cover: Sneaking a Peek, New Holland, Pennsylvania